Phoenix Art Glass
An Identification and Value Guide

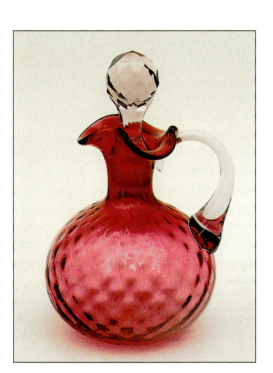

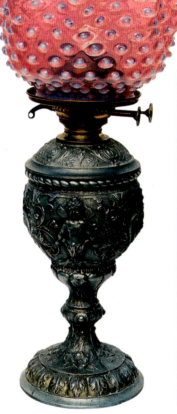

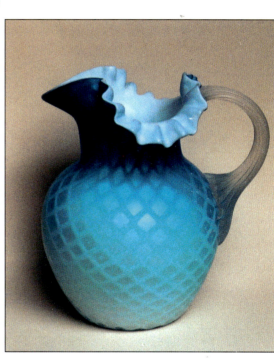

Leland Marple

Schiffer Publishing Ltd.®

4880 Lower Valley Road, Atglen, PA 19310 USA

Library of Congress Cataloging-in-Publication Data

Marple, Lee.
 Phoenix art glass : an identification and value guide / by
Leland Marple.
 p. cm.
 ISBN 0-7643-2044-0 (pbk.)
 1. Phoenix Glass Co.—Catalogs. 2. Art glass—Collectors
and collecting—Pennsylvania—Monaca—Catalogs. I. Title.
NK5198.P48M37 2004
748.2'09748'92—dc22
 2004001227

Designed by Mark David Bowyer
Type set in Seagull Hv BT/Korinna BT

ISBN: 0-7643-2044-0
Printed in China
1 2 3 4

Published by Schiffer Publishing Ltd.
4880 Lower Valley Road
Atglen, PA 19310
Phone: (610) 593-1777; Fax: (610) 593-2002
E-mail: Info@schifferbooks.com

For the largest selection of fine reference books on this and
related subjects, please visit our web site at
www.schifferbooks.com
We are always looking for people to write books on new and
related subjects. If you have an idea for a book please
contact us at the above address.

This book may be purchased from the publisher.
Include $3.95 for shipping.
Please try your bookstore first.
You may write for a free catalog.

In Europe, Schiffer books are distributed by
Bushwood Books
6 Marksbury Ave.
Kew Gardens
Surrey TW9 4JF England
Phone: 44 (0) 20 8392-8585; Fax: 44 (0) 20 8392-9876
E-mail: info@bushwoodbooks.co.uk
Free postage in the U.K., Europe; air mail at cost.

Acknowledgments

Our work to identify the glass made by Phœnix starts with a foundation built by other research oriented glass enthusiasts. Premier among these is William Heacock. The legacy of his many publications showing examples and original materials from trade and manufacturer's catalogs is unequaled. His records provided the first insight into the art glass Phœnix made, and at the same time, identified some of the lines of research that could be followed to be able to identify the products from this firm. We recognize and appreciate his early leadership in this field.

The written material about Phœnix products came to our attention through the courtesy of Tom and Nelia Bredehoft. Tom sent us copies of the descriptions of Phœnix products in trade journals that were in the collections of the Corning Museum of Glass. Collected and presented by year of publication, these records were instrumental in constructing the initial database of documented objects.

Many collectors allowed us to view and photograph examples for this book. These sessions were invaluable not only for the images, but because they provided a better appreciation of the amount and type of glass that did not have a known origin. For the many courtesies extended to us, we would like to thank: Thomas and Neila Bredehoft, Bob and Carole Bruce, George Chapogas, Sam Kissee, Larry Loxterman, Ruth Lusher, Tom and Karin Sanders, and Brian Severn. Many others contributed images, as well as electronic access to examples in their collections. In this regard, we acknowledge the contribution of the following: Jim Brown, Stu Horn, Lee Kinley, Bob McCleskey, Graham & Helen Pullen, Bob & Pat Ruf, and James Sapp.

Additional documentation for Phœnix products was provided by images from the Corning Museum of Glass. We are indebted to Gail Bardhan for making copies of Phœnix advertisements for us to include in this work.

Contents

Introduction

The Phœnix Glass Company began operations at a new facility in Phillipsburg (now Monaca) Pennsylvania, on August 5, 1880. Their first products were leaded glass chimneys and shades for various types of lamps. The firm remained in continuous operation until 1970, except for short periods after devastating fires, making glassware for the lighting industry.[1] There were several occasions, however, when the firm ventured into the manufacture of artistic glass, cut lead crystal, and decorative glass products for the home. This work describes the art glass made from 1883, the time Joseph Webb joined the firm, to 1894 when Phœnix decided to focus exclusively on lighting products.

Joseph Webb was one of two sons of the English glassmaker Joseph Webb (1813-1869). Without doubt, the younger Joseph was involved with glass manufacture at Coalbourn Hill (near Stourbridge). Early in 1883, he immigrated to America and found employment as plant superintendent at Phœnix.[2] At this time, Joseph's glass making expertise was so extensive that a large part of the glass he subsequently made there could not be made in this country by any other firm. Beginning 1888, Phœnix began to promote cut lead crystal. By the time of the 1893 Worlds Exposition at Chicago, the manufacture of artistic glassware seems to have been phased out. The Phœnix exhibit at this event was a colossal seventy feet high structure of glass in the center of the Electrical Building, displaying cut crystal and electrical lighting products. Webb left Phœnix to assist Libbey Glass with the operation of their factory at this Exhibition, but his time with Libbey was short lived. Before the end of 1894, he moved to the Dithridge Fort Pitt Glass Company, then shortly afterwards to the Tarentum Glass Company. Joseph later joined his brother, Fitzroy, in an ill-fated 1900-1901 glass/tile making venture at Coudersport, Pennsylvania. After a short employ at the New Martinsville Glass Company (1901-1904), he went to work at Haskins Glass Company, then moved to Byesville Glass to establish a reputation for them in the art glass field. This did not occur, for he passed away at the end of 1905.[3]

Relatively little is known about the glass made by Webb at the various firms where he worked. Some of the blown, colored glass made at New Martinsville has been documented by Measell[4] through trade advertising, trade catalogs, and a 1904 factory color catalog.[5] A few objects made at the "Joseph Webb Glassworks" are illustrated by Majot in *Coudersport Glass 1900-1904*. If it were not for the reports in trade journals, we would know virtually nothing about the glass Webb made at Phœnix. We begin our presentation with historical information about the activities at Phœnix, paying particular attention to the multitude of colors and effects that Webb made, for they play an important role in the attributions that are made in subsequent chapters.

The approach used here to identify Phœnix products is very different from what the reader will find in books that describe the glass made by other American firms in operation between 1880 and 1900. For the latter, original company catalogs play a major role in product identification. Here, this route does not exist, for the earliest Phœnix catalogs (1890) featured just lamps and cut lead crystal. To our knowledge, the only print materials to illustrate the artistic glassware made by Phœnix are advertisements in contemporary trade journals.

Our research into the art glass made at Phœnix actually started quite by chance. As part of another project, we began to separate various kinds of blown, pattern glass pitchers into groups by manufacturer. After the objects from Hobbs Brockunier, Hobbs Glass, Buckeye Glass, West Virginia Glass, Consolidated Lamp and Glass, and Northwood's first two companies were set aside, we were left with about forty unidentified pieces. When the few imported objects were removed, many of the residual items were obviously related by color and/or shape.[6] Not knowing the firm to have made these items was a very unsatisfactory state of affairs. Further observations disclosed two facts. First, the firm had to have made a wide range of opalescent colors. Second, the firm had to be a major player in the blown glass arena, perhaps of the size of Hobbs Brockunier. It did not take long to recognize that Phœnix Glass was a serious candidate. The challenge placed before us was to find a way to document the Phœnix origin for this small group of objects.

Our first step was to enlarge the database of objects that were related by color, color effect, or mold pattern. We then sought to match an example in this group to a unique description and/or illustration of a Phœnix product in the trade literature. In this respect, we had some extraordinary help from Mr. Tom Bredehoft. Learning of our observation, Tom began to send descriptions of glass made at Phœnix that were printed in various *Crockery and Glass Journal* articles. One of these included a detailed report on "Bronze," a color effect Phœnix introduced in late 1886. This unique trade description matched (exactly) the color of several of our pitchers. Armed with this correlation, we began to make accurate comparisons, and thus acquire additional objects that matched descriptions or examples illustrated in the trade literature. This group forms the database that is the subject of Chapter 2.

Trade advertising and US Patents assigned to Phœnix reveal that in a relatively short period of time, the firm made a wide variety of art glass products in a large number of colors and effects. The firm entered the 1885 World's Exhibition and Cotton Centennial in New Orleans with a very large booth showing over 800 examples of their tableware and lighting products in plain, combined, and mottled colors. An August 1886 trade report lists the manufacture of seventeen different tableware objects, in addition to lighting ware. The patent activity of Joseph Webb indicates the firm was heavily involved in the use of air-trap effects for both tableware and lighting products. Add to this the concurrent manufacture of cut lead crystal, cut cameo, and Impasto Cameo glass, it becomes difficult to find a type of artistic glass that was not produced by Phœnix.

Mold patterns that could be linked to objects through an identity in color and effects to those in the starting database are presented in Chapter 3. In turn, these molds provide additional examples of the optic patterns as well as the color/effects used by the firm, and they are treated in Chapter 4. The extension through the overlap of mold and optic patterns permit us to expand the database in a way that reflects continuity in manufacture. As the database expanded, we did find examples that could be independently attributed to Phœnix through analysis of patents and/or additional trade advertising.

Novelty and decorative products made by Phœnix are illustrated in Chapter 5. Phœnix made many novelty products, according to trade notices. Indeed, novelties were the lifeblood of many contemporary glassmaking firms. The attributions here are based on the colors, effects, and molds illustrated in the previous chapters. We have been successful in identifying mold patterns for shakers, oils, rose bowls, finger bowls, and vases.

Objects that have some characteristics of Phœnix Glass, but could not be linked to objects in our existing database, are discussed in Chapter 6. We look at this situation to be the result of the shortage of examples needed to construct a continuous chain. Finding examples of Phœnix art glass has been difficult, for collectors tend to focus on products of known origin, and/or of a specific type. As a result, most of the large collections we have been able to access contain relatively few objects made by Phœnix. In Chapter 7, we provide examples of products that were made by firms that were in competition to Phœnix Glass. In this way, we can show the subtle facets in manufacturing that allows one to distinguish Phœnix art glass from the products made by other American and European manufacturers.

Beginning in 1888, Phœnix began to de-emphasize the production of art glass, and instead focus on the manufacture of fine, cut lead crystal. From the very start Phœnix made only leaded glass, so the expansion into a more expensive product line was only natural in view of the increasing demand. Knowledge of the early patterns

that Phœnix cut is sparing, as pointed out by Ken Howe in a recent ACGA publication.[7] Even though the firm had entered a display of cut crystal at the 1893 Worlds Exposition, Phœnix discontinued the manufacture of this luxury product in 1894. The manufacture of colored, decorative glass effectively stopped the year before when Webb left the company.[8]

The uninhibited manufacture of colored and decorated glassware by Phœnix was made possible by three fortuitous circumstances. First, Joseph Webb came to Phœnix with sufficient knowledge of glass chemistry and manufacture that allowed the firm to make many colors and color effects that could not be made by any other American firm. In addition, Webb spent considerable time in perfecting glass compositions while at Phœnix. This information is amply recorded in Crockery and Glass Journal articles. Second, the extraordinarily high import tariff of 40% from the Civil War up to 1890, and 60% from 1890 through 1894, essentially prevented the import of high quality, colored glass from England and Europe. Third, the cost of fuel at Phillipsburg was minimal, and certainly less than the equivalent cost to foreign producers. Fancy baskets and cut lead crystal were the only two types of imported glass that could compete successfully with domestic products. The lower wages paid by European firms allowed cut and engraved glass to be sold here in quantity. The reduction in tariff to 35%, resulting from passage of the Tariff Act of 1894, undoubtedly contributed to Phœnix's decision to discontinue the manufacture of cut glass. Domestic glassmaking firms made an insignificant amount of fancy glass baskets. These baskets, often made in unique molds, with handles formed in irregular shapes, were imported (from Bohemia) by American wholesale catalog firms in huge quantities from 1892 through 1903.[9]

We have included as much detail as possible about the art glass examples shown in the illustrations. Information such as the response to different sources of ultraviolet light, the type and number of pins used to form crimps, and the number of ribs in handles are recorded wherever possible. The following codes are used in the captions: H = number of ribs in handle; C = number of crimps in the ruffle; F_1 = response to shortwave ultraviolet light; F_2 = response to long wave ultraviolet light. It is this attention to detail that permits the accurate comparison of one object to another. In addition, we have made every effort to reference the illustrations of Phœnix glass in existing publications. Many of these objects fill in the gaps linking mold patterns together. We use the following abbreviations for these publications:

Code	Reference
BDFT-T	Bredehoft, T., Bredehoft N., Hobbs, Brockunier & Co. Glass. Paducah: Collector Books, 1997.

Code	Reference
BFM	Bredehoft, N., Fogg, G., and Maloney, F.C., *Early Duncan Glassware*. Boston: George Fogg, 1987.
GCD	*Glass Collector's Digest*. Marietta: Richardson Printing.
DD	Heacock, W., Measell, J., Wiggins, B., *Dugan/Diamond*. Marietta: Antique Pub., 1993.
HCK-0	Heacock, W., *Old Pattern Glass*. Marietta: Antique Pub., 1981.
HCK-1	Heacock, W., *Encyclopedia of Victorian Colored Pattern Glass, Book 1*. Marietta: Antique Pub., 1974.
HCK-2	Heacock, W., *Encyclopedia of Victorian Colored Pattern Glass, Book 2, Opalescent Glass from A to Z*. Marietta: Antique Pub., 1975.
HCK-3	Heacock, W., *Encyclopedia of Victorian Colored Pattern Glass, Book 3, Syrups, Sugar Shakers & Cruets*. Marietta: Antique Pub., 1976.
HCK-6	Heacock, W., *Encyclopedia of Victorian Colored Pattern Glass, Book 6, Oil Cruets from A to Z*. Marietta: Antique Pub., 1981.
HCK-9	Heacock, W., Gamble, W., *Encyclopedia of Victorian Colored Pattern Glass: Book 9*. Marietta: Antique Pub., 1987.
HCK-M	Heacock, W., *1000 Toothpick Holders*. Marietta: Richardson, 1977.
HCK-TP	Heacock, W., *Rare and Unlisted Toothpick Holders*. Marietta: Antique Pub., 1984.
HCK-CG	Heacock, W., *Collecting Glass - Vol 3*. Marietta: Richardson, 1986.
ELM	Elmore, J., *Opalescent Glass From A-Z*. Marietta: Antique Pub., 2000.
KRS	Kraus, G., *The Years of Duncan*. Heyworth: Heyworth Star, 1980.
LEE	Lee, R.W., *Nineteenth-Century Art Glass*, 1952. New York: M. Barrows 1957.
LCK	Lechler, M., Lechler, R., *The World of Salt Shakers*. Paducah: Collector Books, 1992.
LGB-1	Lagerberg, T., Lagerberg, V., *Collectible Glass*. Port Richey: Modern Photographers, 1969.
MCI	Innes, L., *Pittsburgh Glass 1797-1891*. Boston: Houghton, 1976.
MCO	Murray, D.L., *More Cruets Only*. Phœnix: Kilgore Graphics, 1973.
NTHCS	Nat. Toothpick Holder Collector's Soc., *Toothpick Holders: China, Glass and Metal*. Marietta: Antique Pub., 1992.
OIG	Baker, G.E., McCluskey, H.H., Spillman, J.S., Eige, G.E., Measell, J.S., Wilson, K.M., *Wheeling Glass 1829-1939*. Wheeling: Oglebay Institute, 1994
RUF2	Ruf, B., and Ruf, P., *Fairy Lamps*. Atglen: Schiffer Pub., 1996.
RVI	Revi, A.C., *Ninteenth Century Glass*, 1959. Atglen: Schiffer Pub., 1967.
SHU	Schuman III, J.A, *The Collectors Encyclopedia of American Art Glass*. Paducah: Collector Books, 1988.
TRO-3	Thuro, C.M.V., *Oil Lamps 3*. Toronto, ON: Collector Books and Thorncliffe House, 2001.

In spite of our best effort, we have no illusions that this work is free of errors. Our hope is that this research leads to a much larger database, and provides the stimulus for the acquisition of new information. Meanwhile, we hope you enjoy our effort to unravel the identity of some of the artistic glass made by Phœnix, and our quest to give credit where it is long overdue.

Values

The value range cited in the captions reflects the information currently available to us. In many cases, the range includes the price an object sold for at auction. For fairy lamps, we used recently published resources.

We would be remiss if the regional variation in sale prices were ignored. In general, we find that the highest prices are obtained in the mid-west part of this country. In addition, certain types of objects such as tumblers, toothpicks, and cruets have a large collector base. This factor definitely promotes the value of these items well above other kinds of tableware.

Rarity is only one factor in the valuation of an item. Condition is the major factor in the value of a piece of glass. Examples that are scratched, chipped, or discolored with a deposit sell for much less than noted in the price range regardless of their scarcity. Objects that are missing parts, or damaged to any extent by fractures, are of minimal interest to collectors. On occasion, some examples may be offered or purchased at a price outside of the stated price range. Neither the Author nor Publisher assumes responsibility for any losses incurred as a result of consulting this guide.

End Notes

1. Phœnix Glass became the victim of several substantial fires. The first in 1884 leveled the building surrounding the furnaces. Major fires also struck in 1893 and 1964, and the facilities were rebuilt after each event. After the 1970 merger of Anchor Hocking, then Anchor Hocking with Newell in 1987, the name was changed to Anchor Hocking Specialty Glass. This separate division at the site in Monaca is still in operation today.

2. It would appear that Joseph Webb did not receive an operational interest in the glass factory at Coalbourn, for in 1882 the factory was still managed by the executors of the late Joseph Webb. For a summary of the American glassmaking activities of Joseph Webb, see Tulla Majot, *Coudersport Glass 1900-1904* (Marietta: Antique Pub., 1999). As plant superintendent at Phœnix, Webb was responsible for the compounding and manufacture of all the glass made there.

3. Measell, J., *New Martinsville Glass 1900-1944* (Marietta: Antique Pub.1994) 15. Apparently, Joseph left written records of the formulation and processing of the glass he could make with Byesville, but the fate of these records is unknown.

4. Measell 90-101.

5. This catalog is in the collections of the Corning Museum of Glass.

6. The identification of imported pitchers is facilitated by documentation from a variety of sources, including wholesale and retail trade catalogs in our collection. In addition, imported goods are generally light in weight, and are rarely finished in the same way as quality domestic products.

7. Howe, K., *Hobstar* (24:5 Am. Cut Glass Assoc. 2002).

8. Heacock, W. *Collecting Glass* (3 Marietta: Richardson Pntg 1986) 62.

9. These items are extensively listed in Butler Brothers wholesale trade catalogs, generally in the fall issues.

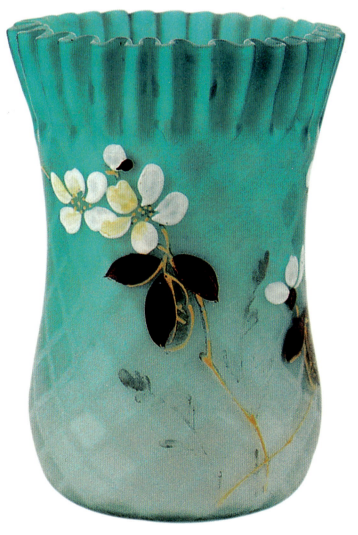

Early Phœnix History

Records of the early operation of Phœnix Glass, as well as the products made by the firm, may be found in reports from two contemporary trade journals, the *Crockery and Glass Journal* and the *Pottery and Glass Reporter*. Major events that took place prior to 1889, and recorded in these journals, are recently summarized by Ken Howe.[1] In this chapter, we present a more detailed history, and summarize the types of colors and effects that Phœnix used for their art glass.

Founded by Andrew Howard and originally situated across from the Rochester Tumbler Co. in Phillipsburg (Beaver County) Pennsylvania, the factory with one 11 pot Teaser furnace began making flint chimneys and shades on August 5, 1880. The business flourished and by the end of 1880, Phœnix employed 160 men and boys. E.D. Dithridge, formerly of Dithridge Chimney Company, signed a contract to superintend the operation of the Phœnix plant on July 1, 1881. Phœnix subsequently leased the Dithridge plant, and contracted for the Dithridge business name, molds, and patents. Chimney and lamp parts (both colored and decorated) were the major products made through 1881 and most of 1882.

Close to the end of 1882, Phœnix installed a second, 12 pot Teazer furnace, and constructed facilities for cutting and decorating shops. Apparently, chimney sales in the first part of 1883 must have been disappointing. On May 14, Mr. Dithridge was discharged.[2] Shortly thereafter, Phœnix began to make new lines of tableware, consisting of pressed berry and ice cream sets, toilet sets, stemware, spoon holders and jelly dishes in the hobnail and diamond rosette patterns. These new products must not have been received well, for by the end of the year, all the molds for them were sold.[3]

The trade notices do not indicate when, but in the interval between May and August, Mr. Joseph Webb was employed at Phœnix as plant superintendent. Webb had an extensive background in glass manufacture, having worked at the Coalbourn Hill Glass Works near Stourbridge, England.[4] Before the end of the year, Phœnix began to manufacture glass in blue, green, amber, canary, lemon, citron, and several opalescent colors.[5] The introduction of new colors in both plain and crackled finishes resulted in sufficient orders that the company could not keep up with demand. Without doubt, Webb was the driving force for this change, and the success that Phœnix began to enjoy in the art glass arena.

The appointment of Webb leads one to wonder what took place in England to prompt him to leave the parent firm. While lacking details, this move might have been his first step in a plan to make high quality art glass for the American market. We do know that in 1882, the executors of the late Joseph Webb sent a representative to New York with enough glass to fill a showroom, with the purpose of soliciting orders for English firms. There are, however, several reasons why we think this venture would have been unsuccessful. The cost of American glass was less than the English equivalent, owing largely to the low cost of fuel needed to fire the furnaces. Extensive coal and natural gas deposits in western Pennsylvania, West Virginia, and Ohio were incentives (and often used as subsidies) for locating glass factories in this region.[6] A major deterrent to English imports was the 40% American tariff imposed on all imported, finished glass and crockery. This rate was in effect to 1890, then was raised to 60%. In effect, high manufacturing cost, the tariff, and the cost of transportation cut off the importation of high quality glass and porcelain ware. Very likely, Mr. Webb realized after this exhibit that it would be far better to make glass for the American market in America rather than England.

In the midst of a successful start for Mr. Webb, things were put on hold at the end of January 1884 when fire destroyed the building surrounding the two furnaces.[7] Fortunately, the molds were stored in a separate building, and were not affected by the fire. Almost immediately, Phœnix management leased the nearby vacant Doyle and Sons glass factory, and within weeks had resumed production. Phœnix later tried to purchase the Doyle factory at an assignee sale, but their offer was declined. The decision was then made to rebuild at Phillipsburg owing to the coming availability of natural gas.[8] New glass making pots were in place by August, and full production resumed in September.

During October 1884 Phœnix made preparations to convert one furnace to run on natural gas from a new well near Rochester. Sufficient gas was obtained to heat the lears, the boiler, as well as the furnaces.[9] The second, 12 pot Teazer furnace was converted in November, with excellent results, for "the fuel imparts additional luster to their already elegant colored ware."[10] Phœnix also planned to display their products at the World's Exposition and Cotton Centennial at the beginning of 1885.[11] In the December 25 issue of the *Crockery and Glass Journal*, it was mentioned that sales agent, Geo. W. Fry, had gone to New Orleans to set up the exhibit that contained "colors and combinations of colors not before seen in glassware.[12]

The December 25, 1884 issue of the *Pottery and Glass Reporter* contains a comprehensive review of the Phœnix glass operation, and an extensive description of

their art glass products. Parts of this review were first reproduced by William Heacock[13] and later by Measell, Heacock, and Wiggins in their book on Northwood Glass.[14] The different types of colored glass (cased, opalescent, and clear) are described in three sections. Colors that were cased (presumably over opal) include Amberine, Azurine, Topazine, and Carnelian. The colors correspond, respectively, to combinations of ruby with amber, ruby with blue, ruby with crystal, and orange with crystal.[15] Opalescent colors in blue, crystal, canary, and pink are specifically listed in a second grouping. Unfortunately, the optic patterns used in conjunction with these opalescent colors are not mentioned. Clear colors in the report were "rose, blue, green, all shades of red, ruby, amber, blue and gold, and numerous others." Two additional colors, yellow and citron, were mentioned in previous 1883 trade reports. Clearly, this is a much larger palette of colors than was available to any other American firm at this early date.

The display of Phœnix glass at the 1885 exhibition in New Orleans is described in the February 5 issue of the *Pottery and Glassware Reporter*.[16] Additional colors include mottled effects in amber, blue, white rose, wine, and Amberine. The mottled patterns Phœnix made are quite distinctive, and were used until Webb left the firm. More important is the description of tableware products: creams, sugars, bowls, finger dips, and water sets. Clearly, Phœnix was making complete lines of tableware in their more popular colors such as Amberine.

Trade journals record a multitude of colors and effects that were made by Phœnix. Ignoring those used for lighting ware, we prepared a summary table listing colors by the year they were first mentioned.

Year	Color or Effect
1883	Crackled glass in blue, green, amber, canary, lemon, citron
1884	Carnelian, Amberine, Topazine, Azurine, spotted blue, crystal, canary, pink; rose, blue, peacock blue, amber, green, shades of red and ruby, amber, gold, Coraline
1885	Mottled wine, opal, mottled amber, blue, white rose. Colored cut glass with color on exterior, threaded colored glass wound spirally around a different colored body. Ivory, Aurina, ruby cased cameo with figures cut on the exterior, amethyst, flint opalescent, canary, citron and rose in Coraline mold pattern. Topaz and rose, Venetian Art (color combination), Etruscan, threaded ware (patented), peach (combination of colors identified as Mandarin), blue and marine opalescent.
1886	Ivory with applied crystal ornamentation in relief and crystal twisted feet. Rose du Barry (in diamond pattern, full tableware line),

Year	Color or Effect
	Bronze (bronze shading to steel grey), Chinese Mandarin (body of pale yellow with smoke-colored tops). Tinted ivory, fairy lamp bases and shades in striped pink and blue. Blue, ruby, canary, and flint shades in Coraline mold pattern. Verde Pearl, carved ivory glass, Rose du Barry with satin finish and diamond pattern, satin finished ivory satin cased inside with colors and with crystal edges. Gold and silver enameling on vases, pitchers, water sets, tankards with enameling in Japanese and other oriental designs. Peach (new line) with decoration, opalescent spot in all colors, opalescent diamond in all colors, etched enamel cameo glass.
1887	Heliotrope, Harlequin, Pearl, ivory, plated Snowstorm, etched, cut crystal, ivory and gold fairy lamps; Bridal Pearl; Verde de Satin Onde (green zig-zag air-trap); gold clouded crystal.
1888	Impasto Cameo in four colors.

Additional information from the trade literature indicates that Phœnix did not issue catalogs for their art glass.[17] The firm sold primarily through their showrooms in Pittsburgh and New York, so it appears there was no need to provide their agents with a printed reference. A possible exception is that a catalog might have been prepared for their sales agent, A.H. Crofts in London, England. Color effects and mold patterns were changed so frequently, in order to create fresh stock, that a catalog would have been quickly outdated. The first recorded publication by Phœnix is a catalog for lamps issued in 1890.[18]

American glass researchers have been slow to match examples to the colors noted above. William Heacock attributed several mold/color/effect combinations to Phœnix, primarily by the process of elimination.[19] To date, no one seems to have used a systematic approach to identify the products made by Phœnix, by grouping examples according to mold pattern, optic pattern, and color effects. In principle, this process should mimic the evolution of products. We are most fortunate that all of the art glass made by Phœnix was blown, rather than pressed. This alleviates the possibility that the relatively inexpensive paste and wood shape molds could have been used at a later time by another firm. Accordingly, the items in this type of linked database must stem from a single manufacturer. The origin of the group is established through items of provenance, and by unique descriptions and advertisements of Phœnix products in the trade literature. In the following chapters, we show how the "Celebrated Webb Art Glass" made by Phœnix may be identified, and how it can be distinguished from the glass made by other, contemporary firms.

End Notes

1. Howe, K., *Hob Star* (24: 5 Am. Cut Glass Assoc., 2002). Several "cut" patterns shown in this article were incorrectly based on J.E. Miller's U.S. Patents. Miller actually worked at George Duncan and Sons, and pressed glass tableware in these patterns are illustrated at length by Bredehoft, N. Fogg, G.A., and Maloney, F.C., *Early Duncan Glassware* (authors, 1987)

2. Dithridge filed suit in the Court of Common Pleas for damages in the sum of $20,000. In this complaint, he alleges that he entered into a contract on July 27, 1881, to superintend the factory at Phillipsburg at an annual salary of $2,500 and 1/4 the profits of the business. It is not clear how this suit was settled.

3. This sale was recorded in both the July 26, 1883 issue of the *Crockery and Glass Journal*, and the July 19, 1883 issue of the *Pottery and Glass Reporter*.

4. It would appear that neither Joseph Webb (the junior) nor H. Fitzroy Webb received a beneficial interest in their fathers firm.

5. This information comes from the October 11, 1883 *Pottery and Glass Reporter*, and is recorded by J. Measell in his book on New Martinsville glass. Both lemon yellow and citron were new colors for American glassware.

6. There was a large coal deposit on land adjacent to the site, but there is no record that it belonged to Phœnix. The proximity of coal was one factor that later led Phœnix to rebuild at Phillipsburg, based on the report in the April 17, 1884 issue of the *Crockery and Glass Journal*.

7. The date was January 29, according to the account in the February 7, 1884 issue of the *Pottery and Glass Reporter*.

8. According to the April 17, 1884 account in the *Crockery and Glass Journal*, natural gas was coming to the area from Rochester.

9. *Glass Journal*, October 16, 1884

10. *Glass Journal*, December 11, 1884

11. *Glass Journal*, December 18, 1884. Hobbs Brockunier, G. Duncan & Sons, Mt. Washington Glass, New England Glass, or the Boston and Sandwich Glass Company did not enter an exhibit.

12. *Glass Journal*, December 25, 1884

13. Heacock, W., *Collecting Glass* 3 (Marietta: Richardson Pntg., 1986)

14. Measell, J., Heacock, W., and Wiggins, B., *Northwood The Early Years 1881-1900* (Marietta: Antique Pub., nd)

15. For these colors, "ine" denotes ruby. Topazine corresponds to ruby die-away to crystal, for nearly all naturally occurring topaz is colorless. Light yellow topaz from Brazil is turned orange (precious topaz) by heat treatment. Colorless topaz from Brazil is turned blue by gamma-irradiation. The salmon colored Utah topaz turns colorless on exposure to light. Pink topaz from Russia is very rare. Carnelian corresponds to orange coated with crystal and plated over opal, identical to the colors in both natural or cooked carnelian agates. Azurine corresponds to ruby die-away to deep blue, a very scarce combination of colors.

16. The entire text is provided in Appendix 1.

17. Not a single Phœnix trade advertisement mentions the availability of a catalog until 1890.

18. A catalog of "illuminated" lamps could be obtained from the company as noted in the Phœnix advertisement in *Harper's Magazine Advertiser*. This appears to be the first of several catalogs featuring lamps and cut glass. In September, 1893, an article in *Crockery and Glass Journal* mentions "The Phœnix Glass Co., are sending out from the New York office one of the handsomest catalogs ever printed in the glass line. The book is large, being about twenty inches long by sixteen inches wide, bound in cloth, with the company's name and address embossed in black letters on the front, and embossed plain on the back. The cuts are unusually good, and the printing is very fine." We are not aware that a copy of this catalog has survived.

19. Heacock, W, Gamble, W., *Encyclopedia of Victorian Colored Pattern Glass 9* (Marietta: Antique Pub., 1987) 53, 65, 68.

Starting Shape Mold, Optic Pattern, and Effect Matrix

Phœnix started 1885 with sufficient orders of lighting and art glass products to run both furnaces full time. Items made include: jugs, tumblers, and finger bowls;[1] water, sugar and cream sets, berry sets;[2] ice-cream, lemonade, and punch sets.[3] Many new colors and color combinations were introduced during 1885, as noted in the previous chapter. In addition, opal glass used to make globes for lighting ware appears also to have been used for tableware. Later in August, a report in the *Pottery and Glassware Reporter* lists many of the items that were being made at Phœnix. In addition to those above, the list includes candles, bobesches, desert sets, bouquet holders, pitchers, water bottles, water sets, smoke bells, flat bells, champagne and other drinking glasses, individual and table sets, peppers, custards, and water ices. In spite of our best efforts, we have been unable to find examples of many of the objects in this listing. It is this wide spectrum of colors, color effects, and objects that sets the production of Phœnix Glass apart from their competitors.[4]

There are two parts to the process we used to identify the glass made by Phœnix. The first was to establish a group of interrelated objects, some of which were identified through unique descriptions in the trade literature. To this group, we added examples that appear in Phœnix Glass advertisements. Next, we extended the database by the inclusion of objects made in the same colors, color effects, and molds. In principle, there should be continuity in all of these attributes over time, so that we end up (ideally) with a database of completely interrelated objects.

The examples that started us on our journey were several that fit the description of "Bronze," a unique color combination of bronze shading to steel gray.[5] Although difficult to capture the colors in a photograph, in daylight this is an accurate description of the pitcher in Plate 1. The water pitcher in Plate 2 is the same color and shape, but made in the diamond optic instead of the panel optic pattern. The top crimps of these pitchers are the same as shown in Plate 3. We classify this shape as the "duckbill" crimp, owing to the wide, semicircular spout. Other items were made in this color combination, including the oil or cruet.

Plate 4 shows a water pitcher matching (exactly) the optic and mold pattern of the pitcher in Plate 1. Three casings of opal, ruby, and green glass were used to make this example. The punch cup, Plate 5, is made in the identical color and optic pattern. The cased ruby/amber punch cup in Plate 6 is made in the same optic and similar shape mold. This cup is engraved with "Worlds Exposition 1885 n.o." on the obverse, and "Louise" on the reverse. The cup is a souvenir from the World's Exhibition and Cotton Centennial held in New Orleans at the beginning of 1885. In principle, all of these objects must originate from the same firm, owing to the overlap of colors and shape molds. The question at this point is whether this conclusion stands up to a careful analysis of all the information available from trade literature, patents, and other sources.

We look first at the technology involved in making the examples in Bronze effect. A close examination of the pitcher shows that the bronze glass is cased with a thin layer of opalescent glass, and then covered with a thick layer of crystal. These pitchers were made by forming a gather of bronze, then coating with a layer of opalescent glass that was thicker at the base than at the end of the blowpipe. The gather was partially expanded to start a die-away effect, then coated with crystal. What American firm had the capability of making this combination of glasses? New England Glass Co. can be ruled out, for J. Locke could not make a compatible combination of two glasses, let alone three. Boston and Sandwich made compatible combinations of two colors of glass, but in spite of extensive documentation there is no record of the production of a clear colored glass like bronze. Mt. Washington Glass did make compatible two-layer combinations, but they appear to be limited to combinations of either translucent or opaque glasses. Hobbs Brockunier made clear and opalescent combinations of two types of glass, but the records show that this firm was incapable of making a compatible three-layer combination. G. Duncan and Sons did make compatible combinations with two layers of glass, but none that involved an opalescent glass. In summary, the only domestic firm that had the technical capability of making colored opalescent glassware with three casings was Phœnix.

Additional confirmation for the Phœnix origin of the examples in Plates 1-6 is available from other sources. The records from the New Orleans exposition show that Phœnix Glass entered the "competition" there, for which they were awarded a Medal of First Class. Detailed descriptions of the exhibit were mentioned in the trade press, and several of them are reproduced in the Appendix. We note that on one exhibit table, Phœnix displayed "both mottled wine colored and Amberine water sets."[6] So there is little doubt that Phœnix made a cased ruby/amber glass combination, and they did so to capitalize on the popularity of Locke's Amberina made at New England Glass. Trade notices also reveal that "fancy things, colored glass cups and pitchers" were purchased for souvenirs by a

sales representative to be engraved at the exhibition.[7] In Plate 6, we show a cup that was engraved as a souvenir. Consider the following possibilities for the source of this example. On short notice (it was not certain that the Exposition would open as scheduled, for it was deeply in debt) the ware had to come from a domestic source. We are aware of only three firms that might have made a ruby/amber combination with the spot optic pattern: Hobbs Brockunier,[8] Phœnix,[9] and G. Duncan and Sons.[10] To make this example, the gather of glass was first blown into a spot optic mold, then into a finished shape mold that in a way that left a raised "rosette" pattern in the bottom of the cup as shown in Plate 7. We are not aware that rosettes of any type appear in objects made in the spot optic pattern used by Hobbs Brockunier or Duncan and Sons. Since Phœnix made their own optic and shape molds, one might expect to find some point of difference.[11] Note also that the handle of the cup was applied starting at the top and finishing at the base. Neither Hobbs nor Duncan applied this "strap" handle to any of their products made in the spot optic prior to 1888. Accordingly, Phœnix is left as the only domestic manufacturer for this cup.[12]

Other punch cups made in the same optic or shape molds as the dated example are shown in Plates 5, 8, 9, and 10. These cups are of a slightly smaller size than the dated cup, and except for the cup covered with pounded glass, all have the impress of a 10 or 12 arm rosette in the bottom. The mottled examples in Plates 9-10 are certainly consistent with those described in the report from the New Orleans exhibition. Mottled effects of these examples appear to be unique to Phœnix, for we have been able to find no record of their production by contemporary firms that were making blown glassware. The cup in Plate 5 is unusual in that ruby is first plated over opalescent glass, then the whole covered with green to yield a triple-cased product. Like Bronze, this color effect is consistent with trade advertisements and reports of the opalescent glass made at Phœnix.[13]

Three important elements of the pitchers in Plates 1-4 are the ruffled top, the "duckbill" shape of the spout, and the way the handle is attached at the top of the neck. The ruffle was made with a mechanical tool that produced an asymmetric ripple pattern. On close examination, it will be noticed that the ruffle incorporates a series of humps that all face towards the center of the object. This effect was produced by a crimping device, in which moveable pins press inwards between raised, stationary pins arranged around a central core. The operating principle for this device was the subject of U.S. Patent #369,296, filed in 1887 by Harry Northwood while he was working at Phœnix.[14] A full complement of pins was used to crimp the top of vases. Omitting sections of both moveable and stationary pins left a segment of glass that could be formed into a pitcher spout. When both types of pins are shaped the same, the transition from spout to

ruffle is abrupt. It is important to note that the Phœnix crimp pattern is distinctly different from the one produced by the device described in the 1886 U.S. Patent #344,585 issued to William Leighton Jr. of Wheeling, West Virginia, who at the time worked for Hobbs Brockunier. Here, the rounded sections face outwards, and this aspect is clearly shown by illustrations in Hobbs Brockunier factory catalogs, as well as by inspection of actual examples.

The illustrations that follow the "Bronze" examples all incorporate the same combination of ruffled top, duckbill spout, and handle attachment. These objects provide additional color and effect combinations that were used by Phœnix between 1885 and 1893. Our working premise was that these color/effect patterns should also appear on items made in additional shape patterns. Over time, we accumulated sufficient examples in documented effects to see that this was the case. Shape patterns we have identified in this way are the subject of Chapter 3.

The attribution for the ruby/amber punch cup engraved at the New Orleans exposition suggests that other colored glass objects that were engraved there should be made in Phœnix colors. Our first (and only) test is a champagne tumbler, Plate 27, in blue/crystal glass. We have found that this identical color combination (over opal) was used for a vase in the "Phœnix Drape" optic mold.[15] In addition, the same blue/crystal combination was used to make water pitchers with triangular necks of the type shown in Plates 76-88. Additional examples of colored glass souvenirs would be helpful for analysis, but the two shown here are the only examples that we have been able to acquire.

The expansion of the initial database continues with an example of "Ivory," a color mentioned in very early 1885 trade notices. Decorated ivory, and ivory and gold, are two color/effects that were mentioned just before the end of the year. Plate 29 shows a tankard pitcher in a color that matches the trade description. The shape of this tankard is exactly the same as the shape of the "Venetian Thread" tankard in the 1886 Phœnix trade ad shown in Plate 28. Although a number of firms made tankard shape pitchers, Phœnix is the only firm we know to have made one in ivory color. The main contribution of this example to our database resides in the elements used for the decoration. Note the "weed" pattern in the background, and in particular, the tiny pods attached to a stem. Later, it will be seen that this element was used for the decoration of air-trap ware made at Phœnix.

We turn now to matching other objects to those illustrated in the Phœnix trade advertisement of November 18, 1886 and reproduced in Plate 34. Many colors of the fine (rib) Coraline No. 407 dome shade may be found in *Student Lamps of the Victorian Era*.[16] Of particular importance is the "satin spatter" shade shown there in Fig. 109. This is the "Snowstorm" effect that is referred to in trade literature descriptions. The snowstorm effect was also applied to fairy lamp bases and shades, and two ex-

amples are illustrated here in Plates 146-147. Coraline shades were in production for a long time, for an 1889 Geo. Duncan and Sons advertisement shows their No. 331 "Block" parlor lamp with a No. 407 Phœnix shade. This lamp was sold with or without the shade. Large dome shades made by Phœnix are almost identical to those made by Hobbs Brockunier, but may be distinguished by a slightly flatter shape and the use of opalescent colors that Hobbs could not make. For example, the opalescent blue/green dome for a hanging library lamp shown by Thuro in Plate C, page 195, can only be a Phœnix product.[17]

The November trade advertisement also shows that Phœnix produced a No. 85 Venetian Thread fairy lamp. In an advertisement the following month, this same image is numbered 4006, and an example is shown in Plate 36. This is well in advance of the arrangement with Samuel Clarke that gave the firm exclusive rights to make his patented lamp designs. It seems only natural that Phœnix would have entered into this field, for they were one of the major manufacturers of glassware for the lighting industry. Trade journal notices mention that Phœnix made these candle powered novelties in many colors and color effects. In addition, they provided standards and epergnes that could be fitted with fairy lamps.

At this time, only two optic patterns appear in illustrations of Phœnix fairy lamps. One is "Venetian Thread," an effect used for tableware and other novelty products. Lamps in this effect are shown in Plates 135-142. The second optic is the diamond air-trap. This pattern is illustrated in plate 40, reproduced from *The Decorator and Finisher Supplement* of December 1887. An actual lamp in "Harlequin" effect matching this illustration is shown in Plate 41. Fairy lamps in other optic patterns, colors, and effects are noted in trade descriptions of Phœnix products. Some of them are illustrated at the end of Chapter 3, as well as by Ruf.[18] While the agreement with Clarke was for Phœnix to become the sole manufacturer for his lamp designs, we know that this was not exactly what took place. Phœnix would have been limited to the production of shades and bases, for the firm made no pressed glassware. Where the pressed candle cups and holders were made is not known, though they would not have had to look further than Pittsburgh to find a supplier.[19] Apparently, a very large business was done in fairy lamps, according to trade reports.

At the beginning of 1887, Phœnix made a line of cheaper, colored merchandise. We are quite sure this line is the one illustrated in the December 23, 1886 issue of the *Crockery and Glass Journal*. Water pitchers with the No. 382 hexagonal crimp pattern illustrated in Plate 28 were made in ruby, blue, light amber, green, citron, and opalescent blue, all with the large spot optic pattern.[20] For some reason, other tableware patterns were rarely made in these colors. The manufacture of this product line was concurrent with the "Polka Dot" optic pattern

that was still being made by Hobbs Brockunier during 1887. At this time, Hobbs was discounting polka dot ware, so it is likely that Phœnix was not satisfied with this line of lower priced goods.[21] According to the September 15, 1887 *Crockery and Glass Journal* report, Phœnix was "...not making so many of the cheaper grades of colors as they used to, but are mainly employing themselves upon better class work."

The trade advertisement in Plate 34 also shows that Phœnix made a "Knob" optic pattern, one very similar to the optic pattern used by Hobbs Brockunier.[22] The knob optic was made primarily in opalescent and "Burmese" colors. Of the few examples of opalescent glass in the Knob optic that we have identified, the knobs are spaced further apart than they are on the ware made by Hobbs Brockunier. In addition, Phœnix examples in ruby opalescent fluoresce white on exposure to short-wave ultraviolet light, while examples from Hobbs are virtually inactive.

Phœnix appears to have made all of their glass with Burmese effect in the Knob optic pattern. Three examples are shown in Plates 44-46. This color effect is generated by the addition of prepared (dissolved) gold and uranium oxide to the raw glass sand mixture. In the conversion to glass, the auric salt (either chloride or sulfate) is reduced to elemental gold under fuel rich conditions, forming a colloidal sol. Light passing through this colloid is scattered, but most strongly in the near-ultraviolet region of the spectrum so that the apparent color is yellow. Reheating the glass to or above the annealing temperature will cause the colloidal particles to increase in size. This increases the predominant wavelength of the scattered visible light, shifting the apparent color of the glass from yellow to red or violet.[23] Excessive heating at the time of manufacture will increase the particle size to a point where scattering imparts only a slight turbidity to the glass. Accordingly, the apparent pink color of Burmese (from either Phœnix or Mt. Washington) disappears, just as it does for Amberina. Low levels of uranium oxide dissolve in glass to impart the strong yellow color. Apparently, Phœnix either used less, or a different source of uranium oxide than Mt. Washington.[24] The lighter yellow appearance of Phœnix Burmese allows us to readily distinguish the products from the two firms. In addition, Phœnix used molded, ribbed handles (if required) instead of smooth handles, and made far fewer shapes than Mt. Washington. At present, we have recorded the celery jar, two shapes of water pitchers, punch cup, vase (or celery), cruet, and a slop bowl. The legal dispute between Frederick Shirley and Joseph Webb over the infringement upon the Mt. Washington patent for Burmese likely had little impact on Phœnix production.[25]

For some reason, Burmese made by Phœnix has previously been attributed to other companies, such as Boston and Sandwich Glass. We can find no record that any firm other than Phœnix or Mt. Washington produced a

translucent or opaque glass containing both gold and uranium.

Other Phœnix shapes documented in trade advertising is the epergne in Plate 51, and the pitchers in Plates 52-54. We have found no examples of these items. The mold for the egg shape pitcher in Plate 53 was later used (1893) for part of their line of cut lead crystal. Note the thick foot in this illustration, a characteristic of many Phœnix pitchers that will be discussed later in more detail. The lobed, decorated pitcher with square neck, Plate 54, is illustrated in the March 1887 *Pottery and Glass Reporter*. This illustration is important in that it provides an example of a decorating pattern used by the firm. When reproduced at original size, a stem with small branches terminated with pods can be seen in the center of the jug. This is the same motif that appears on the example of Ivory in Plate 29. The illustration of the fish decorated tankard in Plate 52, appears at first glance, to be the same as ware made by Mt. Washington Glass. This example shows that Phœnix did make glass that was comparable or superior to other domestic or imported ware, as noted frequently in trade literature descriptions.

As our database enlarged, we began to identify several unique characteristics of the glass made by Phœnix. We point them out at this time, as it would be difficult for one to recognize them solely from the information in the captions.

Phœnix made many items with mottled effect, shown in Plates 12-16, where colored flakes of glass are picked up on a gather of crystal, prior to casing with crystal and blowing to the final shape. One might think that the mottled products made by the various firms (e.g. Northwood) could not be differentiated solely by design. It is our experience that when a sufficient number of objects are accumulated in one place, it is apparent that each firm used unique colors and patterns. The flakes used by Phœnix were only of two colors, unusually large, and they covered most of the crystal body. Much of the time, the surface of the gather was pulled towards the blowpipe to give a streak pattern as shown in Plate 55. Flakes used by other firms are generally smaller, often comprised of more than two colors, and were rarely unevenly distorted.

Another prominent characteristic of Phœnix products is the "die-away" color effect, where the color density gradually changes from top to bottom. Trade descriptions comment frequently on this characteristic from 1886 through 1888, and it was the subject of U.S. Patent application #218,308 filed November 8, 1886 by Joseph Webb. This effect, illustrated in Plate 56, is created by blowing a bubble through a gather of two colors of glass, so that the gather is lengthened as well as expanded in diameter. To our knowledge, Phœnix was the only company to use this technique in combination with an exterior glass of either crystal and heat sensitive opal colors. Objects made with heat sensitive opal generally exhibit a

light, overall opalescence in addition to the opal patterns and/or die-away colors. An overall opalescence is especially noticeable when the opal patterns are developed over ruby.

Phœnix produced a large quantity of satin glass, where the surface is chemically etched. Details for the procedure are lacking, but without doubt the etching agent was hydrogen fluoride (HF, or hydrofluoric acid.) This substance can cause extraordinary damage to skin tissue, and must be handled with exceptional care. We suspect the etching was done by exposure to gaseous HF, even though this would have been a difficult process to manage. This would account for the exceptionally smooth, etched surface that is at once recognizable by touch. At present, no other domestic manufacturer contemporary to Phœnix produced etched glass with this unusual tactile property.[26]

The unique, **chalk white** fluorescence of Phœnix glass when exposed to **short-wave** ultraviolet light is another very important characteristic. We have found this more energetic light source to be far more discriminating than the ultraviolet light from a long-wave source. Most collectors are familiar with the green fluorescence produced when a glass containing uranium is exposed to long-wave ultraviolet light. Glasses without uranium made before 1900 give only a very weak green fluorescence response to long-wave light, and only for thick sections, such as a handle. This effect is likely due to the presence of manganese that was added as a decolorizing agent.[27] In contrast, there is a large difference in the response of ruby, some types of opal, green, and all dark amber glasses when exposed to short-wave light. Obviously, one or more of the elements used in the making of these glasses not only cause fluorescence, but can quench it as well. We cannot be sure why the white fluorescence is produced in the majority of glass Phœnix made, but a good guess is that it originates from trace metals present in the litharge that the firm used for making their high lead content glass.

Another characteristic of Phœnix glass is that the shape molds used for pitchers were usually made with thickened resting edges. Plate 57 shows part of a pitcher base with a slightly flared out wall just where the side meets the base. Here, as in the case for impressed rosettes, the shape of the foot is a unique characteristic for many of the molds Phœnix made on site. In the examples of the type shown in Plate 200, the base is actually thickened into a foot. A problem arises, however, in that the thickened glass may move or sag appreciably during the trip through the annealing lear. When this happens, the bottom of the object must be flat lapped, as shown in Plate 58, in order to sit firmly on a flat surface. It is our experience that the majority of objects made by Phœnix exhibit one of these two features.

One characteristic of the air-trap glass made by Phœnix is that edges are fire polished to seal the air traps.

On occasion, the optic pattern disappears as illustrated in Plate 59. This was purposely done to prevent liquids or solid materials from entering the traps and changing their appearance. This extra step denotes a quality product, and was rarely done for the less expensive glassware that was imported from Europe.

One of the characteristics of Phœnix optic molds is that the design was continued to the center of the cavity. Thus, the optic pattern of objects blown in these molds continues around the edge to the center of the object. The only exception we note is for objects that are blown in the panel optic pattern. The design in the drape pattern tumbler, Plate 60, clearly shows this characteristic. In cases where a transfer is made, the pattern may be partially removed along with the pontil scar.

A word of caution is needed when using the above characteristics to identify Phœnix glass. It is very tempting to base an attribution of an item on a single characteristic. Collectors should avoid this temptation, and examine each of the attributes that apply in order to avoid mistakes.

End Notes

1. *Crockery and Glass Journal*, Jan. 22, 1885.
2. *Glass Journal*, Feb. 5, 1885.
3. *Glass Journal*, July 23, 1885.
4. The colors Webb was capable of making was more extensive than domestic competitors. For example, the firm made a purplish red (Heliotrope), amethyst, and Harlequin. These colors appear to be unique to Phœnix.
5. *Glass Journal*, Oct. 28, 1886.
6. *Pottery and Glassware Reporter*, Feb. 5, 1885.
7. *Glass Journal*, March 19, 1885.
8. Hobbs Brockunier called their spot optic pattern "Polka Dot."
9. The Phœnix spot optic is shown in trade advertisements.
10. Duncan and sons made ruby cased with canary, ruby cased with crystal, but we can find no record of ruby cased with amber. The ruby/amber color combination is not among the colors listed in BFM p. 34.
11. Phœnix made their own molds, and virtually everything else needed to make, decorate, package, and ship their glassware. The mold department (in 1892) was comprised of supt. Wm. Gulliver, and mold makers Richard Lay, R. Sawyer, and Thomas Vail.
12. The reader may wonder why New England did not switch from Amberina to the ruby/amber combination. Apparently, the firm had so much unsold Amberina stock that to do so would have jeopardized their continued sale of glass in inventory. We can find no evidence that Mt. Washington Glass made an amber glass to use in a ruby/amber combination.
13. There are two ways of making "opalescent" glass. One is by casing a thin film of opal glass to a colored glass. The second is to make an opal sensitive glass, where the opalescence is generated by reheating the gather in the process of manufacture. Phœnix used both methods early on, but at present it appears that opal sensitive glass was made only in crystal, blue, and ruby colors.
14. A crimping device was certainly in use prior to the time Harry Northwood joined the firm. We do not know if he filed for patent protection because he recognized the utility of the device in use, or whether he made some significant improvement in the operation.
15. We have renamed the "Wheeling Drape" optic pattern, for it is unique to Phœnix.
16. Miller, R.C., Solverson, J.F., *Student Lamps of the Victorian Era* (Marietta: Antique Pub., 1992).
17. Thuro, C. M. V., *Oil Lamps 3* (Toronto, ON: Collector Books and Thornecliff House (1994), 2001).
18. Fairy lamps in the Snowstorm effect and Coraline mold pattern are shown in Plates 58, 593, and 594 in Ruf, B. and Ruf, P., *Fairy Lamps-Elegance in Candle Lighting* (Atglen: Schiffer Pub., 1996).
19. G. Duncan and Sons might have made the pressed glass candle cups. Somewhat later in 1889, Duncan advertised their No. 331 pressed "Block" table lamp fount with or without a Phœnix "Coraline" shade. See Bredhoft, N., Fogg, G. and Maloney, F., Early Duncan Glassware (authors: 1987) vi.
20. There are only 10 spots across in the large spot pattern for a regulation size 7" water pitcher.
21. The discounting is discussed in the listing at the beginning of the Hobbs Polka Dot section in the fall, 1887 Pitkin and Brooks wholesale trade catalog.
22. William Heacock in an article "A Century of Opalescent Hobnail 1886-1986" that appears in the *Glass Collector's Digest* (1: 2 Marietta: David Richardson, 1987) mentions that Phœnix originally called the pattern "Wart." We have found no reference in the trade literature to indicate Phœnix used this term.
23. Light scattering is significant because the colloidal gold particles are dispersed in a liquid, rather than a solid matrix. Initially, the distribution of the scattered radiation should be isotropic, owing to the spherical shape of the gold particles.
24. Uranium metal forms two oxides, UO_3 and UO_2 (that is present in commercial mixed oxide, U_3O_8.) Shirley did not state which oxide was used in his U.S. Patent #332,294 for Burmese.
25. Revi, A.C., *Nineteenth Century Glass* (1957 Atglen: Schiffer Pub., 1967), 40.
26. Hobbs Brockunier and Hobbs Glass used HF generated *in situ* in an acid bath to etch their glass. This method produces a deeper, coarse feeling etch.
27. Burke, I., *Maine Antique Digest*, March (1990).

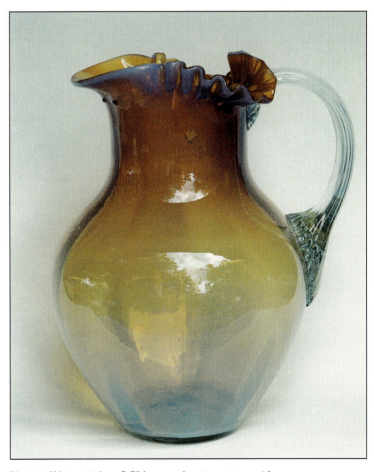

Plate 1. Water pitcher, 8.5" h., panel optic pattern with "duckbill" spout in Bronze shading to steel gray as described in the Oct. 28, 1886 *Crockery and Glass Journal*. The gray stems from a thin opalescent casing on the exterior. (H=22, C=20, F_1=bright white). $250-$350.

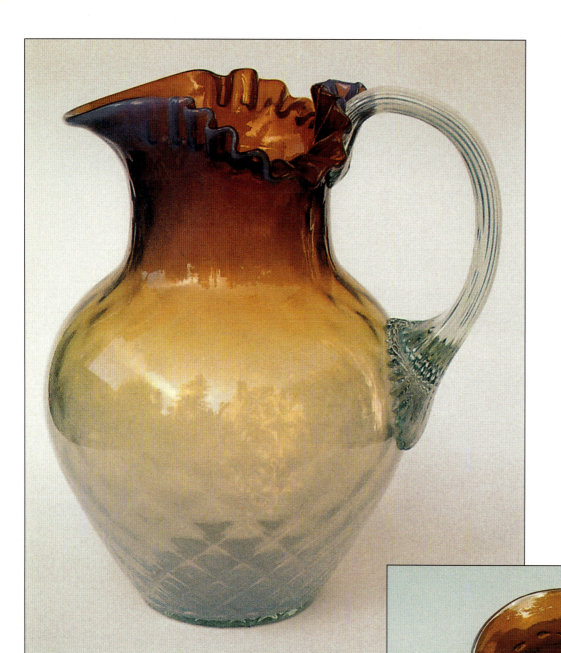

Plate 2. Water pitcher, 8.75" h., diamond optic pattern with "duckbill" spout in Bronze color effect. (H=22, C=20, F_1=bright white). $250-$350.

Plate 3. Top view of the crimp with "duckbill" shape spout for the water pitcher in Plate 1.

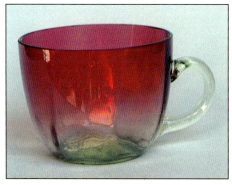

Plate 5. Punch cup, 1.87" h., 2.87" d., applied strap handle. Opalescent cased with ruby die-away to green, with 8-panel optic pattern. Impressed 8-arm rosette in bottom. (F_1=bright green, F_2=bright green). $50-$75.

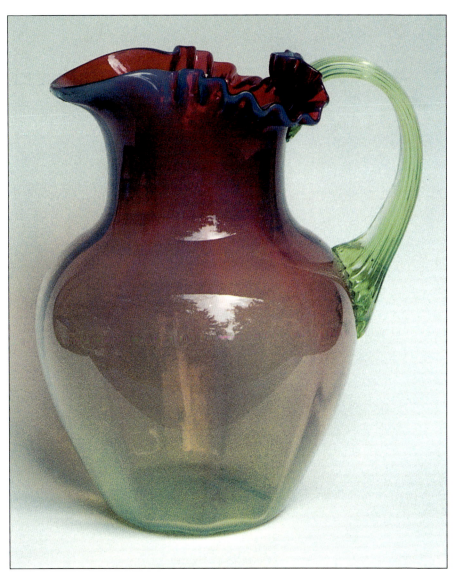

Plate 4. Water pitcher, 8" h., 10-panel optic pattern, crimped top with "duckbill" spout. Opalescent glass cased with ruby die-away to (light) green. (H=22, C=20, F_1=bright green, F_2=bright green). $250-$350.

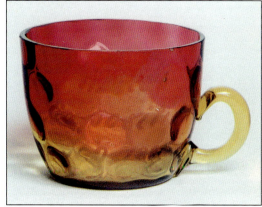

Plate 6. Punch cup, 2.18" h., 3" d., 12 spot optic pattern, cased ruby/light amber glass, impressed 12-arm rosette in bottom. Etched with "World's Exposition n.o. 1886" and "Louise" on back. (F_1=bright white). $50-$75.

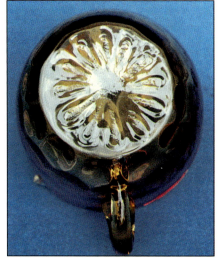

Plate 7. Bottom of punch cup in Plate 6 showing a 12-arm rosette.

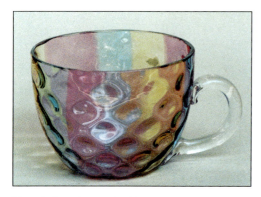

Plate 8. Punch cup, 2.12" h., strap handle with spot optic pattern, rainbow (blue/red/yellow) colors. Impressed 12-arm rosette in bottom. (F_1=bright white). $75-$125.

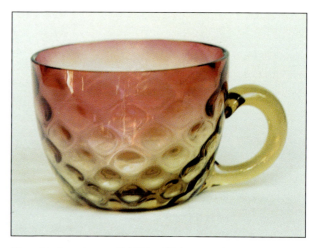

Plate 11. Punch cup, 2.18" h., 3" d., strap handle with spot optic pattern. Cased dark amber/ruby/dark amber glass, 12-arm rosette. The dark amber glass is inactive to ultraviolet light, but the encased ruby that is exposed along the edge of the rim does fluoresce. ($_{ruby}$ F_1=white)$50-$75.

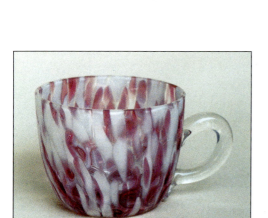

Plate 9. Punch cup, 2.18" h., strap handle with spot optic pattern, ruby and opal flakes in a mottled effect. Impressed 12-arm rosette in bottom. (F_1=bright white). $50-$75.

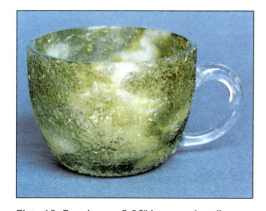

Plate 10. Punch cup, 2.06" h., strap handle, mottled green and opal flakes, covered with pounded glass (overshot). While examples are few, optic patterns appear not to have been used for objects that were to be covered with pounded glass. (F_1=bright white). $75-$125.

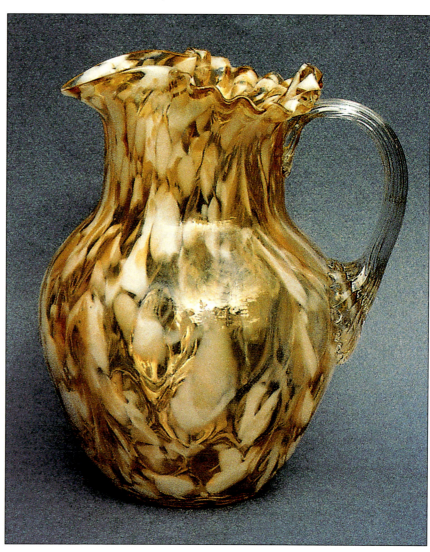

Plate 12. Water pitcher, 7.75" h., apricot and opal flakes in a pulled, mottled color effect, spot optic pattern. (H=20, C=18, F_1=bright white). $125-$175.

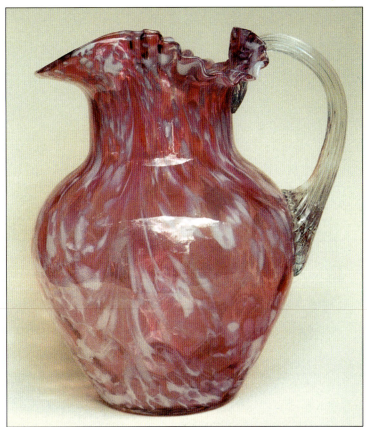

Plate 14. Water pitcher, 8.75" h., ruby and opal flakes in a pulled, mottled color effect, with spot optic pattern. (H=18, C=21, F_1=bright white). $175 $250.

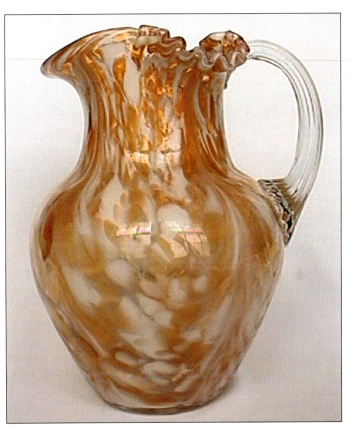

Plate 13. Water pitcher, 9" h., apricot and opal flakes in a pulled, mottled color effect, with spot optic pattern. (H=15, C=22). $175-$250.

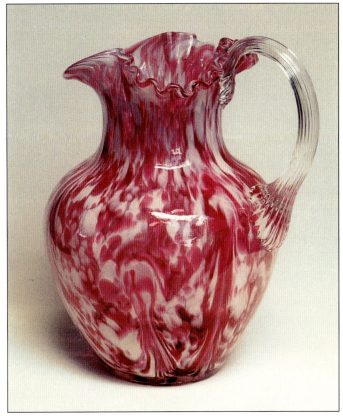

Plate 15. Water pitcher, 6.75" h., ruby and opal flakes in a pulled, mottled color effect, with spot optic pattern. Four long and four short pulls were used to create this effect. (H=20, C=18, F_1=bright white). $250-$350.

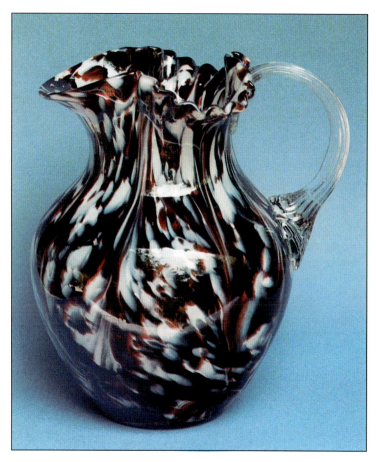

Plate 16. Water pitcher, 8.25" h., maroon and opal flakes in a pulled, mottled color effect, spot optic pattern. (H=14, C=20, F_1=bright white). $250-$350.

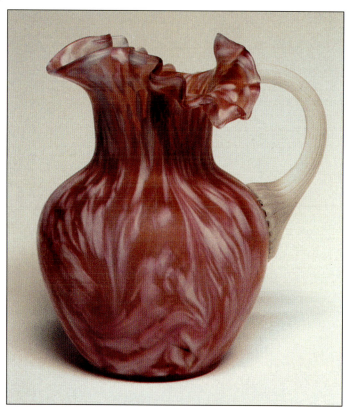

Plate 18. Small pitcher, 5.25" h., apricot, ruby and opal flakes in a pulled, mottled color effect, spot optic molds, satin finish. (H=22, C=15, F_1=bright white). $150-$250.

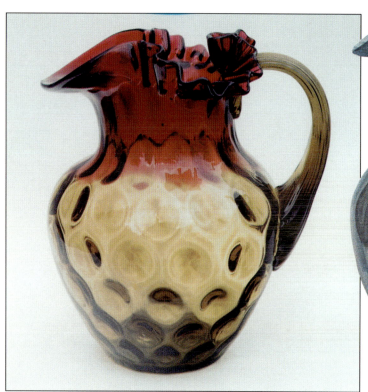

Plate 17. Water pitcher, 7.75" h., Dark amber cased with ruby die-away to dark amber, spot optic pattern. The ruby glass, encased in dark amber, fluoresces a bright white along the rim of the pitcher. (H=20, C=18). $350-$500.

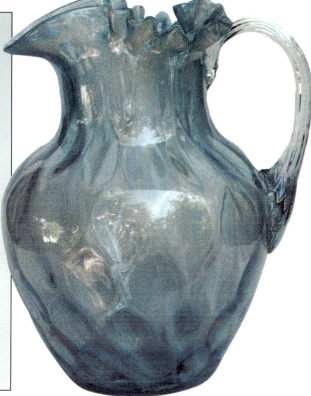

Plate 19. Water pitcher, 7.62" h., blue and opal flakes in a pulled, mottled color effect, with spot optic pattern. A 5.75" h. pitcher in the identical effect is shown in SHU p. 146, bottom right. (H=14, C=18, F_1=bright white). $150-$250.

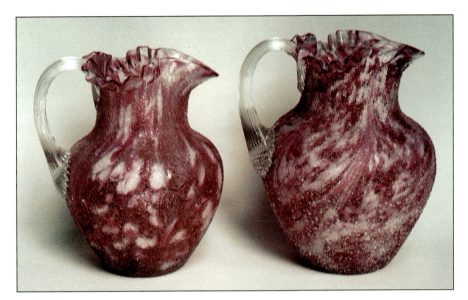

Plate 20. Water pitchers, ruby and opal flakes in a mottled effect, spot optic pattern, surface covered with pounded glass. Left: Height=7.5", diameter=6.02" (H=30, C=20, F_1=bright white) Right: Height=8", diameter=6.02". These examples illustrate the variability in manufacture of the same shape. (H=30, C=20, F_1=bright white). $350-$500.

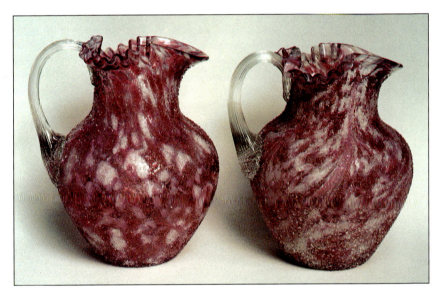

Plate 21. Water pitchers, ruby and opal flakes in a mottled effect, spot optic pattern, surface covered with pounded glass. Left: Height=8.4", diameter=6.50". (H=20, C=20, F_1=bright white). Right: Height=8", diameter=6.02". (H=30, C=20, F_1=bright white). Two sizes of shape molds, and two different rib molds were used in the construction of these pitchers, but they were crimped alike. $350-$500.

Plate 22. Water pitcher, 8.5" h., encased mica. Maroon and opal flakes in a mottled effect. The edge where the base meets the sidewall is rounded. Also made in a 5.75" high cream size pitcher. (H=22, C=20, F_1=bright white). $250-$350.

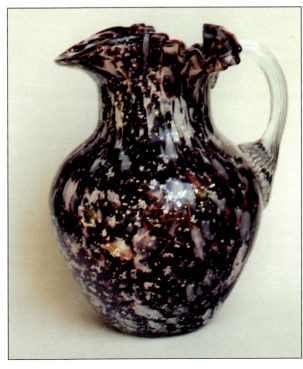

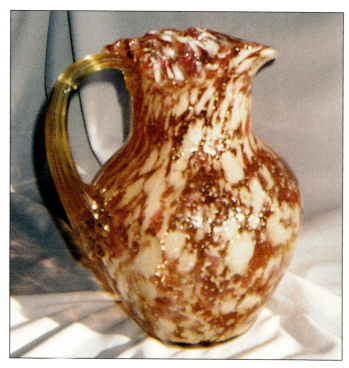

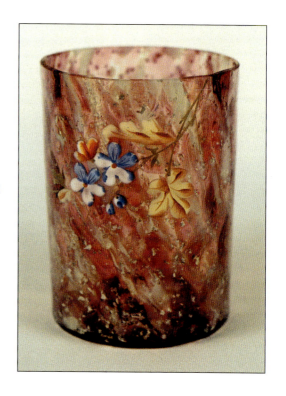

Plate 23. Left: Water pitcher, 8.75" h., encased mica, ruby and opal flakes in a pulled, mottled color effect, exterior casing of light amber. Right: Tumbler with matching color/effect, decorated with the pattern shown in Plate 24. The cruet with matching effect is shown in MCO p.34, bottom #3. A vase with matching effect, with a foot characteristic of Phœnix manufacture, is shown in BDFT-T, p. 32. (H=15, C=20) Pitcher $350-$500. Tumbler $50-$75.

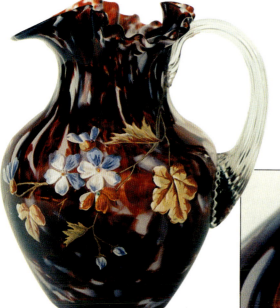

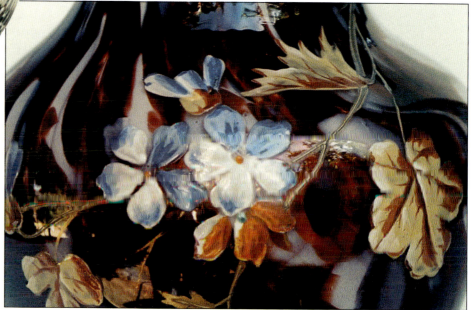

Plate 24. Left: Pitcher, 5.25" h., maroon and opal flakes in a mottled effect, spiral optic pattern with floral decoration. Right: detail of decoration. (H=20, C=10, F₁=bright white). $250-$350.

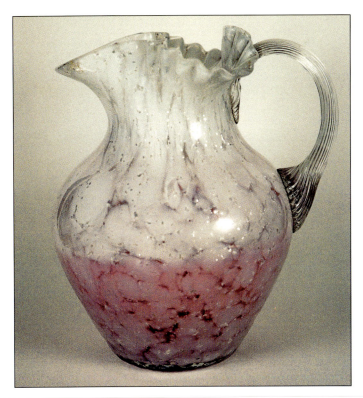

Plate 25. Pitcher, 8" h., ruby shading to clear, entrapped mica with opal flakes in a mottled effect. (H=30, C=20, F_1=bright white). $350-$500.

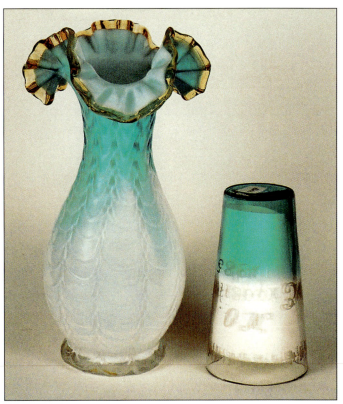

Plate 27. Champagne tumbler, souvenir engraved "N.O. Exposition 1885" on obverse, and "R.K.M" on reverse. Uniform canary fluorescence suggests a small amount of uranium is present in the exterior glass. (F_1=weak green, F_2=canary). Note how well the color compares to the Phœnix Drape 7" vase with amber rim. The opal glass likely contains small amount of uranium (F_1=green F_2=green.) Exterior crystal has normal light white fluorescence on exposure to short-wave ultraviolet light. $50-$75.

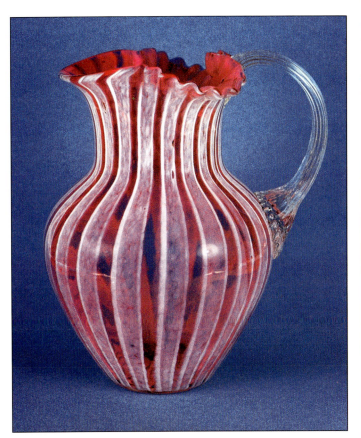

Plate 26. Water pitcher 8.5" high, ruby with vertical opalescent canes, crystal handle. (H=22, C=20, F_1=bright white). $2000-$2500.

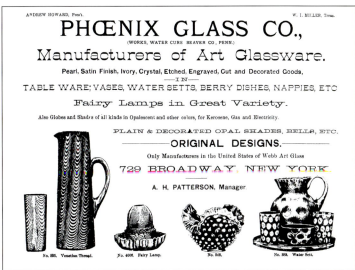

Plate 28. Phœnix Glass advertisement reproduced from the Dec. 23, 1886 Crockery and Glass Journal. Shown are the No. 335 tankard shape pitcher in Venetian Thread effect, the No. 4006 fairy lamp (also Venetian Thread effect), the No. 343 Knob optic shade, and the No. 382 water pitcher with hexagonal shape top. This same illustration was continued through March of 1887. Courtesy of Corning Museum of Glass.

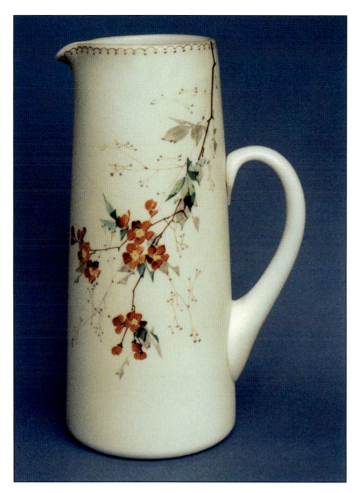

Plate 29. Tankard pitcher, 10" h., top=3.5" d., bottom=4.5" d. Opal glass decorated with ivory finish and floral pattern that includes branched pods. $250-$350.

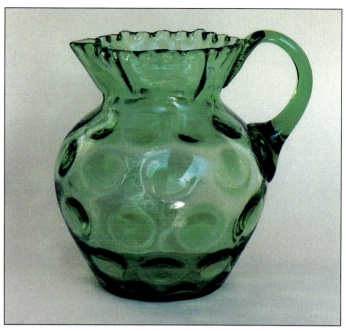

Plate 31. Water pitcher, 7.75" h., green with spot optic pattern and hexagonal crimped top. (F_1=nil). $75-$125.

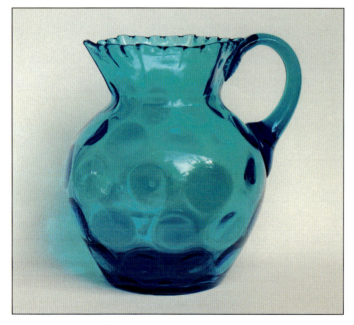

Plate 30. Water pitcher, 7.75" h., deep blue with spot optic pattern and hexagonal crimped top. This is identical to a pitcher that is illustrated in the Phœnix Glass advertisement shown in Plate 28. Different from the pitcher made at the same time by LaBelle Glass Co. by the position of the handle and the top crimp pattern. $75-$125.

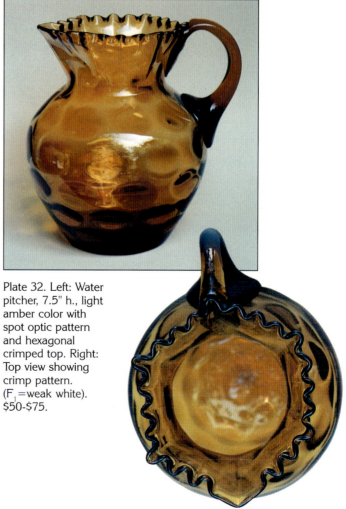

Plate 32. Left: Water pitcher, 7.5" h., light amber color with spot optic pattern and hexagonal crimped top. Right: Top view showing crimp pattern. (F_1=weak white). $50-$75.

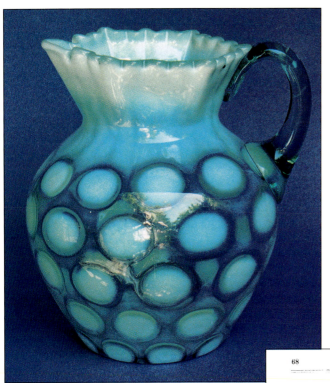

Plate 33. Water pitcher, 7.5" h., hexagonal crimped top with blue opalescent spot optic pattern. (F_1=bright white). $75-$125.

Plate 34. Phœnix Glass advertisement reproduced from the Nov. 18, 1886 issue of the *Crockery and Glass Journal*. Note that the number of the fairy lamp is 85, though the image is the same as the one in the December advertisement. Dome shades in the Knob optic pattern are shown in TRO-3, example *e*, on page 206 and *l* on page 207. The feature that distinguished Phœnix dome shades from those made by Hobbs Brockunier is the high collar shape, and the knobs on the collar. An example of a shade in the E250 mold pattern is shown in TRO-3, example *e* on page 205. Examples of 407 domes in the fine Coraline mold pattern in "Snowstorm" effect (Plates 147-148) were made. *Courtesy of Corning Museum of Glass.*

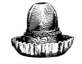
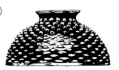

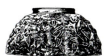
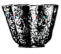

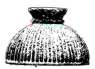

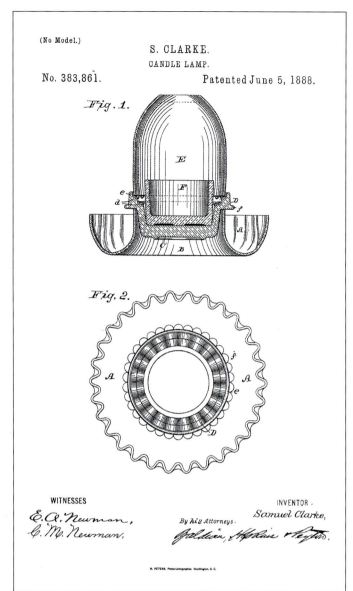

S. CLARKE.
CANDLE LAMP.

No. 383,861. Patented June 5, 1888.

Fig. 1.

Fig. 2.

WITNESSES
E. A. Newman,
C. M. Newman,
By his Attorneys.

INVENTOR .
Samuel Clarke,

N. PETERS. Photo-Lithographer, Washington, D. C.

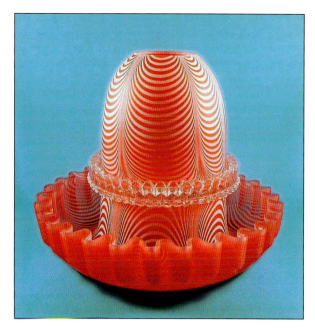

Plate 37. Fairy lamp, 5" h., scarce red dome and base with white Venetian Thread effect, satin finish. Clarke clear, pressed cup rests in center ring of base. $1250-$1500.

Plate 35. Illustration of the design detail for the fairy lamp in the S. Clarke U.S. Patent 383,861 filed April 6, 1887. This was well after the trade notice that mentioned Phœnix was making fairy lamps according to Clarke's patents. This drawing shows that the pins that made the crimp pushed inwards, but in fact, the pins pushed outward on the bases made by Phœnix. Apparently, Phœnix made a special device to crimp the base for fairy lamps. The lamps that follow do show variation in the height of the centerpost.

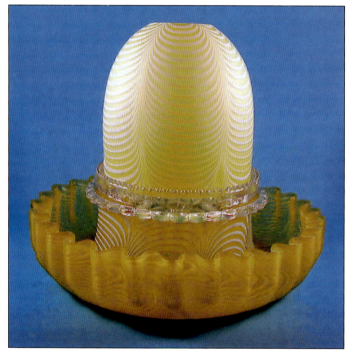

Plate 38. Fairy lamp, 5" h., citron dome and base with Venetian color effect, satin finish. Clarke lamp cup rests on the rim of the center post. $1000-$1250.

Plate 36. Fairy lamp, 4.75" h., 6.5" d. overall. Dome is 3.5" h., pulled white Venetian Thread design on ruby, satin finish. Clear crystal, pressed cup rests in center ring of base, marked "Cricklite Clarke's Trade Mark Patent" with fairy embossed in bottom. This same effect was used for lampshades, an example is shown in LGB-1, #54. ($_{ruby}F_1$=weak white). $1000-$1250.

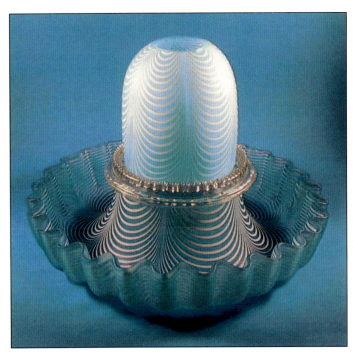

Plate 39. Fairy lamp, 5" h., blue satin finish dome and base with Venetian Thread effect. Clarke lamp containing candle cup rests on the rim of the center post. $1000-$1250.

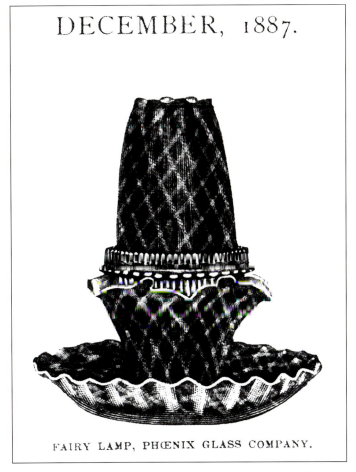

FAIRY LAMP, PHŒNIX GLASS COMPANY.

Plate 40. Illustration of a Phœnix Glass fairy lamp from the Dec. 1887 issue of *The Decorator and Furnisher Supplement. Courtesy Gail Bardhan, Corning Museum of Glass.*

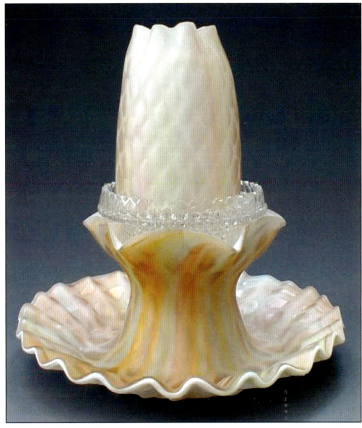

Plate 41. Phœnix glass fairy lamp, 7.5" h., air-trap diamond optic pattern in "Harlequin" color effect. Pressed Clarke "Patent Trade Mark S. Clarke Fairy" cup rests on the six-sided center post. $5000-$7500.

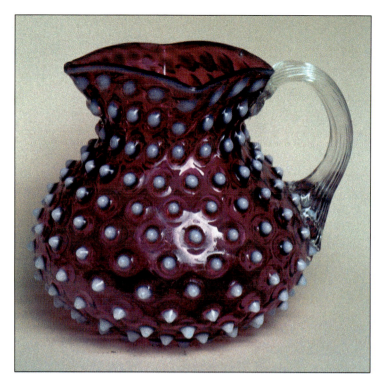
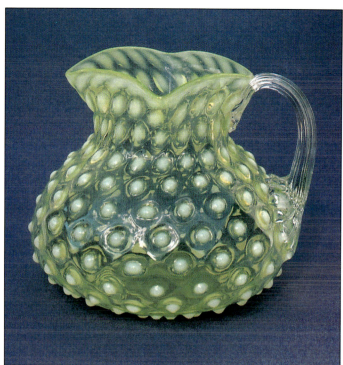

Plate 42. Pitchers, 5.25" h., square top, squat mold, "Knob" optic pattern, with crystal rib handle. Left: Ruby with opalescent knobs. (H=22, F_1=bright white) Right: Canary with opalescent knobs. (H=22 or 24 F_1=green) These pitchers are blown into the optic pattern, while those for the Hobbs Brockunier dewdrop pattern were pressed. One characteristic that distinguishes the Phœnix Knob pattern from Hobbs is that the knobs are spaced further apart. The 20 row spot mold used for this example is identical to the mold used for the shade of the lamp shown in Plate 49. Ruby $250-$350. Canary $350-$500.

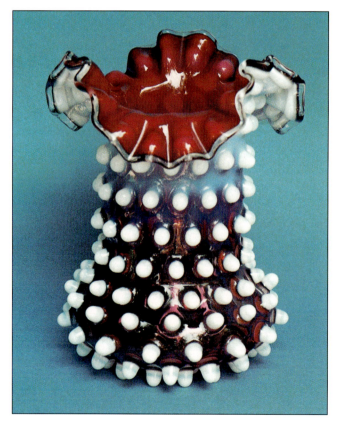

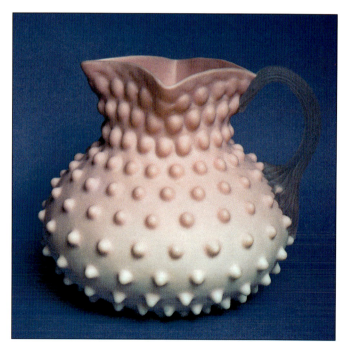

Plate 44. Pitcher, 5" h., square top, Knob optic pattern, with Phœnix Burmese color effect. (H=28, F_1=F_2=bright green). $350-$500.

Plate 43. Vase, 7.25" h., crimped top with ruby opalescent Knob optic pattern. Note the shape of the crimps in the ruffle is the same illustrated in shade #343 from the trade ad shown in Plate 34. (C=22, F_1=bright white). $75-$125.

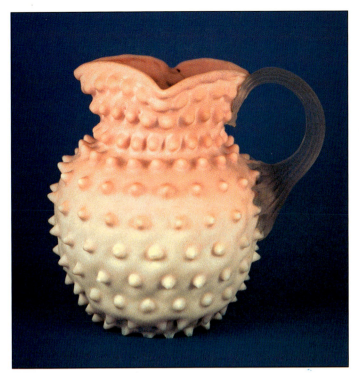

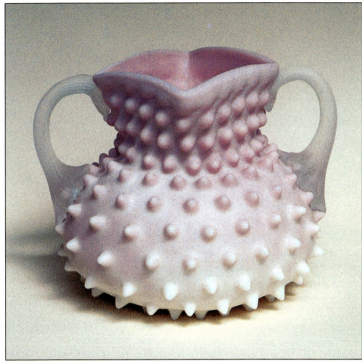

Plate 46. Two handle vase, 5" h., square top, Knob optic
pattern, rib handles with Phœnix Burmese color effect. This
appears to be the same as the pitcher in Plate 44 with an
extra handle. (H=22, F_1=F_2=bright green). $250-$350.

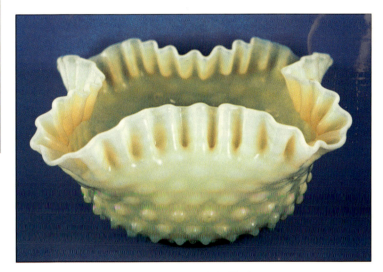

Plate 45. Phœnix Burmese color effect in the Knob optic
pattern. Top: Pitcher, 7.25" h., square top, 22 rib handle.
Bottom: punch cup, 2.62" h. (F_1=F_2=bright green)
Pitcher $350-$500. Cup $50-$75.

Plate 47. Large berry bowl, 11" d., Knob optic pattern with
large foot, made to sit in a holder. Unusual opalescent
citron color effect. The glass does not fluoresce on
exposure to long wave ultraviolet light. $175-$250.

Plate 48. Base of 11" berry bowl
shown in Plate 47, showing the lap
ground base and polished pontil.

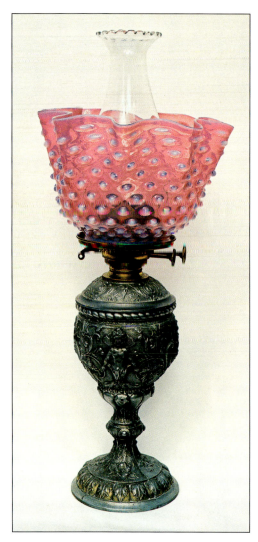

Plate 49. Kerosene table lamp, 19.5" h., burner marked H.B.& H., (Holmes, Booth and Haydens – Boston MA). Shade with 5" base expanding to 8.5" d., with Phœnix Knob optic pattern in pink opalescent effect. (F_1=white). $350-$500.

Plate 50. Vase, 4.75" h., pentagonal top, with Knob optic pattern. This example of canary glass might be a tall celery instead of a vase. The knobs are staggered at the base, but rise in columns owing to deformation in the course of manufacture. (F_1=green). $125-$175.

CUT GLASS, PHŒNIX GLASS COMPANY.

Plate 51. Illustration of Phœnix Glass Co. diamond air-trap epergne in die-away color from *The Decorator and Furnisher Supplement*, Vol. XI, No. 3, December 1887. The caption indicates this item is cut glass, but the pattern is obviously air-trap. We have not found an example of this item. *Courtesy of the Corning Museum of Glass.*

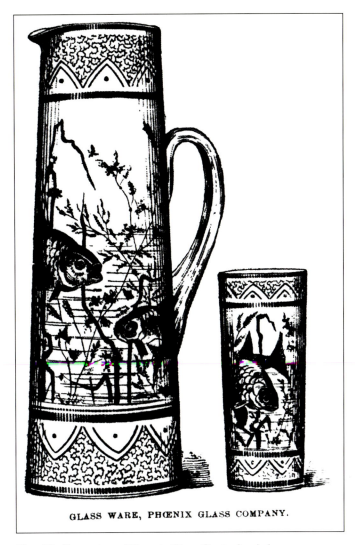

GLASS WARE, PHŒNIX GLASS COMPANY.

Plate 52. Illustration of Phœnix Glass Co. tankard shape pitcher with aquarium decoration from *The Decorator and Furnisher Supplement*, Vol. XI, No. 3, December 1887. We have not found an example of this tankard. *Courtesy of the Corning Museum of Glass.*

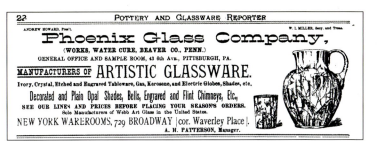
Plate 54. Illustration from the March 3, 1887 *Pottery and Glassware Reporter*, showing a water pitcher with a square top, and lobed (?) body. Elements of the "weed" decoration in the background are found on tankard pitcher (Plate 29) and many other objects. We have not found an example of this pitcher. *Courtesy of the Corning Museum of Glass.*

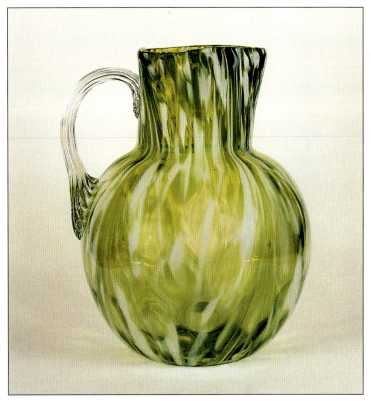

Plate 55. Example of the pulled, mottled pattern that was used with many different mottled effects.

Plate 53. Illustration from the September 1886 *Decorator and Furnisher* showing "Illuminated Glass Pitcher and Tumblers" made by the Phœnix Glass Company. Note the thickened base of the pitcher. We have not found an example of this pitcher, or the floral pattern. The same mold was used several years later to make a cut crystal pattern pitcher. *Courtesy of the Corning Museum of Glass.*

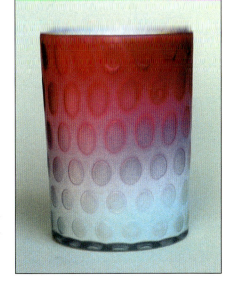

Plate 56. Example of a common ruby/ crystal die-away color transition.

Plate 57. Example showing how the sidewall flares out slightly at the base of a pitcher.

Plate 58. Base of a pitcher that has been lap ground. The circular polished depression in the center is from the removal of the pontil scar.

Plate 59. Edge of a tumbler that has been fire polished to seal the air-traps in the rim. This step required a transfer, so examples of tumblers from Phœnix exhibit a ground pontil.

Plate 60. This example shows the continuation of the drape optic pattern from the side onto the base. Optic patterns used for air-trap tumblers consist of 16 repeating segments, and the patterns also wrap around the base.

Identification of Phœnix Glass by Mold Pattern

In this chapter, we illustrate various types of products by mold pattern that are related to optic, color/effect, and certain manufacturing characteristics of objects illustrated in Chapter 2. It will be obvious at once that many examples are water pitchers. There are two explanations for the abundance of pitchers. First, they were very much in demand, as wholesale trade catalog firms purchased many different types, both individually as well as in sets with tumblers. Second, they may have been first made in order to test the salability of a new shape or color effect. If the response was good, other pieces could be quickly added to create a product line. If the response was poor, emphasis could be changed to another product. In any event, new patterns were very short lived, few were extended to include the seasoning set, and only rarely did any of them include items such as the covered butter.

Before proceeding further, we need to address the competitive environment in which Phœnix operated, even though contemporary competitors to Phœnix in the art glass arena were relatively few. Hobbs Brockunier & Co., followed by the reorganized Hobbs Glass Co., was the strongest competitor in colored, blown tableware. Hobbs line of "Coral" products apparently sold very well, a fact that did not go unnoticed by Phœnix. New opalescent patterns developed at Hobbs Glass after 1888 likely had some impact on the production of Phœnix opalescent ware, but it was about this time that Phœnix began to change direction towards the production of cut lead crystal. Fortunately, factory catalogs from Hobbs firms are available for much of the time Phœnix made art glass, so it is relatively easy to exclude the products Hobbs made from our Phœnix database.

New England Glass (Cambridge, MA) was initially successful with their colloidal Amberina glass.[1] However, by late 1884, simulated Amberina imports began to take a toll. One of the first major product lines Phœnix made and promoted at the New Orleans Exhibition was Amberine, a ruby/amber die-away glass that simulated Amberina. The exclusion of Amberina from the Phœnix database is made easy by the fact that this glass does not fluoresce on exposure to short-wave ultraviolet light. In addition, Amberina, as well as New England's Pomona and Aurora art glass products, may be easily distinguished from Phœnix glass by their documented shapes.[2]

The Mt. Washington Glass Company (New Bedford, MA) also made art glass (Pearl Satin, Peach Blow, and Burmese), but their focus in this early period was on decorated opal ware. The magnificent opal and crystal decorated glass made at Mt. Washington under the direction of Albert Steffin, for which this company is famous, was largely produced after 1890. Many collectors of early American art glass may be surprised to find that some of the examples shown in this book were not made at New Bedford. Though many transparent colors in glass have been attributed to Mt. Washington, yellow is the only one that *may* to be traceable to this firm.[3] This should not come as a surprise, for Frederick Shirley's research centered on the creation of opaque and translucent glasses. If color was desired, it was invariably applied with the decoration. From our present perspective, it is relatively easy to distinguish goods made by Phœnix from those of Mt. Washington, for the colors, effects, and shapes of glassware from these two firms are completely different.[4]

While not a domestic competitor, the Thomas W. Webb glass works in Ambelcote (near Stourbridge, England) made objects in similar colors and effects to those made by Phœnix. The attribution of objects to this firm, instead of Phœnix is expected from the similarity in glass making technology developed by firms in the Stourbridge area. However, the difficulty in importing high quality art glass from England, as mentioned in the previous chapter, essentially eliminates the probability of incorporating this glass into the Phœnix database.

Pitchers with Mechanically Crimped Tops

The first illustrations in Plates 61-66 are those of pitchers with mechanically crimped tops and broad "duckbill" spouts. There are differences in the number of pins used to make these crimped tops, as well as small differences in the basic mold shapes. New color effects, such as green mottled with opal in Plate 63 are important, in that they extend the color effects that can be attributed to Phœnix.

Also in this section, we show objects with the same type of crimped, ruffled top, but with a narrower, "U" shape spout pattern. The configuration of the spout and ruffle could be easily adjusted by changing the number and position of the moveable and stationary pins of the crimping device. Apparently, the types of pins for this and the duckbill crimp were the same, for the transition from lip to ruffle is invariably abrupt. At a later date, the pins adjacent to the spout were shaped somewhat differently than the rest, for the transition is smooth. Here also, the crimps correspond to shapes that would be produced by the machine described in the Northwood U.S. Patent #369,296. It is clear, however, that the actual use of these crimping devices by Phœnix predates the patent filing.

Three types of color/effects used for items with mechanically crimped tops appear repeatedly in varying shape molds. The first, and most prevalent, is a large flake, mottled pattern that is frequently pulled from the bottom of the gather towards the blowpipe. This produces a streak pattern within the mottled surface. Generally, four pulls were made at intervals of about 90 degrees. The surfaces of a few jugs were pulled into whorls, and a few were not pulled at all. The second pattern incorporates mica trapped within the glass layers, so as to produce a spangled effect. The pitcher shown here in Plate 75 is made with fine mica particles with a narrow size distribution, and serves to identify many of the rose bowls in this effect that are illustrated in Chapter 5. The size and distribution of mica is very similar to the products made by Stevens and Williams, but the mold patterns identify the source.[5] The third effect is air-trap, made primarily in three patterns; diamond, zig-zag (herringbone), and windows (raindrop). So many examples of this ware are available in these effects that we treat them separately in Chapter 4.

We must point out here that the pitcher in Plate 67 appears to be identical to the example #222 illustrated in *Dugan Diamond*.[6] Our example of this pitcher has a ground and polished area where the pontil scar was removed. Well before the time the Dugan firm was formed (1904), virtually every American firm was making transfers with snaps. Two of the last firms to use punty rods were Consolidated Lamp and Glass (from 1894 to 1896), and West Virginia Glass (from 1893 to 1896).[7] As the reader will soon see, this example is one of many where the Phœnix origin is incorrectly attributed to another company.

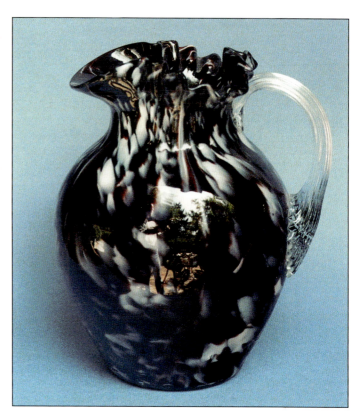

Plate 62. Pitcher, 7.5" h., "duckbill" crimped top, spot optic pattern, maroon and opal flakes in a pulled, mottled effect. (H=20, C=16, F_1=bright white). $125-$175.

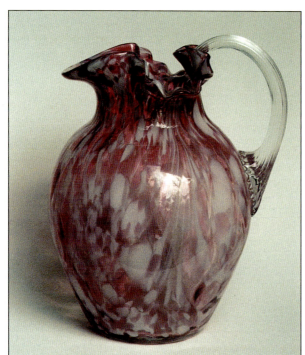

Plate 61. Pitcher, 7.5" h., "duckbill" crimped top, spot optic pattern, ruby and opal flakes in a pulled mottled effect. (H=20, C=16, F_1=bright white). $125-$175.

Plate 63. Pitcher, 7.5" h., "duckbill" crimped top, spot optic pattern, green and opal flakes in a mottled effect. (H=20, C=16, F_1=bright white). $175-$250.

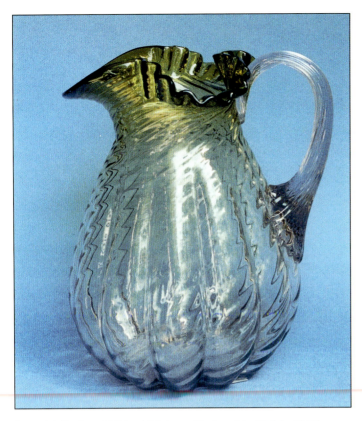

Plate 64. Pitcher, 8.5" h., 12-lobe swirled mold with "duckbill" crimped top. Green at top shading to crystal. A variation made by the procedure described in U.S. Patent 379,089, but the core was not encased in a shell before blowing into the "melon" mold. (H=22, C=20, F_1=bright white). $125-$175.

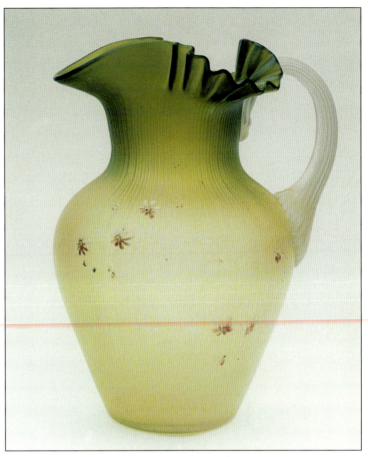

Plate 66. Pitcher, 9.5" h., vertical fine rib mold, "duckbill" crimped top. Satin finish, deep green shading to crystal. Most of floral decoration has been worn away. (H=22, C=20, F_1=bright white). $125-$175.

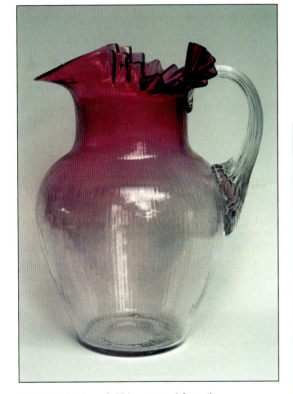

Plate 65. Pitcher, 9.5" h., vertical fine rib mold, "duckbill" crimped top, deep ruby shading to crystal. (H=22, C=20, F_1=bright white). $175-$250.

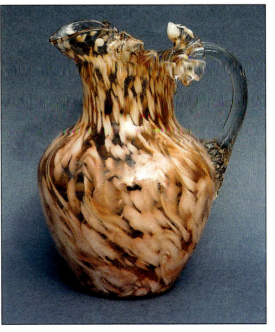

Plate 67. Pitcher, 8.62" h., spot optic pattern, apricot and opal flakes in a pulled, mottled effect. The crimp used for this pitcher is made the same way as the crimp for the duckbill shaped spouts, but the spout is "U" shaped. The same pitcher is shown in DD #222 p. 85. (H=18, C=21, F_1=bright white). $125-$175.

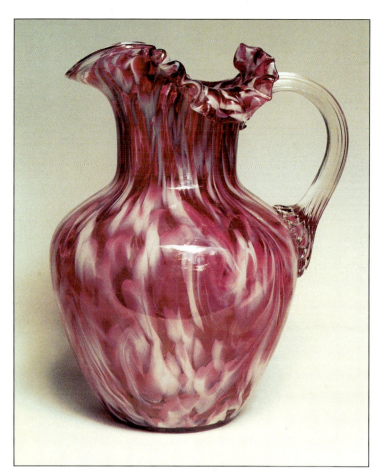

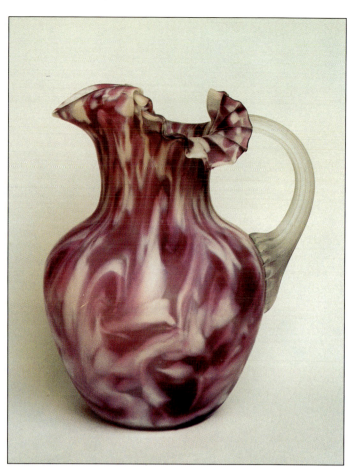

Plate 68. Pitcher, 8.75" h., spot optic pattern, crimped top with "U" shape spout, ruby and opal flakes in a pulled, mottled effect. (H=18, C=21, F_1=bright white). $175-$250.

Plate 70. Pitcher, 9" h., crimped top with "U" shape spout, satin finish with ruby and opal flakes in a pulled, mottled effect. (H=18, C=21, F_1=bright white). $250-$350.

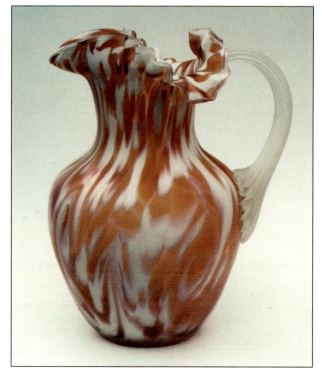

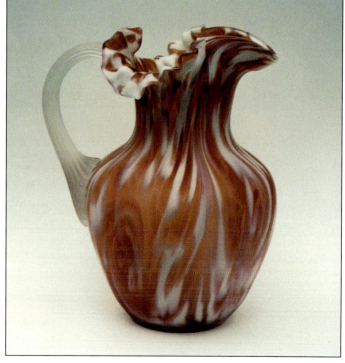

Plate 69. Left: Pitcher, 9" h., crimped top with "U" shape spout. Satin finish, orange-red and opal flakes in a pulled, mottled effect. Right: Other side of pitcher, showing that the pulls were not simply made by pulling the surface of the glass from the bottom of the gather towards the blowpipe. Instead, a whorl was started about one third the way and then pulled towards the blowpipe. (H=18, C=19, F_1=bright white). $250-$350.

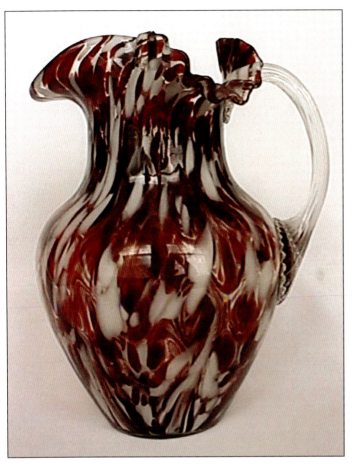

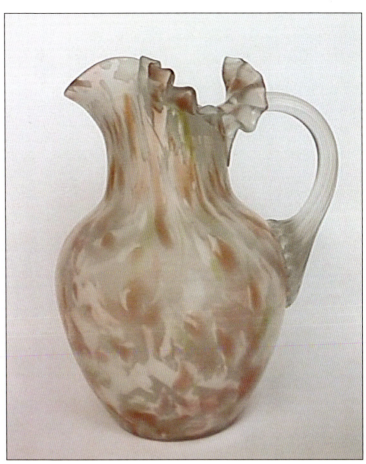

Plate 73. Pitcher, 9" h., crimped top with "U" shape spout. Satin finish, apricot and opal flakes in a pulled, mottled effect. (H=18, C=19, F_1=bright white). $250-$350.

Plate 71. Pitcher, 9" h., spot optic pattern, crimped top with "U" shape spout, maroon and opal flakes in a pulled, mottled effect. (H=22, C=22, F_1=bright white). $175-$250.

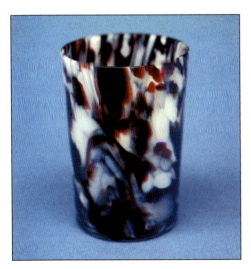

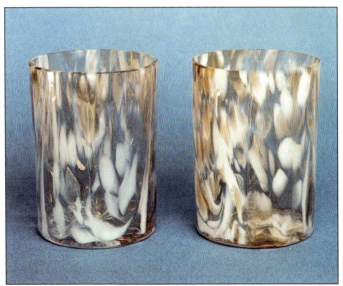

Plate 72. Tumbler, 3.75" h., maroon and opal flakes in a pulled, mottled effect. $50-$75.

Plate 74. Tumblers, 5.62" h., apricot and opal flakes in a mottled effect. There is a 12-arm rosette impressed in the bottom of these tumblers. (F_1=bright white). $50-$75.

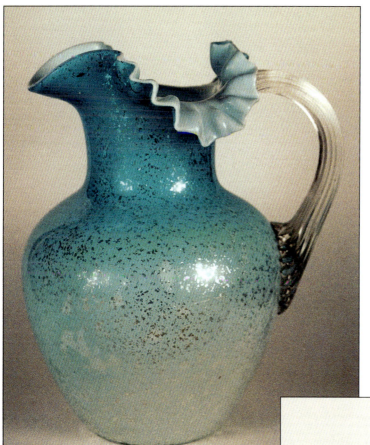

in Plate 85 with blue, red, and yellow canes matches the punch cup in Plate 8. Trade reports during November 1885 describe a punch bowl in "Venetian Art" with superb combination of colors. What is important here is that Phœnix is known to have made examples that combined several colors (other than crystal) into one object, not that Venetian Art was the name for this color combination.

Included in this section are several pitchers where the handle loops well above the top rim. The ruby die-away, satin finish water pitcher in Plate 88 was recently brought to this country from England. The color, diameter, base width, height, and length of the neck are identical to the Phœnix pitcher in Plate 87. Accordingly, these two pitchers must have been shaped in the same mold. Pitchers with loop handles were also made in England and Europe, but the examples from these sources may be identified by the way in which the handle is applied, as well as by the different colors, effects, and sizes.

Plate 75. Pitcher, 8.62" h., crimped top with "U" shape spout, blue die-away color with encased mica. The color effect for this pitcher is identical to the mica encased rose bowls shown in Chapter 5. (H=18, C=21, F_1=bright white). $350-$500.

Ball Shape Pitchers with Triangular Necks

Ball shape pitchers with triangular shape necks, Plates 76-88, use an apex as the spout. These pitchers were made in at least three different sizes and most often had ribbed handles. While many color combinations were used, the most common colors are cased ruby/dark amber, ruby/crystal, and crystal with maroon and opal flakes. A few objects were decorated with good quality enameled floral designs. The first illustrations are examples that link this type of pitcher to the Phœnix database. From the color/effects described in the trade literature, we place the manufacture from 1885 to 1886. One unique example

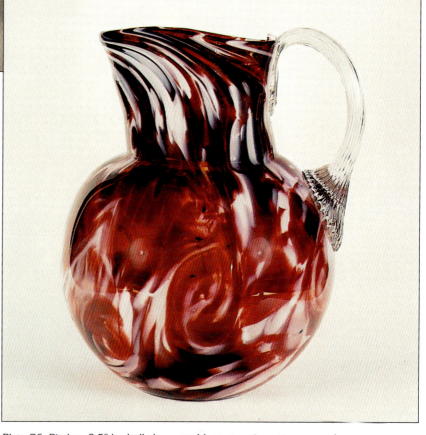

Plate 76. Pitcher, 8.5" h., ball shape mold, spot optic pattern, round neck shaping to a triangular top. Maroon and opal flakes pulled into whorls. (H=30, F_1=bright white). $125-$175.

Plate 77. Small pitcher, 4.5" h., ball shape mold, spot optic pattern, round neck shaping to a triangular top. Small pitchers are much less common than water pitchers. Maroon and opal flakes in a mottled effect. (H=26, F_1=bright white). $175-$250.

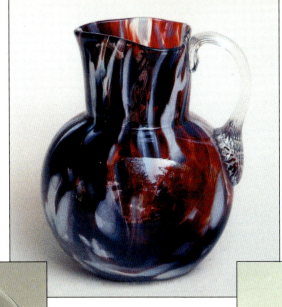

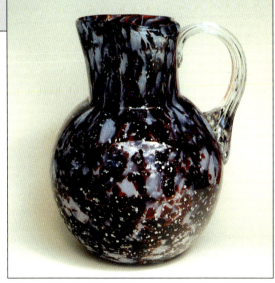

Plate 78. Small pitcher, 4.62" h., ball shape mold, spot optic pattern, round neck shaping to a triangular top. Blue and opal flakes in a mottled effect. (H=18, F_1=white). $175-$250.

Plate 80. Pitcher, 8" h., ball shape mold, spot optic pattern, round neck shaping to a triangular top. Maroon and opal flakes in a mottled effect, with encased mica. (H=16, F_1=bright white). $250-$350.

Plate 79. Small pitchers, 4.75" h., ball shape mold, spot optic pattern, round neck shaping to a triangular top. Green and opal flakes in a mottled effect, and bronze die away to crystal glass. (H=18). $175-$250 each.

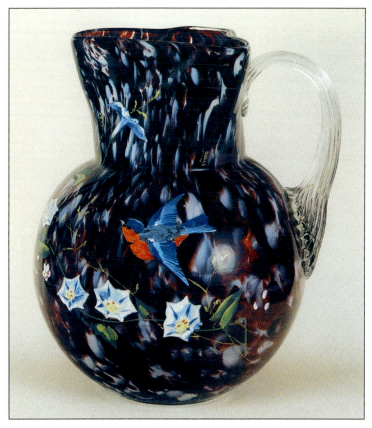

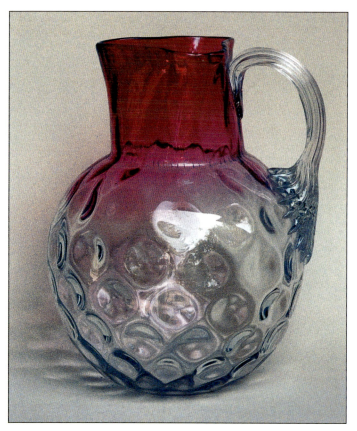

Plate 81. Pitcher, 8.5" h., ball shape mold, spot optic pattern, round neck shaping to a triangular top. Maroon and opal flakes in a mottled effect, decorated with bird and floral design. While most decorated examples of this shape are mottled with maroon and opal flakes, other color effects were decorated. A ruby and opal flake cased in amber pitcher, with spot optic pattern, and decorated with white, 6-petal flowers is illustrated in GCD 2:5, p. 36. (H=20, F_1=bright white). $350-$500.

Plate 83. Pitcher, 7.75" h., ball shape mold, spot optic pattern, round neck shaping to a triangular top. Ruby die-away color effect. (H=16, F_1=white). $175-$250.

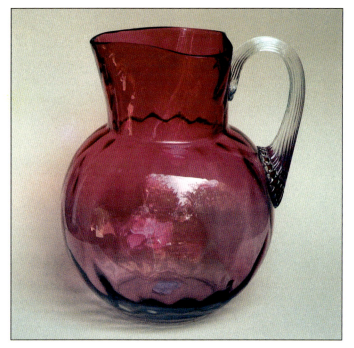

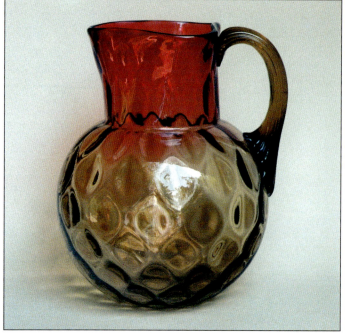

Plate 82. Pitcher, 8.25" h., ball shape mold, spot optic pattern, round neck shaping to a triangular top. Ruby cased with crystal. Small pitchers, 4.5" h., were made in this effect. (H=22, F_1=white). $175-$250.

Plate 84. Pitcher, 9" h., ball shape mold, spot optic pattern, round neck shaping to a triangular top. Ruby die-away to dark amber color effect. This same pitcher is shown in OIG, p. 65, #176, where it is misidentified as a Hobbs Brockunier product. (H=22, F_1=F_2=0). $125-$175.

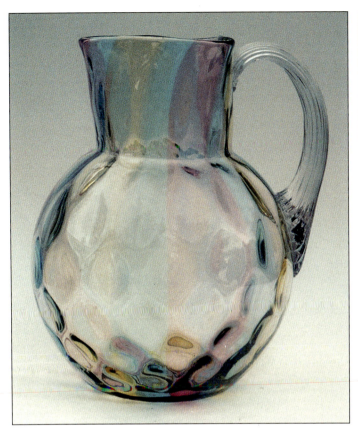

Plate 85. Pitcher, 8" h., ball shape mold, spot optic pattern, round neck shaping to a triangular top. Ruby, yellow, and blue canes embedded in crystal. (H=22, F₁=white). $350-$500.

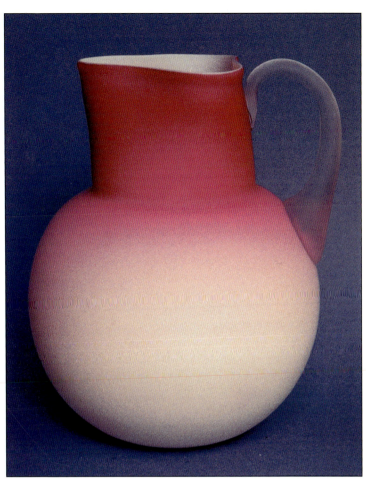

Plate 87. Pitcher, 8" h., ball shape mold, round neck shaping to a triangular top. Satin finish, ruby die-away to crystal over opal. (F_1=white). $250-$350.

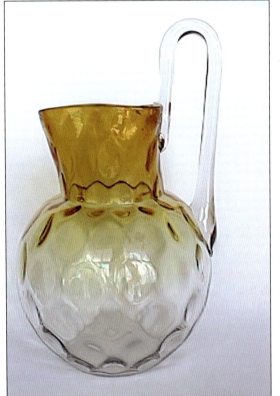

Plate 86. Pitcher, 11" h. (with loop handle), ball shape mold, spot optic pattern, round neck shaping to a triangular top. Bronze die-away color effect. A smaller, 4.75" h. version of this shape is pictured in GCD 3.1, p. 13. $350-$500.

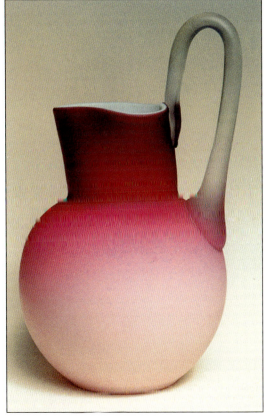

Plate 88. Pitcher, 8" h., 11" h. with loop handle, ball shape mold, round neck shaping to a triangular top. Satin finish, ruby die-away to crystal over opal. This pitcher was blown in the same mold as the one shown in Plate 87. (F_1=white). $350-$500.

Ball Shape Pitchers with Round Necks

Round neck jugs of the type shown in Plates 90-100 can be added to the Phœnix database owing to the mottled color patterns used in their fabrication. These pitchers have a relatively large neck diameter compared to the width. For many we have examined, the ratio of the neck width to diameter is slightly more than 0.5. One observation we have made about American glassware made prior to 1900 is that the size of the neck opening of a pitcher changed in a consistent way, and is indicative of the period of manufacture. It is difficult to insert a hand into objects made from 1883 through 1888. After this time, trade catalog illustrations show a gradual increase in the width of the neck, and flare of the top crimp. This transition is quite apparent upon inspection of the products made consecutively at the Northwood glass factories located at Martins Ferry, Ellwood City, and Indiana (Pennsylvania). This trend reaches a peak with the top heavy, exaggerated ruffle, wide mouth pitchers made by both the Jefferson and Fenton companies just after 1900.

Many color combination/effects were used for the manufacture of Phœnix ball shape, wide neck pitchers, including opalescent patterns. One of the more unique water sets we have on record is a ruby, Venetian Thread effect, coated with pounded glass. The (opalescent) pattern "Diamond and Ellipse," made in both ruby and blue, fits the criteria for a Phœnix origin. A ruby opalescent example of a pitcher in this pattern is illustrated by Heacock.[8] Pitchers were also made with other, unusual opalescent effects. Plate 96 shows a jug made by the canework process, with an exterior of opalescent glass. To create this effect, highly colored blue, red, and yellow rods were arranged in a conical cup, then picked up and fused into the surface of a gather of glass. The combination was next coated with

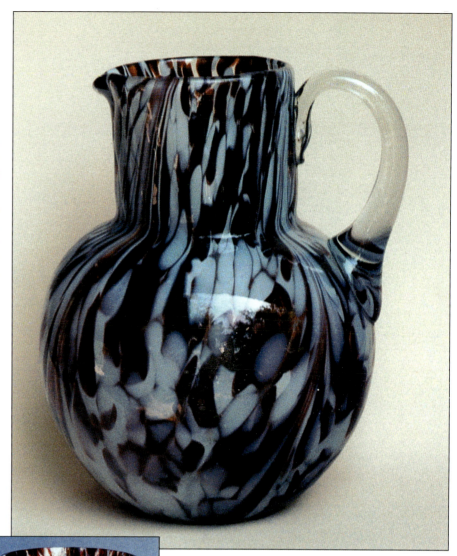

Plate 90. Pitcher, 8" h., ball shape mold with round neck. Maroon and opal flakes in pulled, mottled effect with a spot optic pattern. $125-$175.

Plate 89. Tall celery jar, 6" h., spot optic pattern, maroon and opal flakes in a mottled effect, with encased mica. (F_1=white). $75-$125.

a slightly opalescent glass, then worked on the marver plate to produce a slight twist in the stripes. After blowing to final shape, the rods produce spiral bands in the finished object. All of the research data we have indicates that Phœnix was the **only** domestic glass manufacturer to make art glass by the canework process prior to 1900.

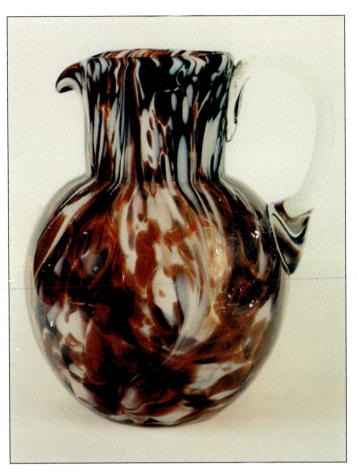

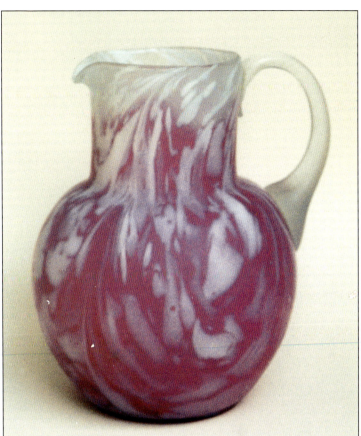

Plate 93. Pitcher, 8" h., ball shape body mold with round neck. Satin finish, ruby die-away to crystal (inverted), with opal flakes in a pulled, mottled effect. (F_1=white). $250-$350.

Plate 91. Pitcher, 7.5" h., ball shape mold with round neck. Maroon and opal flakes in a pulled, mottled effect with a spot optic pattern. Note the difference in appearance that depends on the relative amounts of maroon and opal that are initially picked up on the gather. $125-$175.

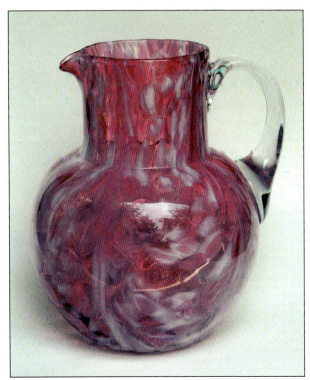

Plate 92. Pitcher, 8" h., ball shape body, spot optic mold with round neck. Ruby and opal flakes in a pulled, mottled effect. (F_1=white). $175-$250.

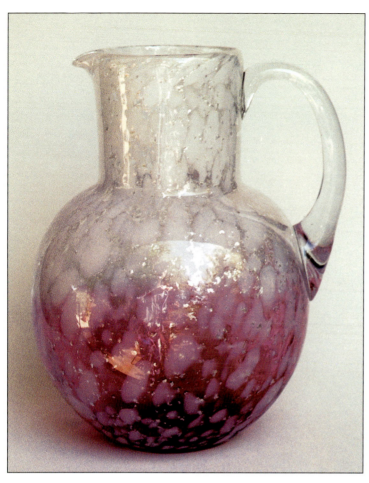

Plate 94. Pitcher, 8" h., ball shape mold with round neck. Ruby die-away to crystal over opal (inverted) with encased mica. Color effect is identical to the example in Plate 25. (F_1=white). $250-$350.

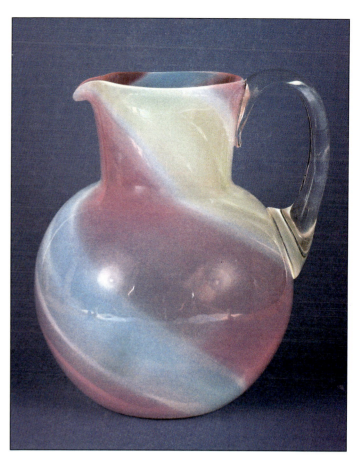

Plate 96. Pitcher, 8.25" h., ball shape mold with round neck. Swirled ruby, blue, and citron canes cased with a slightly opalescent glass. (F_1=weak white). $350-$500.

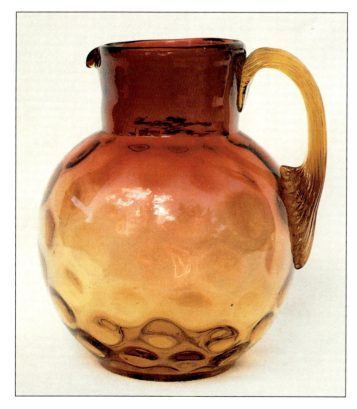

Plate 95. Pitcher, 5.25" h., ball shape body, spot optic mold with ruby die-away to amber colors. (F_1=white). $75-$125.

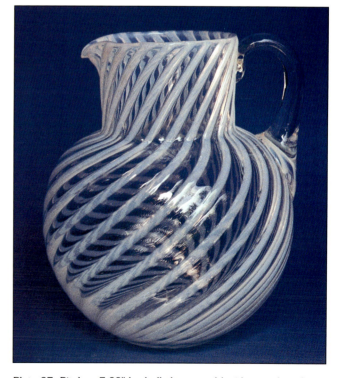

Plate 97. Pitcher, 7.88" h., ball shape mold with round neck. Crystal cased with opal sensitive glass, opal swirl optic pattern. This pitcher was also made in a ruby and blue opalescent effect. (F_1=white). $250-$350.

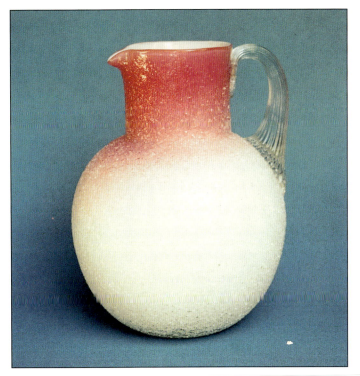

Plate 98. Pitcher, 7.75" h., ball shape mold with round neck. Ruby die-away to crystal cased over opal, exterior coated with pounded glass (overshot). This effect is different from Craquelle, as no expansion took place after application of the glass frit. (H=24, F_1=white). $250-$350.

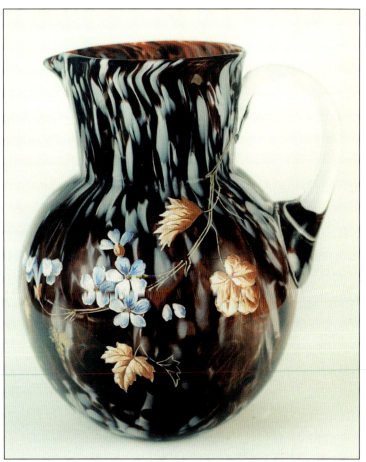

Plate 100. Pitcher, 7.5" h., ball shape mold with round neck. Floral decoration, maroon and opal flakes in a pulled, mottled effect. The decorating pattern is virtually identical to the one shown in Plate 24, showing that these two objects must have been made at the same firm. (F_1=white). $250-$350.

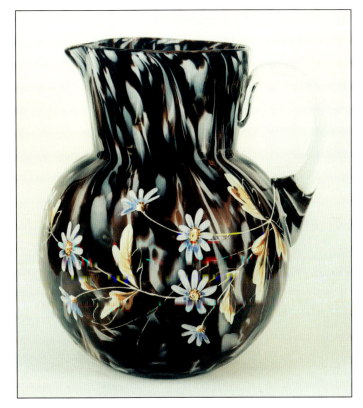

Plate 99. Pitcher, 8" h., ball shape mold with round neck. Floral decoration, maroon and opal flakes in a pulled, mottled effect. (F_1=white). $250-$350.

Pitchers with Shoulders

At a minimum, Phœnix used five different shape molds for shouldered pitchers. Four types are shown in Plates 101-115. The first shape has a relatively smooth shoulder, no crimp at the top, and a smooth spout. The second shape has an abrupt change in shape at the shoulder, and while the water pitcher has a square top, other items do not. For the balance, the crimp pattern continues around the entire top, including the spout, and they differ from each other in the way the body of the jug rises from the base.

The mottled patterns of the smooth shoulder shape in Plates 101-106 connect these examples to the Phœnix database. This shape mold for these examples has been attributed to Hobbs Brockinier, but we have found no example from this firm with a mottled color/effect pattern.[9] Pitchers with square top and mottled effect, Plate 107, connect this shape to the Phœnix database. This shape is important for it shows that Phœnix made the sugar bowl in Plate 109. This is one of two examples to show the Phœnix origin of this opalescent spot optic pattern.

Of the mold patterns with fully crimped tops, the diameter of the jug for the first type increases from bottom to top. In addition to the examples in Plates 110-112, an opalescent stripe optic pattern example of this shape is illustrated in *Old Pattern glass*.[10] Other examples in blue opalescent spot, ruby opalescent spot, and ruby/light amber opalescent window optic patterns are in private collections. At the present time, we are not aware of any example in a color effect other than an opalescent pattern. Our addition of these examples to our Phœnix database is due to the opalescent effects, and to the characteristic white fluorescence for those we have been able to examine. For the second type, the diameter of the jug decreases from bottom to top. Presently, the evidence for the Phœnix origin for the examples in Plates 113-115 is the opalescent spot, ruby/amber color combination. W. Heacock attributed this shape to Phœnix, largely by the process of elimination.[11] Interestingly, the cruet in this same color effect does not mimic the shape of the jug. Several sizes of jugs were made, all with a substantial, almost solid foot. Like other ruby/light amber products from Phœnix, the ruby glass fluoresces a strong, chalky white upon exposure to short-wave ultraviolet light. It is for this reason we also attribute the source of these jugs to Phœnix.

Very few examples are known for a third shape where the side rises vertically from the base. An example of a pitcher in air-trap effect is shown in Plate 177. This shape was also made with the ruby/light amber cased over opal with the Phœnix Drape optic pattern as shown in Plate 203. It is the unique nature of these two examples that identifies the Phœnix origin.

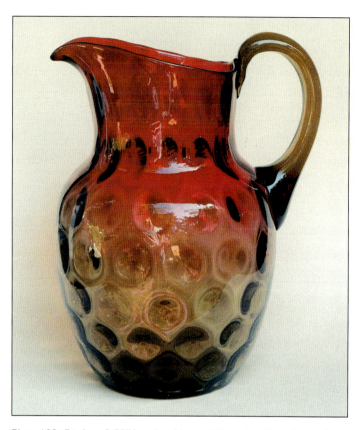

Plate 102. Pitcher, 9.25" h., shoulder mold, spot optic pattern. Ruby die-away encased in dark amber glass. Ruby glass was initially plated onto dark amber, then the gather was cased with more dark amber glass. However, the ruby is exposed at the top where the excess glass was trimmed to finish the piece. ($_{amber}F_1=0$, $_{ruby}F_1=$white). \$175-\$250.

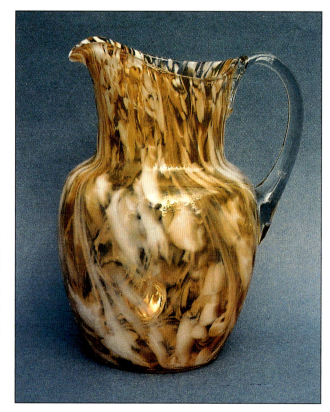

Plate 101. Pitcher, 9.37" h., shoulder mold, spot optic pattern. Apricot and opal flakes in a pulled, mottled effect. This is one of two optic patterns used in conjunction with this shape. ($F_1=$white). \$175-\$250.

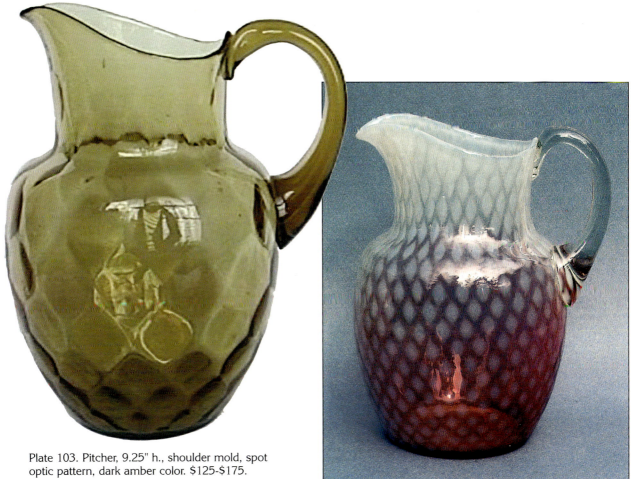

Plate 103. Pitcher, 9.25" h., shoulder mold, spot optic pattern, dark amber color. $125-$175.

Plate 105. Pitcher, 9" h., shoulder mold, diamond optic pattern. Inverted ruby die-away to opal sensitive crystal, opal diamond effect. The normal ruby die-away to opal sensitive glass, with opal diamond effect, is shown in HCK-2, p. 49, but it is incorrectly attributed to Hobbs Brockunier. (F_1=white, F_2=weak green). $350-$500.

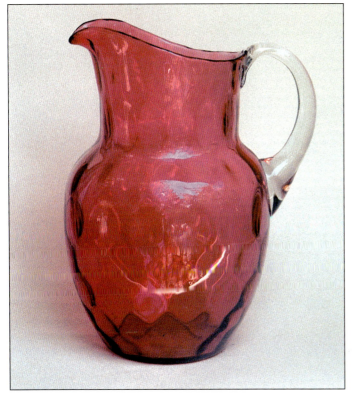

Plate 104. Pitcher, 8" h., shoulder mold, spot optic pattern, ruby color. This pitcher was also made in a teal color with a light amber handle. (F_1=white). $175-$250.

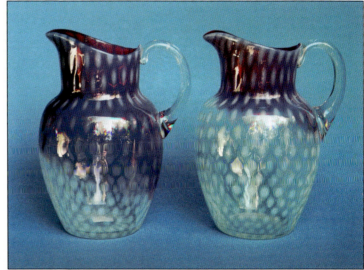

Plate 106. Pitchers, 5.75" h., shoulder mold, 24 across spot optic pattern, same as used for the examples in Plate 185. Ruby die-away to opal sensitive crystal, distorted opal spot effect. These two examples show the variability in manufacturing of a given item. The distortion on blowing into the shape mold elongates the spots into ellipses. ($_{ruby}$ F_1=white). $350-$500 each.

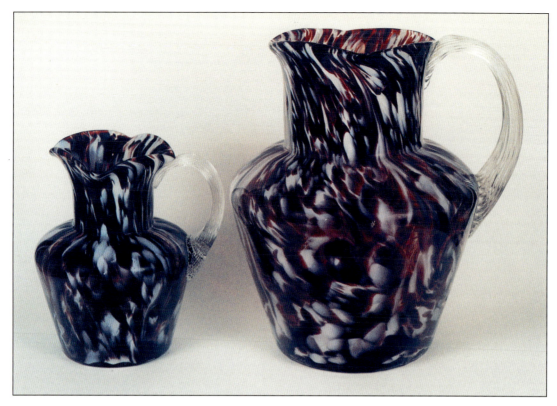

Plate 107. Pitchers, 5.75" h., and 8" h., angled (out) shoulder mold, spot optic pattern. Maroon and opal flakes in a pulled, mottled color effect. The spot optic pattern is identical to the one used to make the pitchers in Plates 183-184. Another example of the water pitcher is shown in LEE, pt. 27. (Left, H=26, F_1=white: right H=22, F_1=white) Left $125-$175. Right $175-$250.

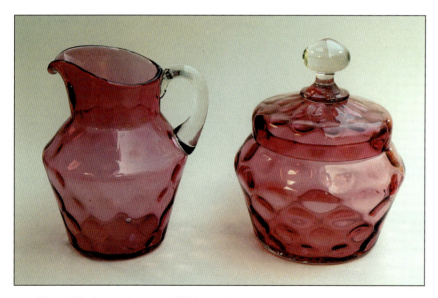

Plate 108. Covered sugar, 4.62" h., and cream pitcher, 4.25" h. Angled (out) shoulder mold, spot optic pattern in ruby color. Set $175-$250.

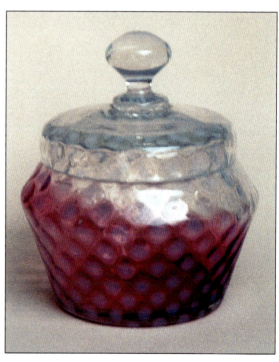

Plate 109. Covered sugar, 4.62" h., angled (out) shoulder mold, spot optic pattern, ruby die-away to opal sensitive crystal (inverted), with opal spot optic. The top of the sugar bowl was cut off and ground flat, so there is no pontil scar. The corresponding cruet in this effect is illustrated in HCK-9, p. 99, #270. (F_1=white). $175-$250.

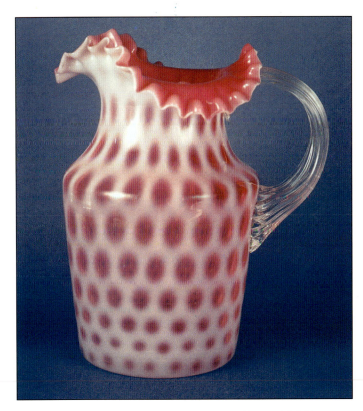

Plate 110. Pitcher, 8.75" h., angled (out) shoulder mold, fully crimped top (including the spout). Ruby cased with opal sensitive crystal, with opal windows optic pattern. This mold pattern is made in several optic effects, including a crystal opalescent stripe that appears in HCK-0, p. 210. $500-$750.

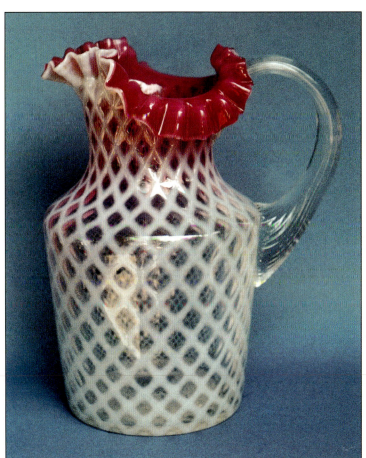

Plate 112. Pitcher, 9.5" h., angled (out) shoulder mold, fully crimped top. Ruby die-away to opal sensitive crystal, with opal lattice (or diamond reverse) optic pattern. This same color/effect combination was used to make shades for hall lamps. (C=28, $_{ruby}F_1$=bright white). $500-$750.

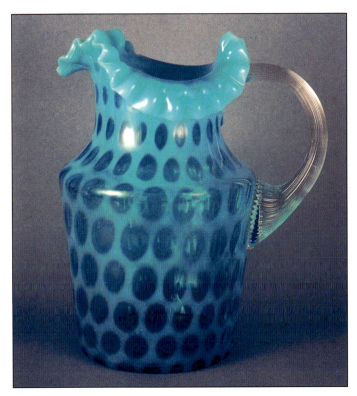

Plate 111. Pitcher, 8.75" h., angled (out) shoulder mold, fully crimped top. Blue cased with opal sensitive crystal, with opal windows optic pattern. Also made in a ruby die-way to amber with opal windows optic pattern. $500-$750.

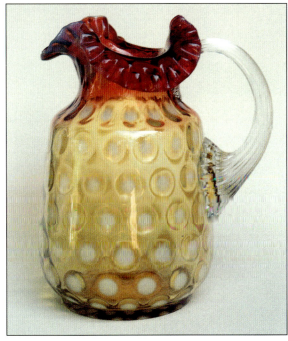

Plate 113. Pitcher, 7.25" h., tankard style angled (in) shoulder mold, fully crimped top. Ruby die-away to opal sensitive amber with opal spot optic pattern. There is a substantial variability in the appearance of objects made in this pattern. (H=19, $_{ruby}F_1$=white). $750-$1000.

Square Shape Pitchers

Square jugs with round necks shown in Plates 116-121 were made in several sizes, though those smaller than the juice pitcher seem to be scarce. Color effect and optic pattern links to the Phœnix database are established by several examples, including a ruby die-away zig-zag air-trap optic (Plate 159), and lemon yellow opalescent zig-zag optic pattern. Bright, cadmium yellow was a color unique to Phœnix at the time, and is very similar to the yellow often attributed to Thomas W. Webb in England. The most common color for the square shape jug is in ruby die-away to light amber. Some time ago, we thought that objects made with a combination of blue and amber glass as in Plate 118 were European imports. We have subsequently learned otherwise. Phœnix used this color combination for objects made with both the spot and "Phœnix Drape" optic patterns.

Plate 114. Pitchers, large 7.25" h. as illustrated in Plate 113, and small, 6.37" h., tankard style angled (in) shoulder mold, fully crimped top. Ruby die-away to opal sensitive amber with opal spot optic pattern. The oil with matching color combination is shown in HCK6, p. 17. (H=16 for small pitcher, $_{ruby}F_1$=white) Small $500-$750.

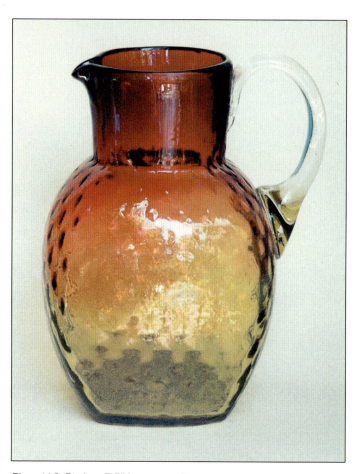

Plate 116. Pitcher, 7.5" h., squared body shape with round neck. Ruby die-away to light amber in diamond optic pattern with crystal handle. (F_1=white). $175-$250.

Plate 115. Pitcher, large 8.25" h., tankard style angled (in) shoulder mold, fully crimped top. Opal sensitive light amber with opal spot optic pattern. Matching tumbler, 3.62" h. (H=19). Pitcher $350-$500, Tumbler $50-$75.

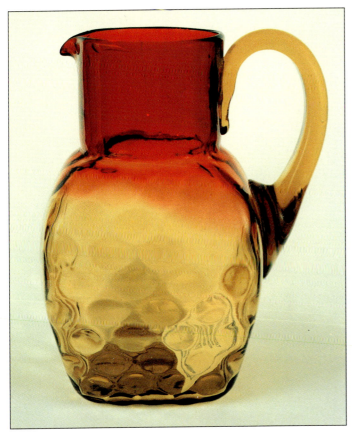

Plate 117. Pitcher, 7.5" h., squared body shape with round neck. Ruby die-away to light amber with spot optic pattern with amber handle. The optic pattern continues to the center bottom. (F_1=white). $175-$250.

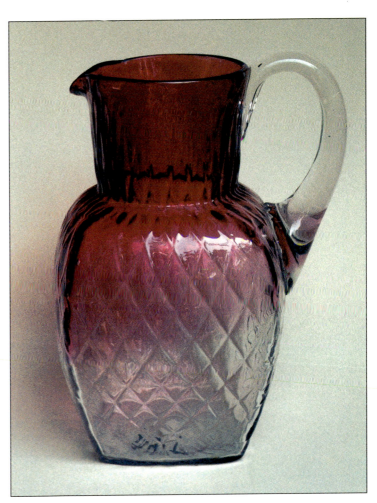

Plate 119. Pitcher, 8" h., squared body shape with round neck. Ruby die-away to crystal, with diamond optic pattern. (F_1=white). $175-$250.

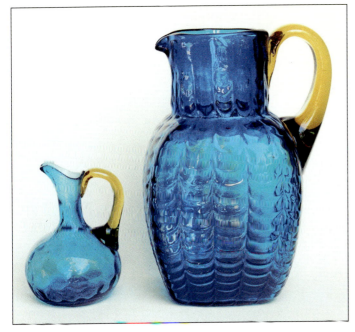

Plate 118. Right: Pitcher, 8.75" h., squared body shape with round neck. Blue with dark amber handle in Phoenix Drape optic pattern. Left: Cruet, 4" h., (w/o stopper). Blue with amber handle, in spot optic pattern. These two objects were made with identical glasses. The pitcher shown here was also made with the spot optic pattern. (Both blueF_1=white) Pitcher $175-$250. Cruet $125-$175.

Plate 120. Pitcher, 7.62" h., squared body shape with round neck. Bright yellow with opal zig-zag optic pattern. The ruby color example with opal zig-zag pattern appears on the cover of HCK-9. $350-$500.

Plate 121. Pitcher, 8.62" h., squared body shape with round neck. Crystal covered with pounded glass, then with colored threads. Likely made to resemble "Peloton" ware from Europe. This pitcher was made in a variety of sizes, including a small cream. (F_1=white). $125-$175.

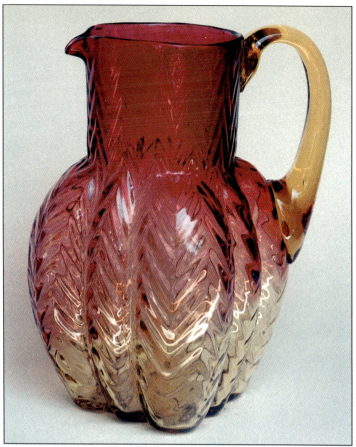

Plate 122. Pitcher, 6.75" h., overall squared shape with 8 alternating large and small lobes, round neck. Ruby die-away to light amber, with zig-zag optic pattern. (F_1=strong white). $175-$250.

Lobed Pitchers

There are two types of jugs with lobes that are linked to the Phœnix database through mottled color combinations. Both patterns have eight distinct lobes, but they differ significantly. For the first type, Plates 122-126, four large lobes alternate with four smaller ones, and all are arranged in an overall square shape. Air-trap optic patterns commonly used by Phœnix were used to make pitchers and celeries in this shape, and they are shown in Plates 161-165. Many items were made in this pattern, suggesting a full range of tableware was available at the time. This shape mold was also used to make objects, as in Plate 124, that would compete with products from New England Glass (Agata), and Mt Washington Glass (Wild Rose) between 1886 and 1888.

The lobes in the second type shown in Plates 127-133 are of uniform size, and are arranged in a circular fashion. This was one of the last art glass patterns produced by Phœnix, based on the appearance in the 1891-1892 Montgomery Ward & Company catalog. To date, we know only of pitchers and cruets to be made in this pattern.

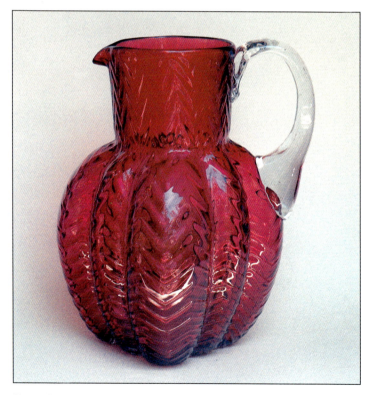

Plate 123. Pitcher, 8.62" h., overall squared shape with 8 alternating large and small lobes, round neck. Ruby cased with crystal, in the zig-zag optic pattern. (F_1=white). $175-$250.

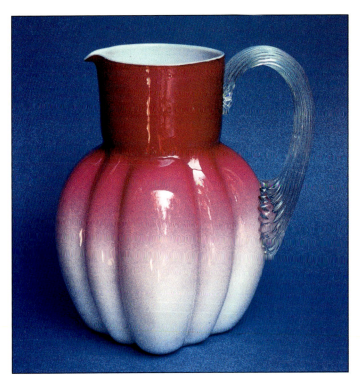

Plate 124. Pitcher, 7.25" h., overall squared shape with 8 alternating large and small lobes, round neck. Ruby die-away to crystal cased over opal glass. This color combination was likely made to simulate the "Peachblow" products that were being made at New England Glass. (H=22, F_1=white). $250-$350.

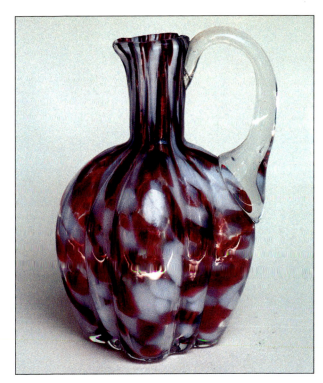

Plate 126. Oil pitcher, 5" h., (without stopper) overall squared shape with 8 alternating large and small lobes. Ruby and opal flakes in a pulled, mottled color effect. A complete cruet in this mold pattern is shown in MCO, p. 25, bottom #4. The mottled effect links this mold pattern to the Phœnix database. (F_1=white). $175-$250 with stopper.

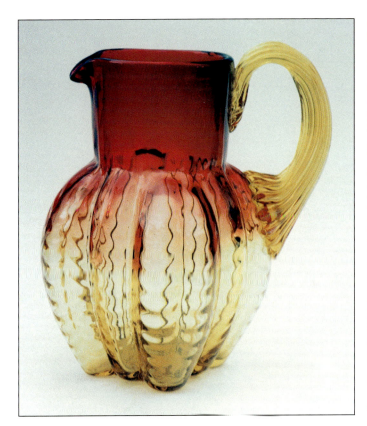

Plate 125. Pitcher, 6.5" h., overall squared shape with 8 alternating large and small lobes, round neck. Ruby die-away to light amber, with Phœnix Drape optic pattern. (H=14, F_1=white). $350-$500.

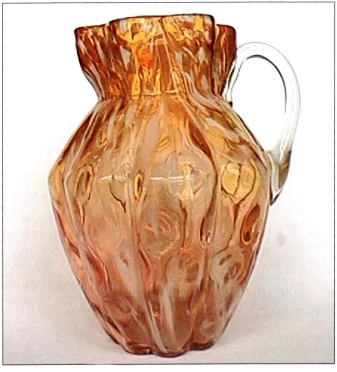

Plate 127. Pitcher, 9" h., overall round shape, with 8 even sized, vertical lobes. Amber and opal flakes in pulled, mottled effect. Note the difference in the relative amounts of amber and opal flakes that were picked up in the making of this and the one in Plate 128. Examples of the water set (Colibri Water Set) in this mold are illustrated in the 1991-92 Montgomery Ward & Co. No. 49 catalog. Price with 13" hammered brass tray was $2.55 per set with six tumblers. $250-$350.

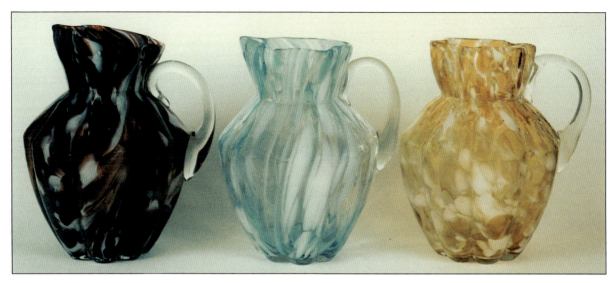

Plate 128. Cream pitchers, 5.25" h., overall round shape with 8 even vertical lobes. Maroon with opal, blue with opal, and amber with opal flakes in pulled, mottled effects. ($_{amber}F_1$=white, $_{blue}F_1$=strong green/white, $_{maroon}F_1$=weak white) Each $175-$250.

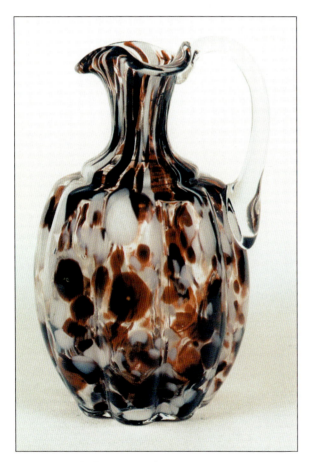

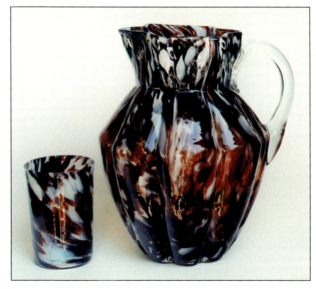

Plate 130A. Pitcher, 9" h., overall round shape with 8 even vertical lobes. Maroon and opal flakes in pulled, mottled effect. Tumbler, 3.75" h., with maroon and opal flakes in a swirled, mottled effect. (F_1=white) Pitcher $175-$250 Tumbler $50-$75.

Plate 129. Oil pitcher, 5" h., (without stopper) overall round shape with 8 even lobes, tri-foil top. Maroon and opal mottled effect distorted in the neck, with spot optic pattern. A cruet with the same shape with ruby (inverted) die-away to crystal with opal mottled effect matching Plate 133 is shown in MCO, inside back cover. (F_1=bright white).

Plate 130B. Illustration of the "Colibri" water set in the 8 even lobed pattern with mottled effect offered by Montgomery Ward and Co. in the fall 91/spring 92 catalog. The description mentions that this pitcher is lined with white glass, but the illustration clearly shows it is not. *Courtesy of the University of Wyoming American Heritage Library.*

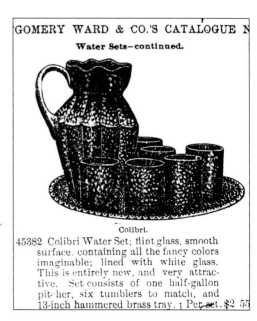

GOMERY WARD & CO.'S CATALOGUE N

Water Sets—continued.

Colibri.

45382 Colibri Water Set; flint glass, smooth surface, containing all the fancy colors imaginable; lined with white glass. This is entirely new, and very attractive. Set consists of one half-gallon pitcher, six tumblers to match, and 13-inch hammered brass tray. Per set, $2 55

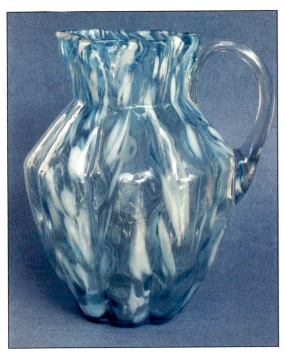

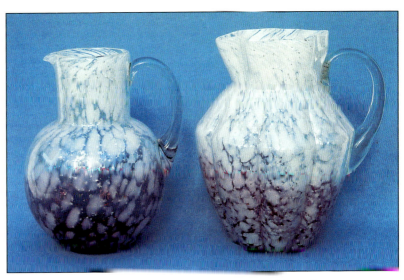

Plate 133. Examples with identical color effects. Left: 8" h., ball shape with round neck, inverted ruby die-away to crystal, opal flake mottled effect with encased mica. Right: 9" h., overall round shape, with 8 even lobes. Inverted ruby die-away to crystal, opal mottled effect with encased mica. This pitcher was also made with the ruby at the top instead of the bottom. The cruet matching the lobed pitcher is illustrated in MCO, inside back cover. The toothpick in the ring base mold in the same effect is illustrated in HCK-M, p. 55, #287. A tumbler in blue die-away to crystal with encased mica is in a private collection, but it is not known if there is a matching pitcher. (both F₁=white) Pitcher (right). $250-$350.

Plate 131. Pitcher, 5.25" h., overall round shape, with 8 even vertical lobes. Blue and opal flakes in a pulled, mottled effect. (F₁=white). $175-$250.

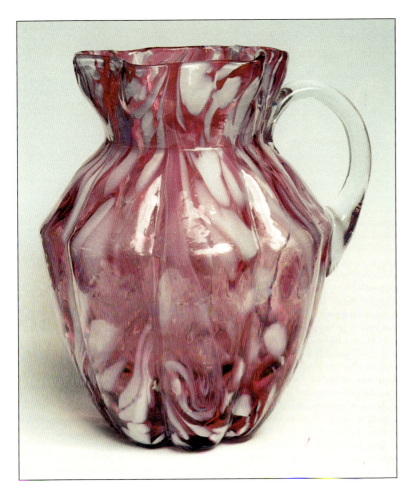

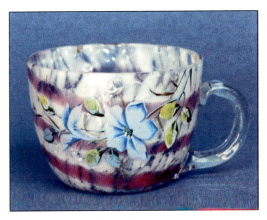

Plate 134. Custard cup, 2.12" h., made in the spot optic pattern. Ruby swirl in an opal flake mottled effect. A 12-arm rosette is impressed in bottom. A tumbler was also made in this effect, and a decorated toothpick (?) holder is illustrated in HCK-M, p. 55, #289. The toothpick may be a salt shaker with collar removed, for a ruby die-away to light amber (inverted) shaker with the same shape is shown in LCH p. 201, top center. (F₁=white). $75-$125.

Plate 132. Pitcher, 8" h., overall round shape, with 8 even vertical lobes. Ruby and opal flakes in a pulled, mottled effect. (F₁=white). $175-$250.

Fairy Lamps

A wide variety of fairy lamp patterns were made by Phœnix in the same color/effect patterns illustrated in the previous chapter. We show just a few examples in Plates 135-149. Many types of Phœnix lamps are illustrated by the Ruf's in their very descriptive publication, though the origin of them is omitted unless the example is marked. To date, the only unique color/effects described in trade literature that we have been able to match to examples are "Venetian Thread," "Snowstorm," "Harlequin," and "Impasto Cameo." On the other hand, the window, lattice, and stripe opalescent patterns that were used by Phœnix for other lines of tableware also appear to have been used for fairy lamps. A ruby opalescent lamp base in the windows optic pattern is illustrated here in Plate 148. A complete lamp in the ruby opalescent lattice optic pattern is shown in Fig. 229, Ruf2.[12] The opalescent swirl pattern for the lamp shown in Plate 145 was used to make the pitcher in Plate 226, as well as parts for table lamps. The technique used to make the swirl pattern is described in Webb's U.S. Patent #379,089. Instead of encapsulating the core in a shell, the partially blown, rib shaped core is reheated to develop the opalescent pattern. Twisting the core on a marver plate yields a spiral pattern when it is blown into the shape mold.

Fairy lamps made by the canework process in this country were only made by Phœnix. However, production in England and in Europe makes it difficult to differentiate the various products that one finds today. One characteristic we have seen in Phœnix, "rainbow" canework color combinations is that the transition of one color to another is very subtle. Rainbow colored fairy lamps are known to occur with the "PATENT" mark, and those where the letters are in a straight line are undoubtedly of Phœnix origin.[13] We suspect that the canework process was also used by Phœnix to make their fairy lamps in the stripe optic pattern. At present, we have not found a fairy lamp with a stripe optic that we can link into the Phœnix database.

End Notes

1. New England, after a successful first season, made a warehouse full of Amberina for the second season, but it did not sell. Poor sales and a worker strike put this firm on the verge of bankruptcy through much of 1884-85.

2. New England Glass products are discussed by Lee in *Nineteenth Century Art Glass* (1952: New York: Barrows, 1957).

3. This excludes ruby (cranberry) that is not a simple glass, but a sol of colloidal gold.

4. A photograph of the Mt. Washington Glass display at the late 1887 New Bedford Industrial Exposition appears in Leonard Padgett's *Pairpoint Glass*. Close examination reveals that most of the products were decorative, and nearly all were made of opal, Rose Amber, Peachblow, or Burmese glass.

5. An example of mica spangle glass made by Stevens and Williams is shown here in Plate 309, and in Plate 95 of Manley, *Decorative Victorian Glass* (New York: VanNostrand, 1981).

6. Heacock. W., Measell, J., and Wiggins, B., *Dugan/Diamond* (Marietta: Antique Pub., 1993).

7. Consolidated Glass used transfers by punty rods for Kopp's red glass blown in the Bulging Loop optic pattern. West Virginia Glass used this type of transfer to make ware in the opalescent polka dot and swirl optic patterns.

8. Heacock, W., Gamble, W., *Encyclopedia of Victorian Colored Pattern Glass 9* (Marietta: Antique Pub., 1987).

9. Heacock, W., *Encyclopedia of Victorian Colored Pattern Glass 2* (Marietta: Richardson Pntg., 1977).

10. Heacock, W., *Old Pattern Glass* (Marietta: Antique Pub., 1981) 210.

11. Heacock, W., *Collecting Glass - Vol. 3* (Marietta: Antique Pub., 1981) 64.

12. Ruf, B., Ruf, P., *Fairy Lamps* (Atglen: Schiffer Pub., 1996) 75.

13. Two types of marks were used on objects with multi-color, or rainbow effect. Both are made by the application of acid resistant ink before the etching process. The letters in the mark Phœnix used are arranged in a straight line. The letters in the other mark are arranged in an arc. We have not been able to find a patent, either here or in England, to which this mark refers, other than the ones issued to Joseph Webb.

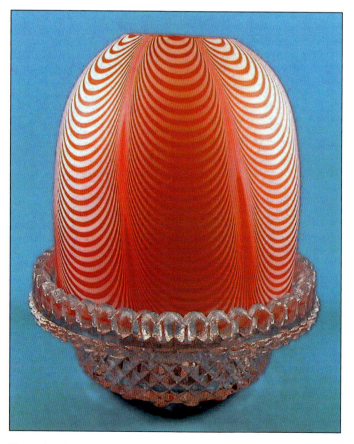

Plate 135. Fairy lamp, overall 4.25" h., dome 3.12" h., Venetian Thread on unusual red background, pressed crystal Clarke Patent cup. $250-$350.

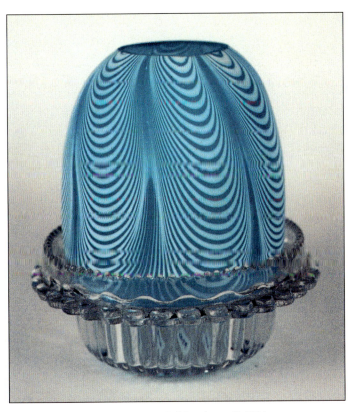

Plate 136. Fairy lamp, overall 4.25" h., dome 3.12" h.,
Venetian Thread on blue background, pressed crystal
Clarke Patent cup. (dome F_1=white). $250-$350.

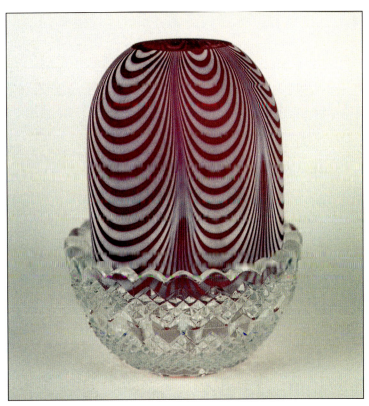

Plate 138. Fairy lamp, overall 3.88" h., dome 2.75" h.
Venetian Thread decoration on ruby. Pressed crystal S.
Clarke Pyramid cup. (F_1=white). $175-$250.

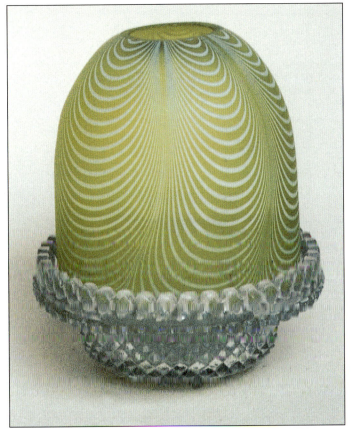

Plate 137. Fairy lamp, overall 4.5" h., dome 3.0" h.,
Venetian Thread on citron background, pressed
crystal Clarke Patent cup. (F_1=white). $250-$350.

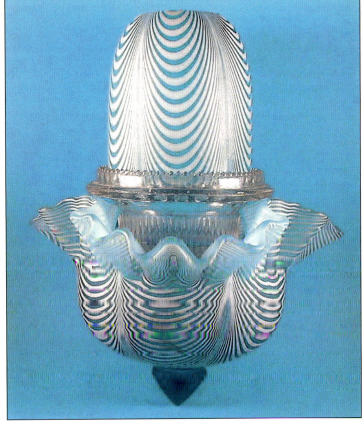

Plate 139. Hanging fairy lamp, overall 6.25" h., Venetian Thread on
blue background. Pressed crystal Clarke cup rests on rim of base.
Chain held by bracket that fits over bottom point, three lengths
wrap around base and join at the hanger. A complete lamp
assembly is shown in Fig. 776, in RUF2, p. 222. $1000-$1500.

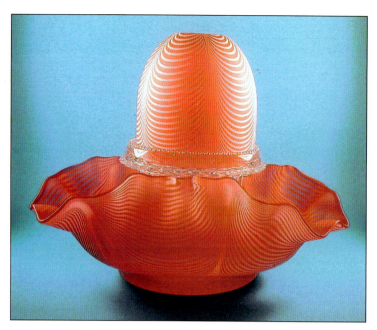

Plate 140. Fairy lamp, overall 6.5" h., Venetian Thread on unusual red background. Pressed crystal Clarke cup rests on rim of the base.$1000-$1500.

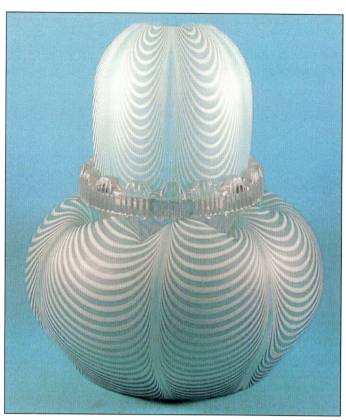

Plate 142. Fairy lamp, overall 5.62" h., Venetian Thread on light blue background. Pressed crystal Clarke cup sits on rim of the base.$750-$1000.

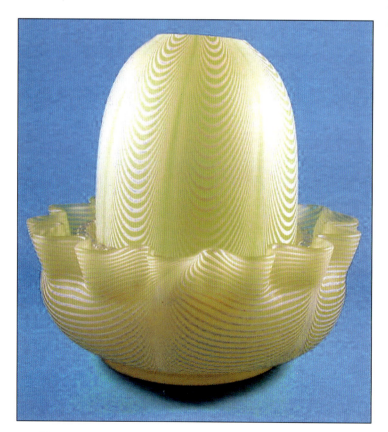

Plate 141. Fairy lamp, overall 5" h., Venetian Thread on citron background. Pressed crystal Clarke cup sits inside the base. $750-$1000.

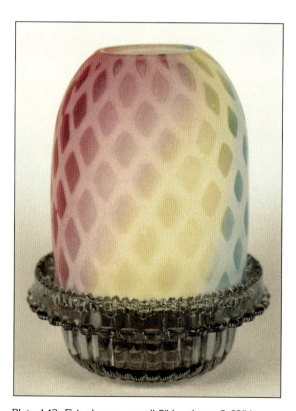

Plate 143. Fairy lamp, overall 5" h., dome 3.62" h., air-trap diamond optic pattern with ruby/yellow/blue canes. Pressed crystal Clarke cup marked "American Patent Nov 9 1886 352296." (F_1=white). $500-$750.

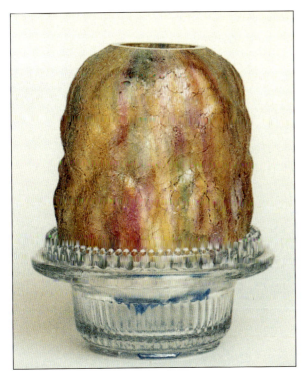

Plate 144. Fairy lamp, overall 3.62" h., shade 2.5" h., Harlequin color with Craquelle finish. Pressed crystal cup marked with Clarke "fairy" imprint. Harlequin was also used for tableware, for a tumbler is shown in HCK-9, p. 97, # 242. (F_1=weak white). $350-$500.

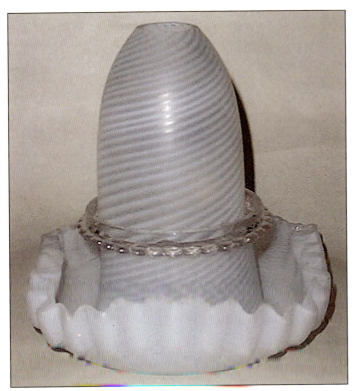

Plate 145. Fairy lamp, overall 5.5" h., opal swirl optic pattern in opal sensitive crystal. Pressed crystal Clarke cup rests in center post of matching base. This optic pattern is made according to the procedure described in U.S. patent 379089 issued to J. Webb in 1888. The core was not cased, but twist on the marver plate to produce the swirl pattern, then blown to shape. This pattern in ruby opalescent effect was also used for lamp shades in style E 250 (Plate 35.). $1000-$1500.

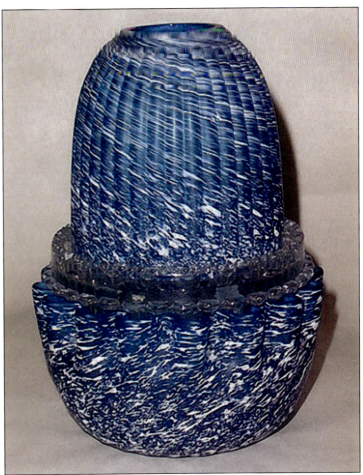

Plate 146. Fairy lamp, 6.5" h., dome made in the Coraline mold pattern, Clarke pressed crystal cup. Blue ground with opal "Snowstorm" effect. $750-$1000.

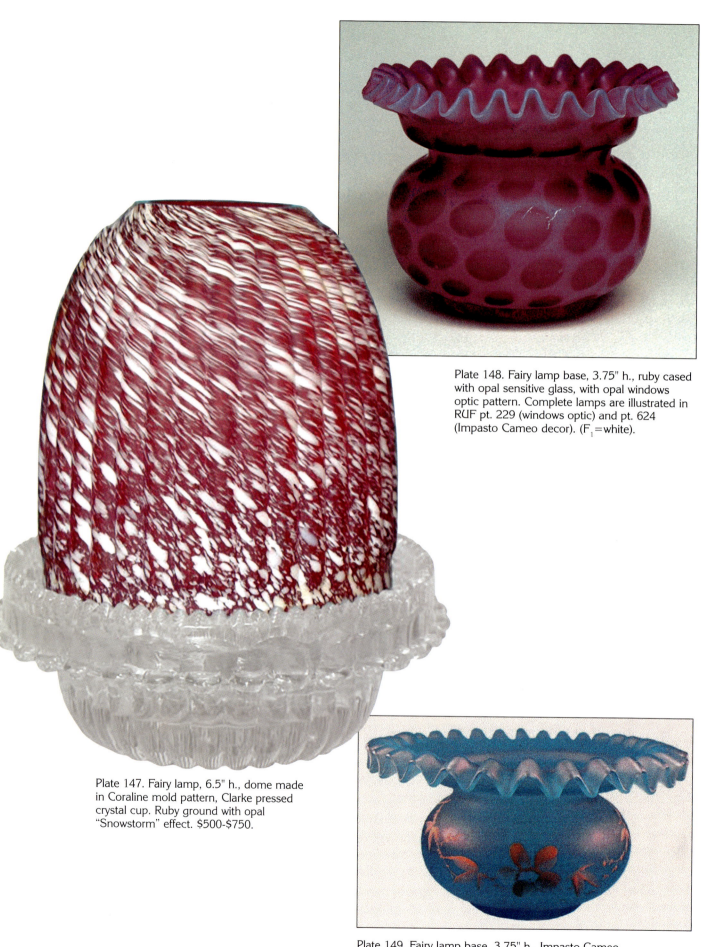

Plate 148. Fairy lamp base, 3.75" h., ruby cased with opal sensitive glass, with opal windows optic pattern. Complete lamps are illustrated in RUF pt. 229 (windows optic) and pt. 624 (Impasto Cameo decor). (F_1=white).

Plate 147. Fairy lamp, 6.5" h., dome made in Coraline mold pattern, Clarke pressed crystal cup. Ruby ground with opal "Snowstorm" effect. $500-$750.

Plate 149. Fairy lamp base, 3.75" h., Impasto Cameo decor on a satin blue background. The cameo on the base is identical to the example in RUF, pt. 626.

Identification of Phœnix Glass by Optic Pattern

In the previous chapter, we identified mold patterns by matching color/effect patterns to known Phœnix objects. Here we group additional objects with known Phœnix optic patterns without regard to the mold. In this way, we expand the database to include objects made in different shape molds than those already described.

Air-Trap Optic Patterns

One of the more interesting facts we have uncovered is that Phœnix, rather than Mt. Washington, was the **major** manufacturer of air-trap ware in this country. Three optic patterns, diamond, zig-zag (now herringbone), and windows were used extensively for many types of glassware including parts for lamps. Other air-trap patterns appear to have been used, such as the *moire*, but examples are very scarce.

Without question, the majority of air-trap ware made in this country was based on the early Richardson patent (England) of January 26, 1858. The first American patent for air-trap was obtained by Dean-Peltier in 1881 (U.S. # 237,371), and it was subsequently assigned to the Mt. Washington Glass Company. Revi reported that some of the concepts in this patent were in later ones issued to Joseph Webb at Phœnix and to F. Shirley at Mt. Washington.[1, 2] We find that while there are some similarities, the claims made in these three patents are actually quite different. The Dean-Peltier patent has two claims. The first describes a process where a molded gather of glass is coated by dipping into molten glass, trapping air in the recessed areas. The patent illustration shows that to do this successfully, the traps have to be deep and spaced far apart. The second is a general claim for any glass with entrapped air, with no regard to the process of manufacture. The Shirley 1886 patent has eight claims, but only the fourth concerns the manufacture of air-trap. Specifically, this claim covers the entrapment of air by coating a molded gather with an exterior shell of **heat sensitive glass**. The other claims actually concern the manufacture of satin finished, opal or opaque glasses coated with a heat sensitive glass. In effect, Shirley's patent describes the process by which New England Glass made Aurora, and Hobbs Brockunier made Coral, rather than the manufacture of air-trap products. Although Mt. Washington possessed the Dean-Peltier patent, there seems to be no surviving record of any commercial products from this firm. In fact, the only indication that this firm made any air-trap ware at all comes from a trade advertisement that lists "Pearl Satin" among their products. Unlike Phœnix, we can find no evidence that Mt. Washington used their

existing shape molds for air-trap products. The lack of examples and documentation helps to explain why this type of glassware was omitted in a recent publication describing the artistic glass Mt. Washington made prior to 1900.[3, 4]

Clearly, the process used by Joseph Webb at Phœnix did not incorporate specific concepts in either the Dean-Peltier or Shirley patents, for the glass core was coated with a colored glass prior to molding, then encased in a prepared glass shell. This is a much more practical way to achieve a die-away color effect than using a heat sensitive glass. This process is spelled out in Webb's U.S. No. #363,190 patent that was granted on May 18, 1887.

Besides Phœnix and Mt. Washington, only Hobbs Glass Co. is known to have made air-trap patterns prior to 1890. Hobbs made only one optic pattern, and examples are exceptionally scarce.[5]

Air-trap ware produced by Phœnix was relatively inexpensive at the time. Satin finish, windows patterned water pitchers were priced at $16 per dozen in a ca. 1889 Irwin and Eaton wholesale trade catalog.[6] While priced more than pitchers in other effects, this was certainly less compared to the cost of other art glass products. Pitkin and Brooks at the end of 1887 listed Amberina water pitchers from New England at $16 per dozen, Burmese pitchers from Mt. Washington at $24 per dozen, and Coral pitchers from Hobbs Brockunier at $18 per dozen.

The presentation begins with Plates 150-155 that includes an example made with "Bronze" color and "duck-bill" shape spout, but without the opalescent casing. At least three sizes of pitchers were made, in at least two very similar shape molds, using the diamond and window optic patterns. The examples in Plates 156-158 have the "U" shaped spout, and crimped top. These objects are made in the same shape molds as those shown in the previous chapter beginning with Plate 67. The balance of the presentation in this section basically follows the sequence of mold types in chapter 3. Decorated examples of air-trap are scarce, yet they provide essential links between objects within the database. Where possible, we show a detail of the decorating pattern.

The attribution of Phœnix air-trap ware is relatively easy. Some objects were stamped "PATENT" with an acid resist prior to etching.[7, 8] This mark eventually appears in outline against the satin background, and is very difficult to see. Some objects were blown into shape molds and finished with crimps used for tableware. Unique colors, such as Mandarin, Bronze, Harlequin, and Heliotrope (all described in the trade literature) were used by Phœnix with air-trap optic patterns. The decoration used on ex-

amples of air-trap ware also aids in the identification of Phœnix products. For example, certain facets of the decor of the pitcher shown in Plate 54 show up on the pitcher in Plate 163. This overlap with objects in the database provides confirmation of a unique source on one hand, and at the same time provides the means for extending the database.

In November, 1886, Phœnix introduced "Mandarin" glass, with a trade description of "dark brown, shading very gradually to pale yellow." The diamond quilted air-trap vase in Plate 278 accurately conforms to this description. The shape of this vase has certain characteristics of English manufacture, but the foot (in addition to the color) declares the Phœnix origin. Although promoted in the trade literature, this color effect must not have been very popular for we have been able to find very few examples.

The last five objects in this section warrant further comment as they appear to be unmatched to the Phœnix database. All three of the air-trap pitchers have the same fluorescence characteristics, and identical ribbed handles. Though different optic patterns, the pitchers in Plate 178 were made in the identical shape mold. For some time, we had our doubts about the Phœnix origin of the swirl air-trap example, even though the smooth satin finish was certainly indicative of Phœnix manufacture. Our reason for inclusion here arises from the fact that the process for making this optic pattern, not at all obvious from a casual examination, is fully described, claimed, and illustrated in Webb's 1887, U.S. Patent #379,089. In addition to the swirl air-trap effect, the procedures in this patent were used to make objects in other swirl effects. An example of a fairy lamp with opalescent swirl optic pattern is shown in Plate 145. Detailed comparison of the two examples shown in Plate 179 show that they too were made in the identical shape mold. The pitcher in the Amberine color combination shown in Plate 180 completes the link to the Phœnix database. Comparisons such as these serve to illustrate the relationships that exist between objects when the database is properly constructed.

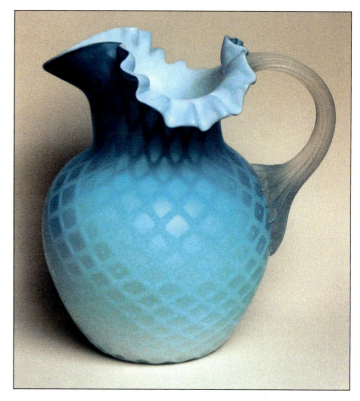

Plate 151. Air-trap pitcher, 8.5" h., crimped top with "duckbill" spout. Satin finish, blue die-away to crystal over opal glass, with diamond optic pattern. A water pitcher in this effect is also shown in LEE, Pt. 32. The cups and mugs in this pattern have similar, ribbed handles. (H=28, C=18, F_1=white). $500-$750.

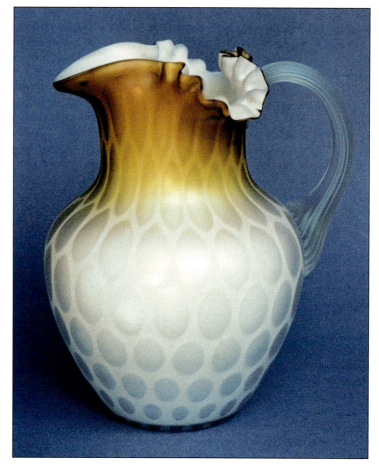

Plate 150. Air-trap pitcher, 7.5" h., crimped top with "duckbill" spout. Satin finish, bronze die-away to crystal over opal glass, with windows air-trap optic pattern. Note this example does not shade through a light red to crystal, as is the case for the example in Plate 152. The color at the top is Bronze, and not apricot, though the difference between the two colors is slight. The mustard jar in this optic is illustrated in LEE, Pt. 22. (H=22, C=18, F_1=white). $750-$1000.

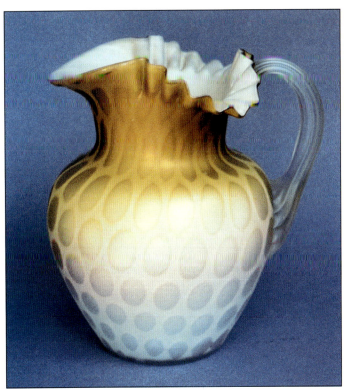

Plate 152. Air-trap pitcher, 7.5" h., crimped top with "duckbill" spout. Satin finish, deep apricot die-away through light red to crystal over opal glass, with windows optic pattern. (H=16, C=18, F_1=white). $500-$750.

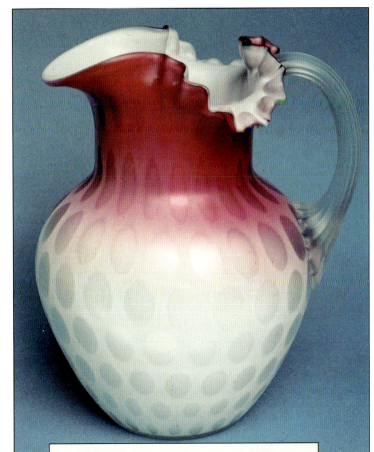

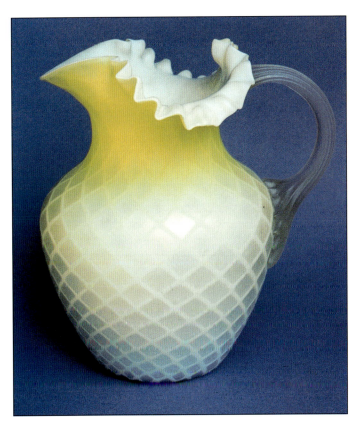

Plate 153. Air-trap pitcher, 8.5" h., crimped top with "duckbill" spout. Satin finish, bright yellow die-away to crystal over opal glass, with diamond optic pattern. (H=18, C=21, F_1=white). $350-$500.

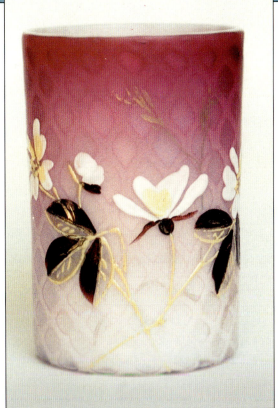

Plate 154. Top: Air-trap pitcher, 7.75" h., crimped top with "duckbill" spout. Satin finish, deep ruby die-away to crystal over opal glass, with windows optic pattern. Bottom: Tumbler, 4" h., satin finish, with ruby die-away to crystal colors and floral decoration. The pitcher in the same color combination was also decorated with the design on this tumbler (H=16, C=18, F_1=white). Pitcher $500-$750, Tumbler $125-$175.

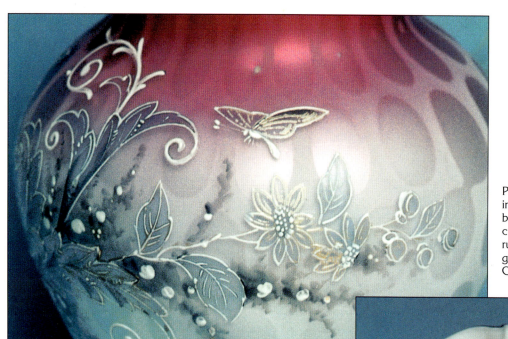

Plate 155. Left: Detail of decoration that includes a silver and white enamel butterfly. Right: Air-trap pitcher, 7.75" h., crimped top with "duckbill" spout. Deep ruby die-away to crystal, cased over opal glass, with windows optic pattern. (H=16, C=18, F_1=white) Pitcher $650-$1000.

Plate 156. Air-trap pitcher, 8.5" h., crimped top with "U" shaped spout. Satin finish, ruby die-away to crystal over opal glass, with diamond optic pattern. (H=18, C=23, F_1=white). $350-$500.

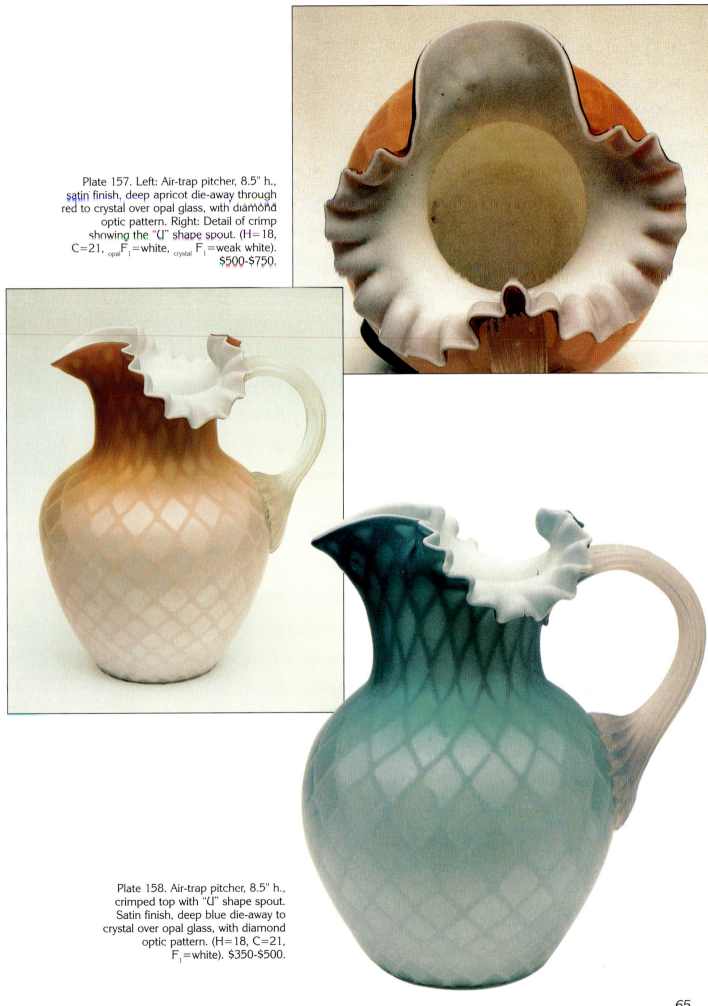

Plate 157. Left: Air-trap pitcher, 8.5" h., satin finish, deep apricot die-away through red to crystal over opal glass, with diamond optic pattern. Right: Detail of crimp showing the "U" shape spout. (H=18, C=21, $_{opal}F_1$=white, $_{crystal}F_1$=weak white). $500-$750.

Plate 158. Air-trap pitcher, 8.5" h., crimped top with "U" shape spout. Satin finish, deep blue die-away to crystal over opal glass, with diamond optic pattern. (H=18, C=21, F_1=white). $350-$500.

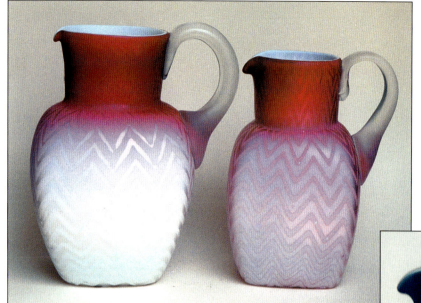

Plate 159. Air-trap pitchers: Left: 9.25" h. Right: 8.25" h. Both square body shape with round neck, satin finished, ruby die-away to crystal over opal glass, with zig-zag optic pattern. Air-trap pitchers were also made in other shapes we have identified as Phœnix products. One is the ball shape with triangular neck of the type illustrated in Pts. 76-89. A tumbler that matches this shape is shown in GCD 8:3, p. 40. (F_1=white) Left $500-$750. Right $350-$500.

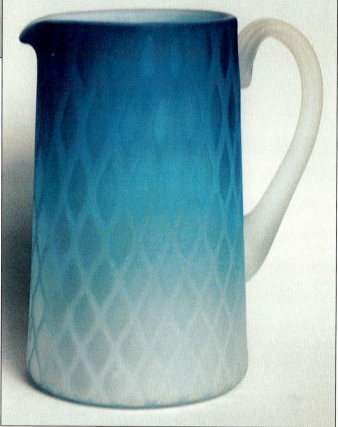

Plate 160. Air-trap tankard shape pitcher, 6.88" h., with satin finish, blue die-away to crystal over opal glass, with diamond optic pattern. Apparently, few tankard shapes, as well as ball shapes, were made in air-trap optic patterns. An example of the tall tankard of the shape in Pt. 28 in ruby die-away to crystal over opal with diamond optic pattern is shown in GCD 3:5, p. 56. (H=12, F_1=white). $500-$750.

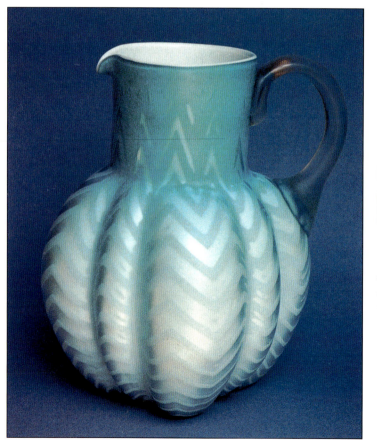

Plate 161. Air-trap pitcher, 8.25" h., squared shape with 8 uneven lobes. Satin finish, blue die-away to crystal over opal glass, with zig-zag optic pattern. The cruet matching this pitcher is illustrated in MCO p. 17, bottom row #3. (F_1=white). $350-$500.

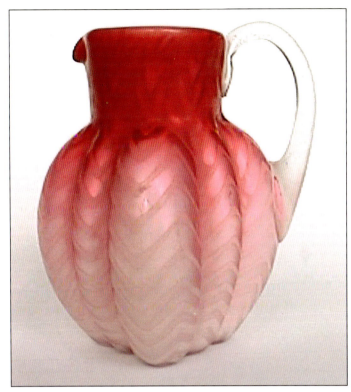

Plate 162. Cream pitcher, 5" h., squared shape with 8 uneven lobes. Satin finish, ruby die-away to crystal over opal glass, with zig-zag optic pattern. $250-$350.

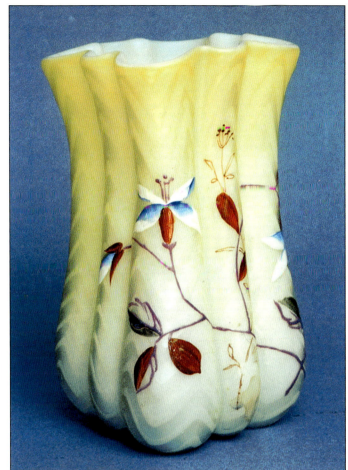

Plate 164. Air-trap celery jar, 5.25" h., squared shape with 8 uneven lobes. Satin finish, yellow die-away to crystal over opal glass, with zig-zag optic pattern. Decoration similar to pitcher in Plate 163 (F_1=white). $175-$250.

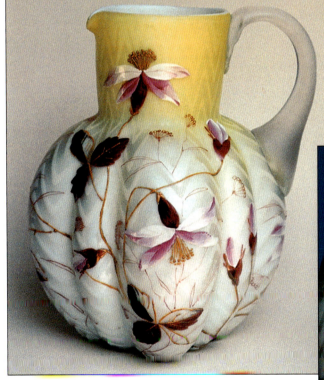

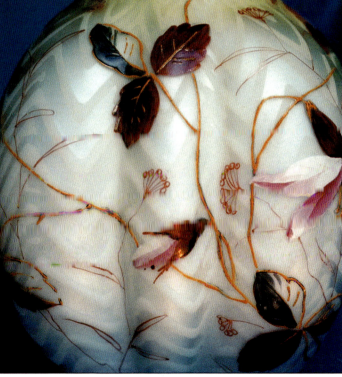

Plate 163. Left: Air-trap pitcher, 6.25" h., squared shape with 8 uneven lobes. Satin finish, yellow die-away to crystal over opal glass, with zig-zag optic pattern. Right: Detail of the decoration. Note the characteristic half-painted leaves and the fan shape, "weed" decor in the background. This pitcher was also made in dark orange shading through ruby and decorated with the same floral pattern. (F_1=white). $500-$750.

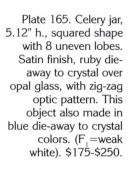

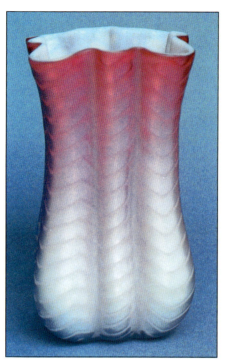

Plate 165. Celery jar, 5.12" h., squared shape with 8 uneven lobes. Satin finish, ruby die-away to crystal over opal glass, with zig-zag optic pattern. This object also made in blue die-away to crystal colors. (F_1=weak white). $175-$250.

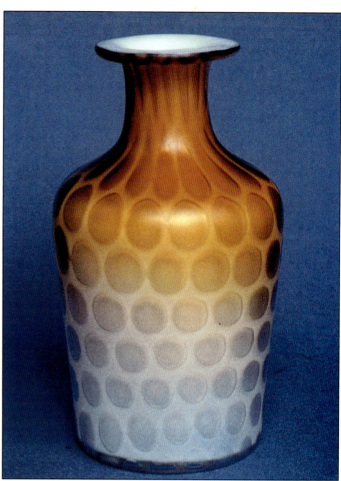

Plate 167. Cologne (stopper missing) 5.37" h., cylinder shaped. Satin finish, deep apricot die-away through pink to crystal over opal glass, with windows optic pattern. Marked with un-etched "PATENT" in a straight line. ($_{opal}F_1$=bright white, $_{crystal}F_1$=white) Complete $500-$750.

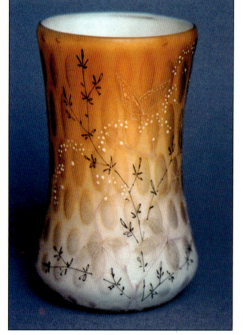

Plate 166. Left: Celery jar, 4.75" h., cylinder shape. Satin finish, deep apricot die-away through pink to crystal over opal glass, with windows optic pattern. Right: Detail of the decoration. Note the butterfly is enameled in white, not in gold as is typical of imported products. ($_{opal}F_1$=white). $250-$350.

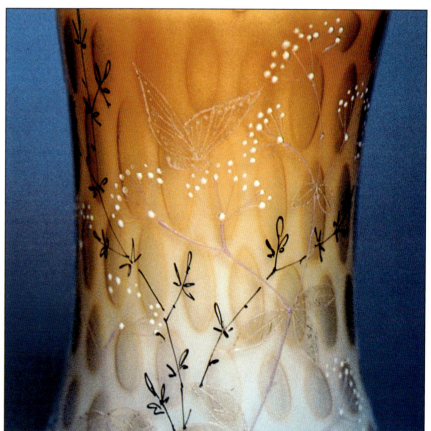

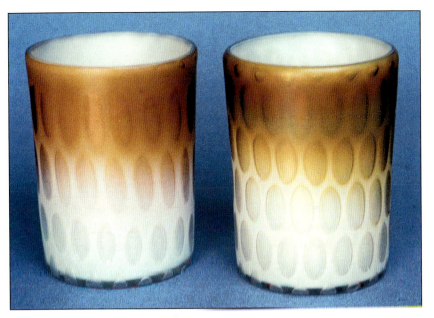

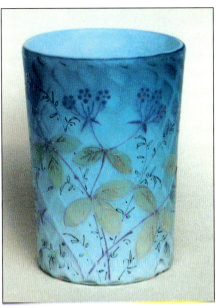

Plate 168. Tumblers, 3.75" h., cylinder shaped with windows optic pattern. Left: Satin finish, deep apricot shading through pink to crystal over opal glass. Right: Satin finish, bronze shading to crystal. Each $75-$125.

Plate 170. Tumbler, 4.0"h., cylinder shape, with diamond optic pattern. Satin finish, blue die-away to crystal over opal glass, leaf decoration with black "weed" foliage in background. (F_1=white). $75-$125.

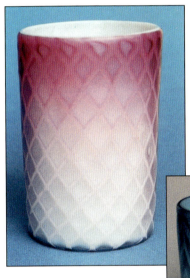

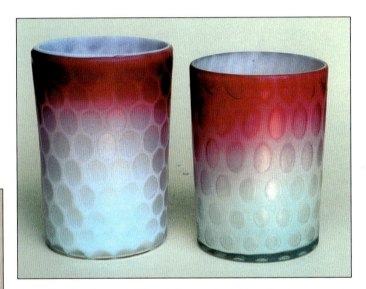

Plate 171. Tumblers, 3.75" and 4" h., satin finish with windows optic pattern. These two ruby die-away tumblers show the variation in manufacturing that was acceptable at the time. Each $75-$125.

Plate 169. Tumblers, 3.75" h., cylinder shape, satin finish with diamond and zig-zag optic patterns. ($_{ruby}$ F_1=weak white; $_{blue}$$F_1$=white; $_{yellow}$$F_1$=orange) Each $75-$125.

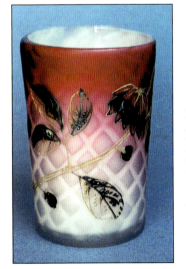

Plate 172. Tumbler, 3.75" h., satin finish with diamond optic pattern. Black enamel leaf decoration on ruby die-away to crystal over opal glass. ($_{opal}$ F_1= white). $125-$175.

69

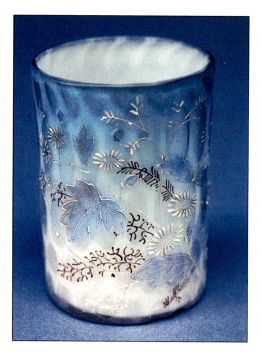

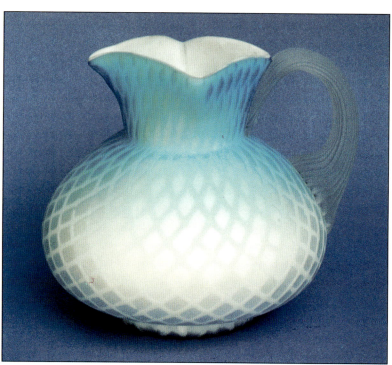

Plate 173. Tumbler, 3.75" h., satin finish with windows optic pattern. White and black enamel leaf decoration on blue die-away to crystal over opal glass. $125-$175.

Plate 175. Pitcher, 6" h., footed, squat shape with ribbed handle. Satin finish, blue die-away to crystal over opal glass, with diamond optic pattern. This shape was made in many different sizes and effects. (H=28, F_1=white). $500-$750.

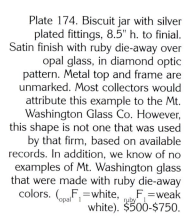

Plate 174. Biscuit jar with silver plated fittings, 8.5" h. to finial. Satin finish with ruby die-away over opal glass, in diamond optic pattern. Metal top and frame are unmarked. Most collectors would attribute this example to the Mt. Washington Glass Co. However, this shape is not one that was used by that firm, based on available records. In addition, we know of no examples of Mt. Washington glass that were made with ruby die-away colors. ($_{opal}F_1$=white, $_{ruby}F_1$=weak white). $500-$750.

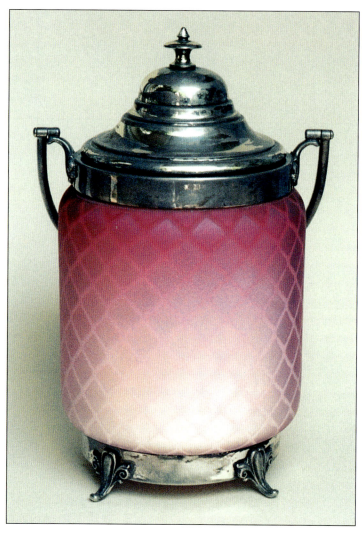

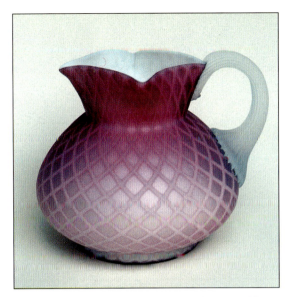

Plate 176. Pitcher, 5" h., footed, squat shape mold with ribbed handle. Satin finish, ruby die-away to crystal over opal glass, with diamond optic pattern. A 5.5" example in orange die-away to crystal over opal glass in this shape is shown in SHU p. 99 top. ($_{opal}F_1$ = white). $500-$750

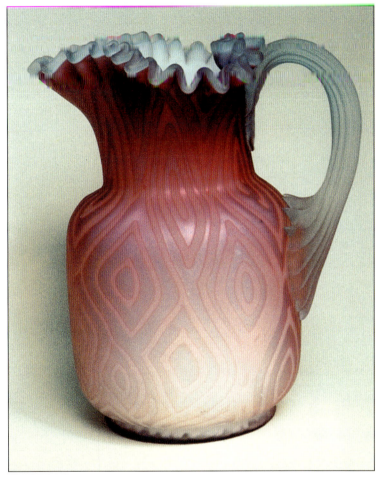

Plate 177. Pitcher, 8.25" h., shoulder shape with fully crimped top. Satin finish, ruby die-away to crystal over opal glass, with moire optic pattern. Phœnix made a novelty product that is described in the May 14, 1885 issue of the *Crockery and Glass Journal*. It is a flower basket, "shaped somewhat like the tall conical hat so much in vogue at present, only of course, with the position reversed." In this reference, the name of the color/effect is "Rubicon." An example of this type of basket is shown in Plate 20 of *Art Glass Nouveau*. The moire pattern used for the basket is identical to that used to make the pitcher shown here. In turn, this same shape pitcher was made in the "Phœnix Drape" optic in Amberine colors that were also cased over opal and shown in Plate 203. $750-$1000.

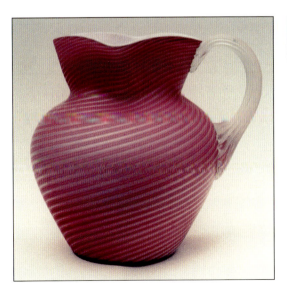

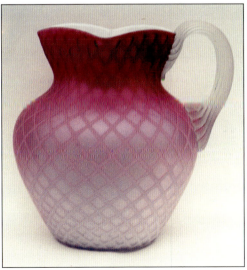

Plate 178. Pitchers, 8" h., "New England" shape with ribbed handle. Left: Satin finish, swirl air-trap with ruby exterior cased over opal glass. This example was made exactly as described in U.S. Patent #379,089 filed in 1886 and issued to Joseph Webb in 1887, except it was not blown into a melon shape mold. (H=16, F_1=white) Right: Satin finish with ruby die away to crystal over opal glass, with diamond optic pattern. Measurements show these two examples were blown in the identical shape mold. (H=16, F_1=white) Left $1000-$1500. Right $750-$1000.

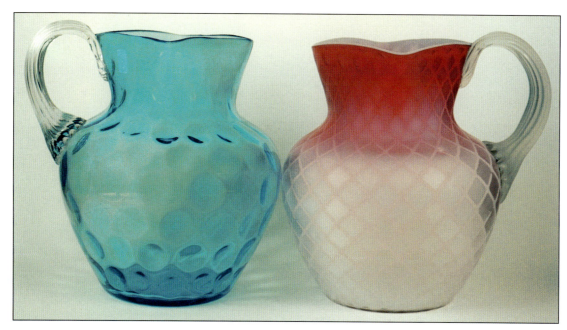

Plate 179. Pitchers, similar to "New England" shape, with ribbed handles. Left: 7"
h., square top, blue with spot optic pattern. (H=20, F_1=weak green) Right: 7" h.,
satin finish with ruby die-away to crystal over opal glass in the diamond optic
pattern. The identical shape mold was used for these pitchers. The shape of
these pitchers matches the opalescent honeycomb example that is shown in
HCK-9, p. 96. (H=16, F_1=weak white) Left: $75-$125. Right: $500-$750

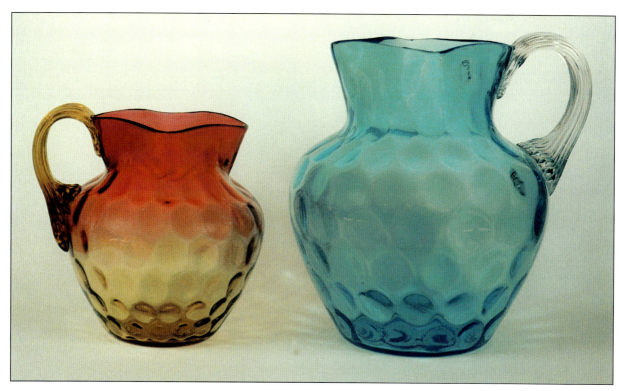

Plate 180. Pitchers, square top, similar to "New England" shape, with
ribbed handles. Left: 5" h., ruby die-away to light amber, with spot optic
pattern. (H=16, F_1=white) Right: 7" h., blue, with spot optic pattern.
(H=20, F_1=weak green) Left $125-$175. Right $125-$175.

Opalescent Spot, Diamond/ Lattice Optic Patterns

Examples of objects in the spot, diamond, and lattice optic patterns are shown in Plates 181-191. The manufacture of the spot and diamond patterns "in all colors" by Phœnix is recorded in their July 22, 1886 trade advertisement. It appears that both spot and diamond patterns were combined on occasion to make a product line. This is not apparent until one looks at the undistorted optic patterns that can be found in the bottom of objects. Tankard shaped water pitchers in "Craquelle" effect were made in the small diamond optic, but all other tableware items with this finish were made in the spot optic pattern.[9] In many cases, the opalescent pattern is not well developed, regardless of whether the base color is crystal, ruby, or blue.

The ball shape was also used for pitchers in the opalescent spot optic with Cracquelle finish. Cracquelle was very popular in the 1883-1885 time period, though the nature of the effect varied between manufacturing firms. The surface of Phœnix Cracquelle has what appears to be slightly raised islands, giving a brecciated appearance. This effect is formed by the re-expansion of a shaped, surface cooled piece into the final shape mold.[10] Examples of Cracquelle made by Hobbs Brockunier lack this characteristic. In addition, the fractures in Phœnix products do not extend into the glass wall, while those in Hobbs products do. Cracquelle from either firm should not be confused with the overshot effect, where crushed or pounded glass is applied to the surface of a nearly finished object.

Relatively few objects in the spot optic without the Craquelle finish have been identified. Many are small items, such as the oil, and they are grouped with novelties in Chapter 5.

Examples of the large opalescent diamond optic pattern are shown in Plates 196-198. The square shape pitcher is the link to the Phœnix database. The pitchers in large diamond optic may also be attributed to Phœnix from their characteristic fluorescence. We can also tie this pattern to the Phœnix database by the mold pattern for the berry bowl, as it is the same as the ruby/amber berry bowl in the collections of the Oglebay Mansion Museum as noted in the caption for Plate 197.

Objects with the opalescent "lattice" optic are included in this section, since it is actually the inverse of the diamond optic. Here, the thick linear sections are opalized in the process of manufacture. Objects were made in ruby/opal, blue/opal, and possibly crystal/opal effects. At present, our link to the Phœnix database is provide by the 8-lobed example in Plate 190, and by the characteristic fluorescence upon exposure to short-wave ultraviolet light.

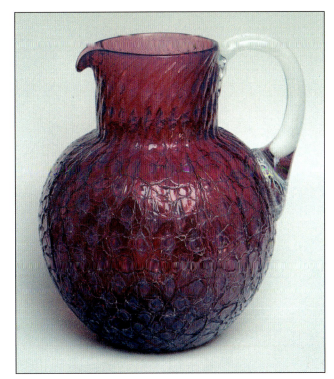

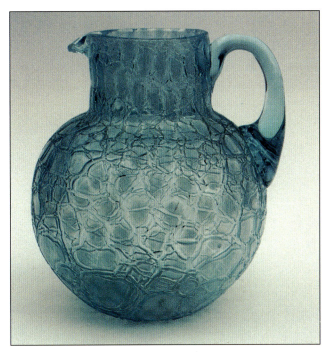

Plate 181. Top: Pitcher, 7" h., ball shape with round top, crackled finish. Ruby cased with opal sensitive crystal, with distorted opal spot optic pattern. Bottom: Small pitcher, 5" h., round top ball shaped with Craquelle finish. Blue cased with opal sensitive crystal, with distorted opal spot optic pattern. This pattern is currently called "opalescent diamonds," but in fact the spot optic was used for this ware. The opal diamonds usage should be abandoned, so as not to confuse the pattern with the opal diamond optic that was made by Phœnix. This ware is part of the "Craquelle" line of products that Phœnix began to make in late 1884. Phœnix appears to be the first domestic firm to have made opalescent pattern glass for the American market. The ball shape cruet in the same effect is shown in HCK-9, p. 96, # 225. The tankard pitcher also shown in HCK-9, p. 96, # 224 is actually made in a diamond optic pattern, the same as the tankard shown here in Pt. 194. (both F_1=white) Top: $350-$500. Bottom: $125-$175.

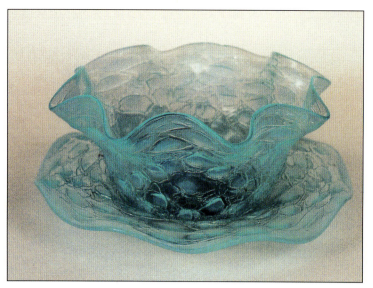

Plate 182. Finger bowl and place, bowl 2.5" h., place 6" d., blue with opalescent spot optic and Craquelle finish. $125-$175.

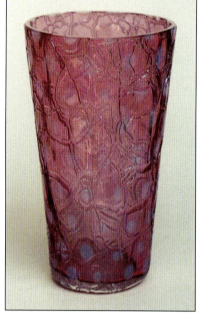

Plate 184. Left: Champagne tumbler, 3.75" h., Craquelle finish, spot optic pattern. Right: Punch cup, 2.12" h., strap handle with opalescent spot optic pattern. A toothpick in the shape of an ice bucket, and an oval shape cruet are known in ruby/opal effect with the Cracquelle finish. This ware was made in blue, ruby, and crystal colors. (F_1=white). $125-$175 each.

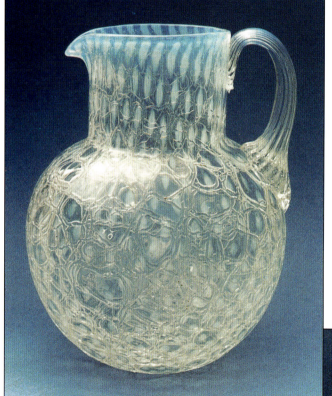

Plate 183. Left: Pitcher, 7.25" h., ball shape with round top, Craquelle finish. Opal sensitive crystal with opal spot optic pattern. Right: View looking into the bottom of the jug that clearly shows the spot optic was used to make this ware. Both smooth and ribbed handles were used on items with Craquelle finish. The cruet in this shape is shown as #249, HCK-6, p. 36. (H=22, F_1=white F_2=green). $125-$175.

74

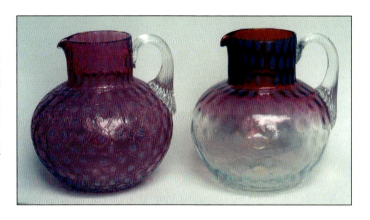

Plate 185. Small pitchers, 5" h., ball shape with round top, made in the identical mold, with the identical 24 across spot optic pattern. Left: Craquelle finish ruby cased with opal sensitive crystal. Right: Ruby die-away to opal sensitive crystal. (H=30, F_1=white) Left $175-$250. Right $125-$175.

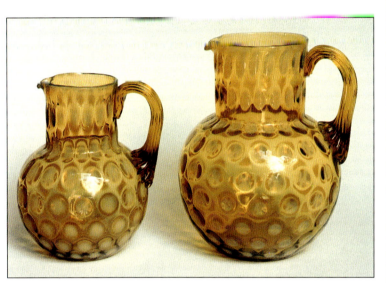

Plate 186. Small pitchers (left) 4.5" h., (right) 5.5" h. Ball shape with round top, opal sensitive amber glass with spot optic pattern. This pattern also made in a water size pitcher in the spot optic, and a small jug in the honeycomb optic pattern that is shown in HCK-9, p. 99, # 274. (Both H=15, F_1=white) Left $50-$75. Right $75-$125.

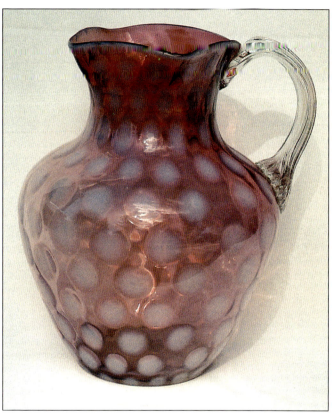

Plate 188. Pitcher, 8.5" h., unique shaped base with square top. Ruby cased with opal sensitive crystal, with opal spot optic pattern. The glass for this example is identical to the glass used for the shade in the Knob optic pattern, shown in Plate 49. (H=16, F_1=white). $250-$350.

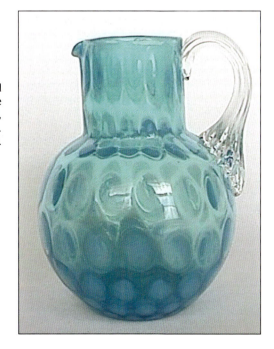

Plate 187. Pitcher, 4.25" h., ball shape base with round top. Blue cased with opal sensitive crystal, with opal spot optic pattern. (H=15). $175-$250.

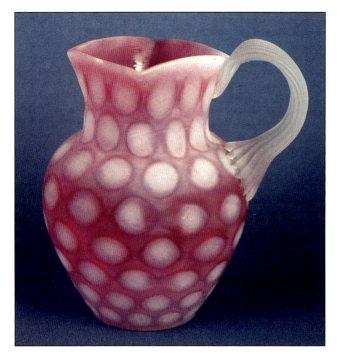

Plate 189. Small pitcher, 4.5" h., shape matches example in Plate 188. Satin finish, ruby cased with opal sensitive crystal, with opal spot optic pattern. (H=16, F_1=white). $250-$350.

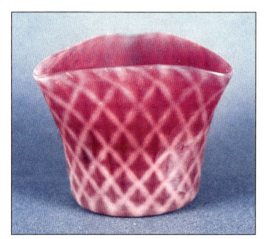

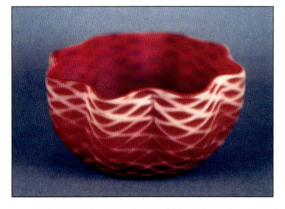

Plate 190. Top: Toothpick, 2" h., triangular shape top. Satin finish, ruby cased with opal sensitive glass, with opal lattice (reversed diamond) optic pattern. A toothpick holder in this same shape, with inverted ruby die-away to light amber in the diamond optic pattern is shown in HEA p. 21, #1093. Bottom: Small bowl, 1.88" h., and 3.88" d., with 8 even lobes. Ruby cased with opal sensitive crystal, with opal diamond optic pattern. Toothpick: (F_1=white). $500-$750 Bowl: (F_1=white). $125-$175.

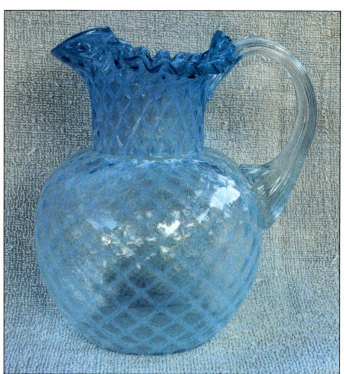

Plate 191. Pitcher, 8.5" h., bulbous base, crimped top. The pins adjacent to the spout have been modified to make a smooth transition from the spout to the crimp. Blue cased with opal sensitive crystal glass, with opal lattice optic pattern. Other examples of this mold pattern are shown in Plates 214-215. $175-$250.

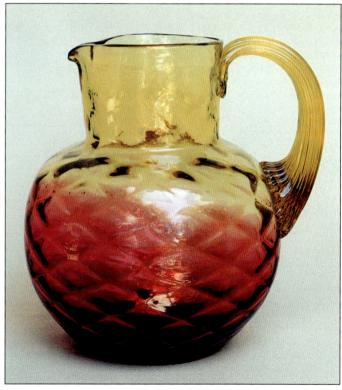

Plate 192. Pitcher, 5" h., ball shaped with round neck. Ruby die-away to light amber (reversed) with diamond optic pattern. The identical pitcher is shown on page 52 in SHU where it is attributed "probably" to the New England Glass Company. The cruet in the same color and optic effects is shown in MCO, p. 10, bottom row, #3. (H=28, F_1=white). $175-$250.

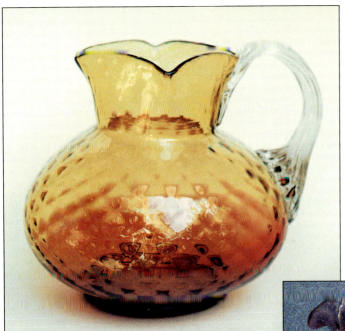

Plate 193. Pitcher, 6" h., squat shaped with foot and square top. Ruby die-away to light amber (reversed) with diamond optic pattern. Also made in a 4.5" size with 20-rib handle. As for all examples of this shape, the foot is considerably thickened. The corresponding large berry bowl in this effect is illustrated in OIG, p. 65, #174 where it is miss-identified as a Hobbs Brockunier product. (H=16, F_1=white). $350-$500.

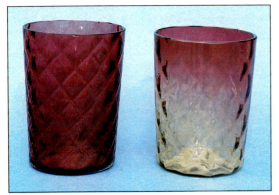

Plate 194. Tumblers, 3.62" h., with 12-row diamond optic patterns. Left: ruby cased with crystal. Right: ruby die-away to light amber. (Both F_1—white). Both $20-$35.

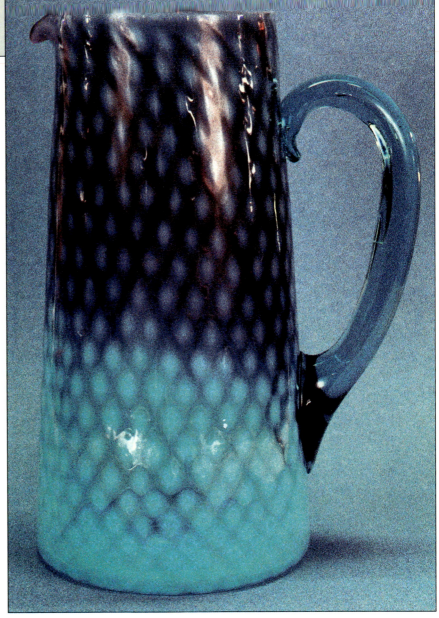

Plate 195. Tankard, 9" h., ruby die-away in opal sensitive blue, with opal diamond optic pattern. The opal diamond shapes are generated within the clear diamond framework. This is a very scarce color combination, corresponding to Azurine without an interior opal casing. >$5000.

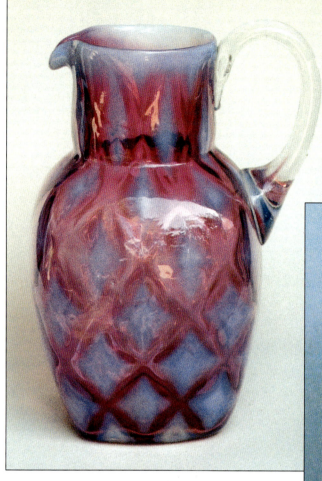

Plate 196. Pitcher, 6.5" h., squared shoulder mold with round neck. Ruby cased with opal sensitive crystal, with large opal diamond optic pattern. ($_{ruby}F_1$=white). $1000-$1500.

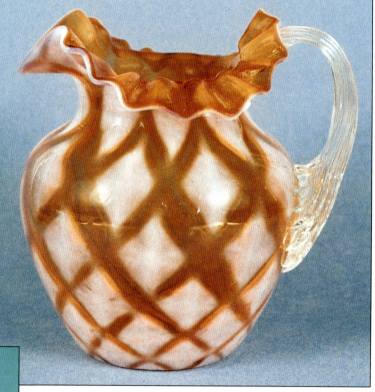

Plate 198. Pitcher, 5.5" h., shoulder mold variation with fully crimped top. Orange cased with opal sensitive crystal (Carnelian without the opal lining), with opal large diamond optic pattern. (H=14, C=19, F_1=white). $500-$750.

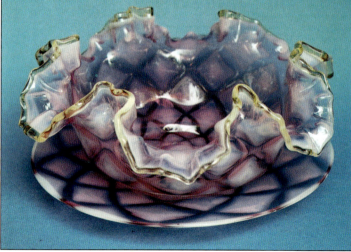

Plate 197. Master berry bowl and place, bowl 10.5" d., place 9.5" d. Ruby cased with opal sensitive crystal, with large opal diamond optic pattern. When this was made, the rim of the place might have been crimped. However, the edge is currently fashioned exactly the same way as the place for the cheese dish shown in Plate 247. This bowl was also made in ruby die-away to amber glass (inverted) in the diamond optic pattern. An example is illustrated in OIG, #174 (p. 65) where it is miss-identified as a Hobbs Brockunier product. (F_1=white). $750-$1000.

Drape Optic Pattern

Objects made in the Phœnix Drape optic effect are shown in Plates 199-207, and the links to our database are provided by the pitchers in Plates 200-202. The drape optic is one of the more interesting patterns made by Phœnix, owing to the diversity in colors in which this pattern may be found. Colors known at present include several shades of blue, green, bronze, ruby, and amber. All of these colors appear in combination with opal glass,

but only blue, ruby, and amber were used to make transparent products. A wide variety of objects were made, including decorative items. This is also one of the few optic patterns used to make a ruby opalescent water set, where the opal drapery effect was generated by reheating the glass during manufacture.

It is interesting to note that examples in the drape pattern made of opal cased with ruby and light amber glass have been historically referred to as "Wheeling Drape" or "Wheeling Peachblow." This terminology has been in use for a long time, for Ruth Lee used Wheeling Peachblow in her book on *Nineteenth-Century Art Glass*.[11] Now that the origin of the pattern has been established, we find no reason to use Wheeling in the name. We now refer to this pattern as "Phœnix Drape," since it refers to the optic pattern rather than a specific color/pattern combination. The items in the cased ruby/amber color combination were made with at least two formulae for the opal casing. One casing shows a green fluorescence on exposure to all ultraviolet light sources, the other white on exposure to short-wave ultraviolet light. It appears to us that Phœnix Drape in the ruby/light amber over opal effect was made to compete with Aurora (New England Glass) and Coral (Hobbs Brockunier) product lines.

Although similar drape patterns were used for glassware made in Europe, they may be distinguished from Phœnix Drape by the fact that they do not exhibit a "ladder" rail between the drape segments. In addition, many Phœnix objects have a thickened foot that frequently had to be flat lapped for the object to properly rest on an even surface. This type of foot is not generally found on imported glass, for it increased the cost of manufacture and shipping. Lastly, the Phœnix Drape pattern is invariably raised on the exterior surface. Apparently, the cuts in the optic mold were sufficiently deep that the pattern was not smoothed out when the gather was blown to final shape.

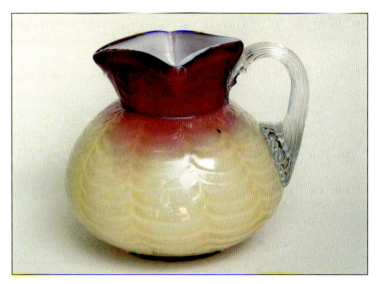

Plate 200. Left: Pitcher, 4.5" h., squat shape and square neck. Ruby die-away to light amber over opal glass (matches Amberine) with 10-panel "Phœnix Drape" optic pattern. Right: A second example of the "Phœnix Drape" pattern that shows the difference in the amount of ruby that was used for this pattern. The banded appearance of this ware leaves little doubt it was made in 1886-87 to compete with Hobbs "Coral." Ruth W. Lee incorrectly attributed of this "original Peachblow" pitcher to Hobbs Brockunier. (H=24, $_{opal}F_1$=green, $_{crystal}F_1$=weak white). $250-$350.

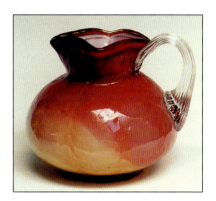

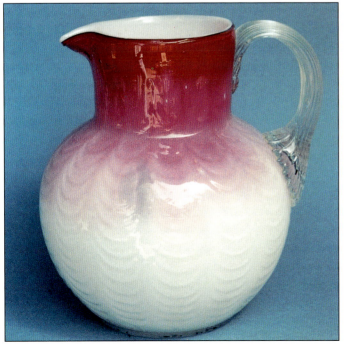

Plate 199. Left: Small pitcher, 6.5" h., ball shape with round neck. Right: Punch cup, 2.12" h. Ruby die-away to crystal (over opal) in "Phœnix Drape" optic pattern. This color effect matches the "Topazine" described in the December 1884 Pottery and Glassware Reporter. This pitcher shape also was made in a ruby die-away to light amber glass cased over opal glass (Amberine). (H=24, F_1=white) Pitcher $350-$500. Cup $125-$175.

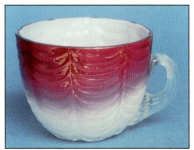

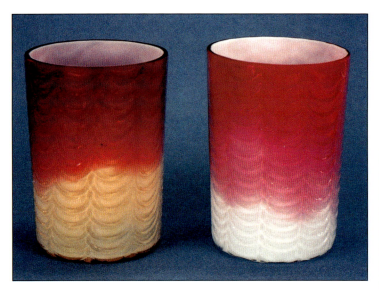

Plate 201. Tumblers, 3.88" h., in 10-panel "Phœnix Drape" optic pattern. Left: Ruby die-away to light amber glass. Right: Ruby die-away to crystal. ($_{opal}F_1$=green, $_{crystal}F_1$=white) Each $125-$175.

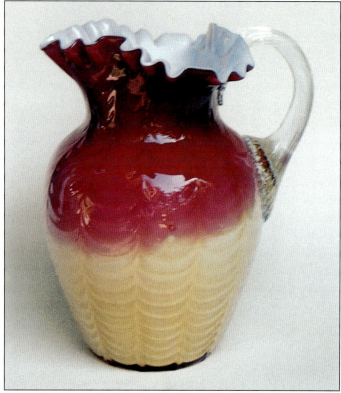

Plate 203. Pitcher made in the 12-panel "Phœnix Drape" optic pattern with fully crimped top. Shoulder shaped (angled in) 9.5" h., ruby die-away to light amber cased over opal. This example, along with a matching footed cruet, is shown in LEE Pt. 7. ($_{opal}F_1$=white, $_{amber}F_1$=white). $750-$1000.

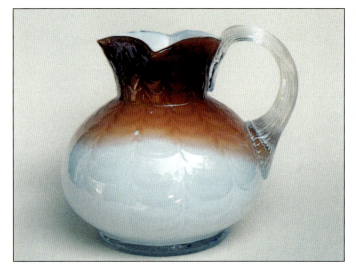

Plate 202. Pitcher, 5.25" h., squat body shape and square top. This orange die-away to crystal (over opal) in a 12-panel "Phœnix Drape" optic pattern is a color combination matching the "Carnelian" referred to in the December 1884 *Pottery and Glassware Reporter*. ($_{crystal}F_1$=weak white). $1500-$2000.

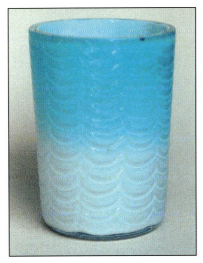

Plate 204. Tumbler, 3.75" h., blue die-away to crystal cased over opal, with 10-panel "Phœnix Drape" optic pattern. ($_{opal}F_1$=green, $_{crystal}F_1$=white). $175-$250.

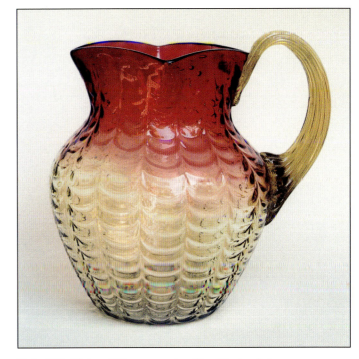

Plate 206. Pitcher, 7" h., square top New England shape with ribbed handle. Ruby die-away to light amber with 14-panel "Phœnix Drape" optic pattern. The oil in this pattern is shown in LEE, Plate 4. (H=16, F_1=white). $350-$500.

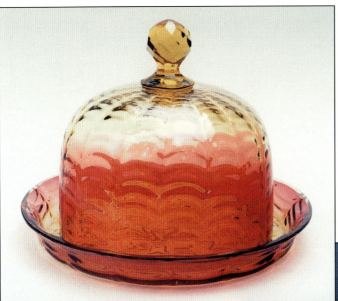

Plate 205. Cheese dish, plate 8.25" d., cover, 6" h., ruby die-away to light amber with the 12 panel "Phœnix Drape" optic pattern. Since the cover was not transferred in the making, the color combination appears to be upside down. $500-$750.

Plate 207. Pitcher, 8.25" h., and tumbler, 3.62" h., modified tankard shape with square top. Ruby cased with opal sensitive crystal, with opal 10-panel "Phœnix Drape" optic pattern. (H=14, F_1=white) Pitcher $2000-$3000. Tumbler $175-$250.

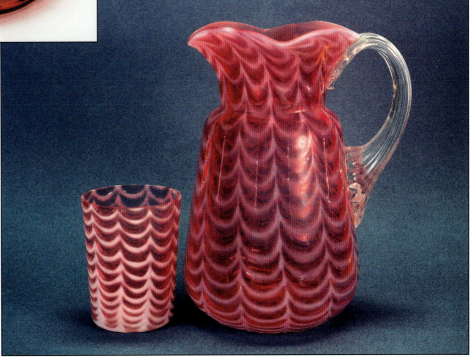

Honeycomb and Window Optic Patterns

Relatively few examples of the honeycomb optic pattern are known, and those we can document to have been made by Phœnix are water pitchers. Like the Phœnix Drape optic, the honeycomb optic was cut deep enough to leave a hexagonal depressions on the exterior surface of the finished product. Objects blown in the Window optic pattern, on the other hand, have depressions that are circular, and the ribs between the openings are not nearly as pronounced. At present, the link of these two optic patterns to the Phœnix database is provided by the honeycomb optic pattern that was used on the Phœnix square shape pitcher of the type shown in Plate 120. Elmore shows the ruby opalescent example with this shape on the back cover.[12]

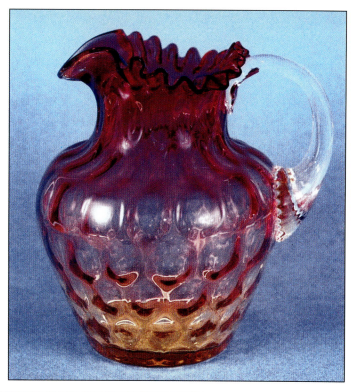

Plate 209. Pitcher, 5.5" h., crimped top, ruby die-away to light amber with honeycomb optic pattern. (H=24, C=16, F_1=white). $175-$250.

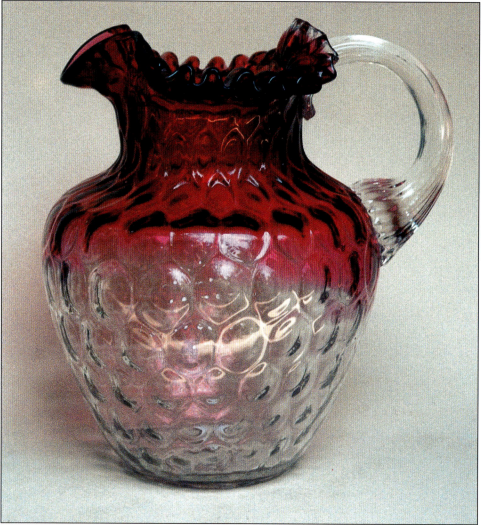

Plate 208. Pitcher, 7.75" h., crimped top, ruby die-away to crystal with honeycomb optic pattern. (H=19, C=24, F_1−white). $250-$350.

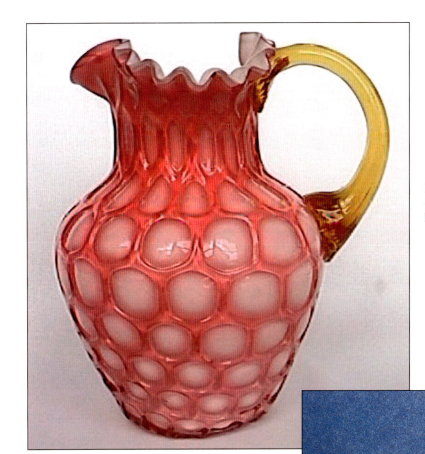

Plate 210. Pitcher, 5.75" h., crimped top, ruby cased over opal glass with honeycomb optic pattern. (H >24, C=18). $500-$750.

Plate 211. Cheese cover, faceted finial, ruby cased over opal glass with honeycomb optic pattern. $250-$350.

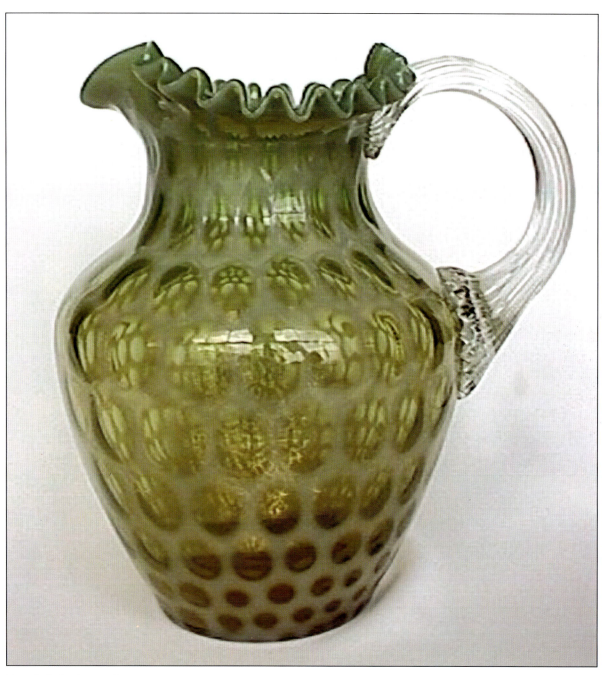

Plate 212. Pitcher, 7.5" h., shoulder shaped variant with fully crimped top. Dark green die-away to opal sensitive light amber, with opal honeycomb optic pattern. This pitcher is also illustrated in ELM p. 193 #1126. (H=22, C=22). $250-$350.

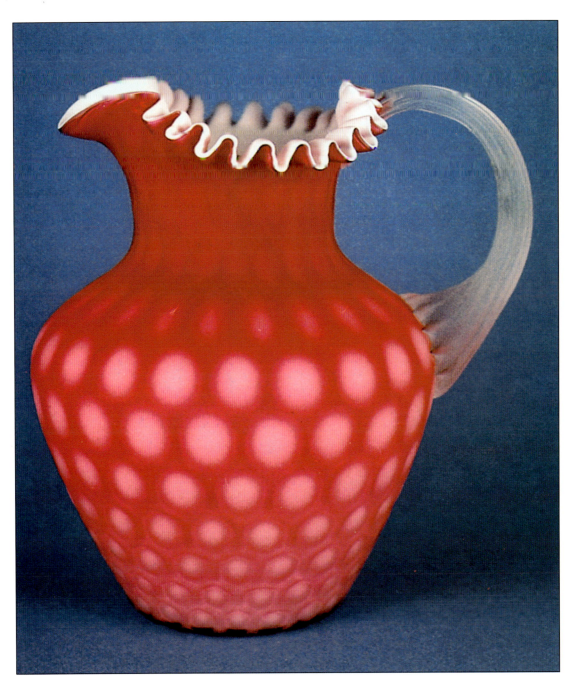

Plate 213. Pitcher, 8.12" h., crimped top, satin finished ruby die-away to crystal, cased over opal glass, with honeycomb optic pattern. The pins adjacent to the spout have been modified to make a smooth transition from the spout to the crimp. The honeycomb pattern continues to the bottom center of this pitcher. (H=16, C=24, $_{ruby, opal}$F$_1$=white). $250-$350.

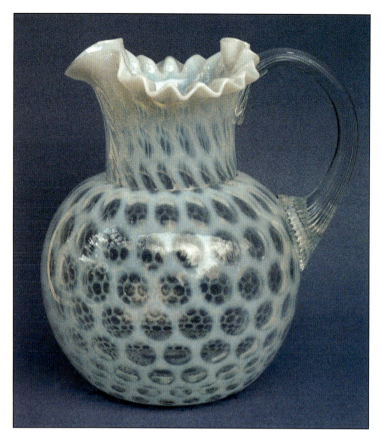

Plate 214. Pitcher, 8.5" h., bulbous base, crimped top. The pins adjacent to the spout have been modified to make a smooth transition from the spout to the crimp. Opal sensitive crystal glass, with opal window optic pattern. A pitcher in the identical shape, made in the ruby/dark amber combination, is illustrated in GCD 3:1, p. 13. This pitcher shape was also made in ruby cased over opal with the honeycomb optic. (H=36, C=18, F_1=white). $250-$350.

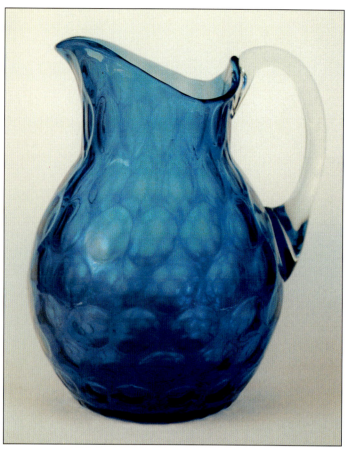

Plate 216. Pitcher, 7.25" h., modified shoulder mold. Deep blue cased with crystal, with windows optic pattern. We did not think that Webb made a "cobalt" blue, but in fact this color was used for a toothpick holder that is illustrated in NTHCS p. 31 # 232. (F_1=strong white). $350-$500.

Plate 215. Pitcher, 5.25" h., bulbous base, crimped top, ruby die-away to crystal, with windows optic pattern. (H=24, C=14, F_1=white). $250-$350.

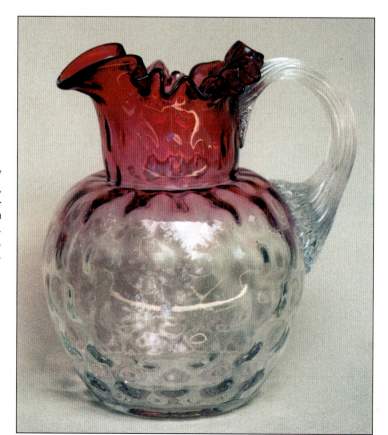

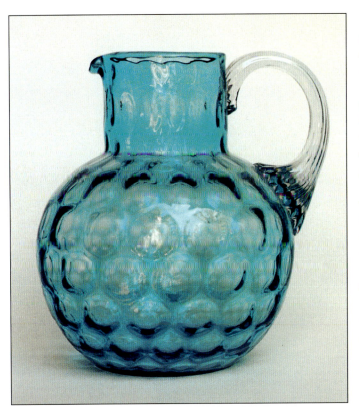

Plate 217. Pitcher, 5.62" h., ball shape mold with round top. Blue cased with crystal, with windows optic pattern. The abnormal green fluorescence of the blue glass is thought to be due to the presence of a small amount of uranium. (H=24, F_1=weak green). $175-$250.

Plates 222-224 show examples in the rib panel optic pattern. This pattern was used for other products including fairy lamps. An example of the latter is shown in Fig. 120, RUF2.[13]

Hobbs Brockunier also made panel optic products, but the mold patterns were quite different from those used by Phœnix. In addition, examples made in ruby glass by Hobbs (corresponding to those in an 1883 trade advertisement) lack the characteristic white fluorescence on exposure to short-wave ultraviolet light. Many color/effects used at Phœnix could not be made by Hobbs, owing to Leighton's very limited knowledge of glass chemistry. For example, Hobbs could not have made a ruby die-away to green with opalescent casing (Plate 4) based on the recorded glass compositions used at Wheeling.[14] Finally, some objects with panel optic patterns exhibit a light, overall opalescence that is, at present, unique to Phœnix.

Panel and Ribbed Panel Optic Patterns

Both Phœnix Glass and Hobbs Brockunier used the panel optic pattern at some time between 1883 and 1888. This pattern is simple to make, compared to the ribbed panel optic with vertical, raised ribs between the panels. Considerable skill is needed to keep the rib pattern straight, which may account for the absence of tableware in this pattern. The attribution of the paneled example with "Bronze" effect was the starting point of our research. However, a number of color or effects were used (some in the identical shape molds), that are unique to Phœnix. Most of the ball shape molds with panel optic patterns have the characteristic thickened foot, and the sidewall of the jug often flares out very slightly where it meets the bottom.

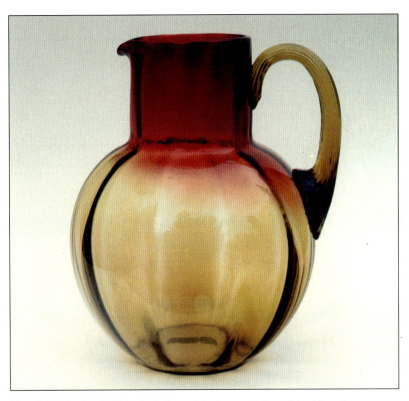

Plate 218. Pitcher, 7.5" h., ball shaped body, round top, ribbed handle. Ruby die-away encased in dark amber, with panel optic pattern. This pitcher also came in a 4.5" and 8.25" h. sizes. Also see example in GCD 9: 4, p. 65. (H=22, $_{amber}F_1$=0, $_{ruby}F_1$=white). $125-$175.

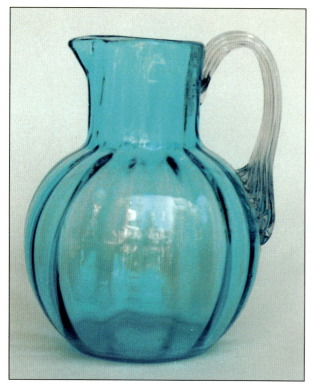

Plate 219. Pitcher, 5" h., ball shaped body, round top, with ribbed handle. Blue cased with crystal, with panel optic pattern. This example was also made with a blue handle. The blue glass likely contains some uranium, owing to a green fluorescence on exposure to short-wave ultraviolet light. (H=16). $125-$175.

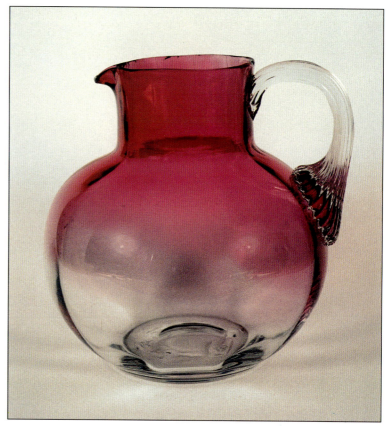

Plate 221. Pitcher, 5.12" h., bulbous shape, round top, ribbed handle. Ruby die-away to crystal, with panel optic pattern. (H=22, F_1=white). $125-$175.

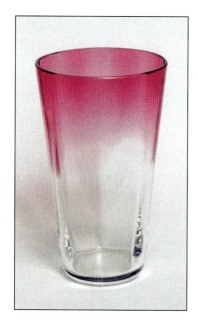

Plate 220. Champagne tumbler, 3.88" h., ruby die-away to crystal, with panel optic pattern. The base of this example is smaller compared to the champagne tumblers made by New England Glass. The attribution to Phœnix is made from the strong fluorescence. (F_1=white). $50-$75.

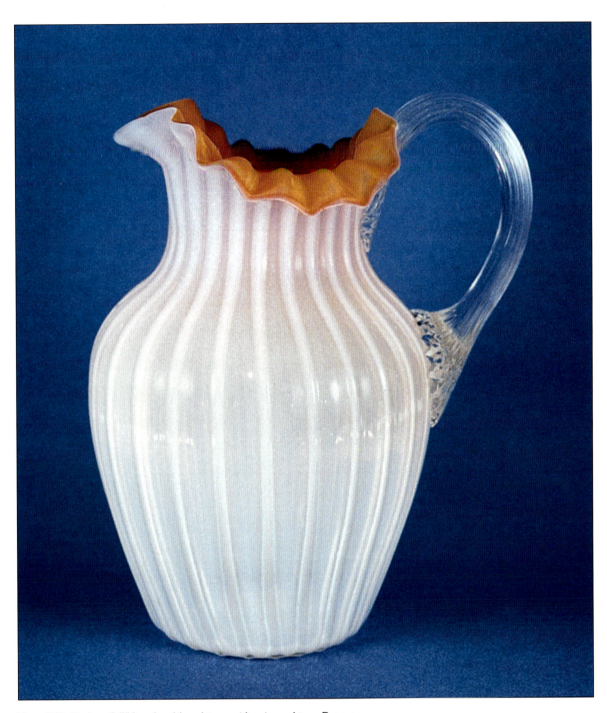

Plate 222. Pitcher, 8.5" h., shouldered type with crimped top. Bronze die-away to opal sensitive crystal, ribbed panel optic pattern. For this example, a much thicker opal casing is applied over the bronze glass, compared to the thin casings under the bronze for objects in "Bronze" effect shown in Plates 1 and 2. (H=20, C=15, F_1=white). $250-$350.

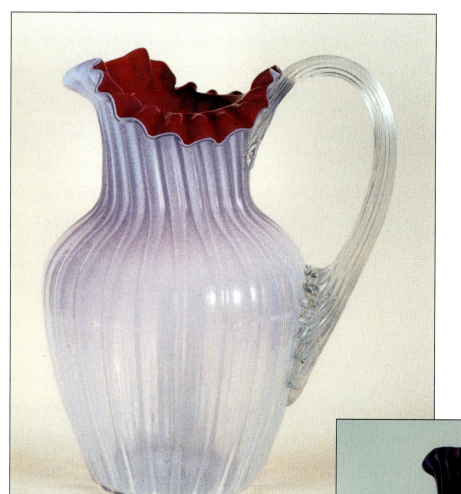

Plate 223. Pitcher, 8.5" h., shouldered type with crimped top. Ruby die-away to opal sensitive crystal, ribbed panel optic pattern. The cruet matching this color effect is illustrated in MCO, p. 62, center #3. (H=20, C=15, F_1=white). $250-$350.

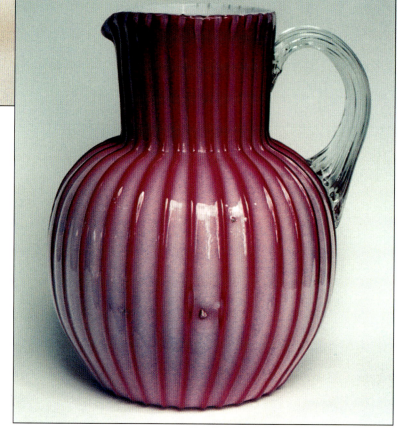

Plate 224. Pitcher, 8.25" h., bulbous shaped base with round top. Ruby cased over opal in ribbed panel optic pattern. (H−16, F_1=white, $_{opal}F_1$=weak white). $350-$500.

Stripe and Swirl Optic Patterns

Relatively few domestic firms made an opalescent stripe optic pattern. Considerable skill was required to keep the stripes vertical upon reheating to develop the opalescence, and during the expansion into the shape mold. Expansion widens the stripes, but they are not distorted so long as the blower does not twist the gather. Our link to the Phœnix database is through the tumbler shown in Plate 228. This example has the Phœnix Cracquelle finish, and the color is "Bronze." Along with the diamond and spot, Phœnix was the first domestic firm to make the stripe optic pattern, for Bronze was an early 1886 product. The Phœnix, narrow neck opal stripe pitcher in Plate 227, also made in ruby, is distinctly different from examples with stripe optic made by Northwood and Buckeye after 1890, in that the stripes are very wide.

Phœnix also made some objects in the stripe optic pattern by the equally difficult canework process. Here, highly colored rods are picked up on the surface of the gather, then fused into the glass. When blown into final shape, the rods expand into stripes. Two characteristics of canework pieces are that the edges of the stripe are more strongly colored than the center, and the border of the pattern is well defined against the background color. In contrast, opalescent stripes developed by reheating the gather are deeper colored in the center than the edges, and the border between the stripe and the background color is diffuse.

The swirl optic pattern begins life as a stripe optic. After the development of the opalescence, the gather is turned on a (marver) plate. When blown into final shape, the pattern appears as a spiral on the exterior of the object. When the ribs of the optic mold are cut deep, the ribbed pattern may persist after the expansion into the shape mold. Many opalescent, swirled optic examples made by Hobbs Glass also have slightly raised ribs. The spiral ribs are less pronounced on Phœnix products. The swirl and stripe optic made by Nickel-Plate Glass is quite similar to that made by Phœnix, but the shapes of the water pitchers #84 and 94 in a surviving U.S. Glass catalog are quite different from any that were used by Phœnix.[15]

End Notes

1. A discussion of Phœnix and Mt. Washington Glass air trap patterns may be found in Revi, A.C., *Nineteenth Century Glass* (1957: Atglen: Schiffer Pub., 1967) 2.

2. U.S. Patent 344,415 issued to F.S. Shirley, June 29, 1886, added two features to the Dean-Peltier patent. The first is to use a heat sensitive glass for the outside casing. The second is to etch the exterior surface of a finished piece. We can find no evidence that Mt. Washington had the technology that would allow them to produce a cased heat sensitive, colloidal gold glass, with or without air-traps.

3. Even the "Mt Washington" example shown by Revi on p. 5 is made in a shape mold that cannot be attributed to Mt. Washington.

4. Sisk, B., *Mount Washington Glass* (Paducah: AB Collector Books, 2003).

5. Bredehoft, T., *Glass Tumblers-1860s to 1920s.* (Paducah: Collector Books, 2003), 198.

6. This catalog is in the Rio Grande Historical Collections, University of New Mexico at Las Cruces, New Mexico.

7. The letters of the Phœnix mark form a straight line. From their regularity, it is apparent that a transfer process was used to apply the acid resist. Similar "patent" marks may be found on air-trap ware, but the letters form an arc. It is not clear who used this mark variant.

8. An English patent GB 9422 for the manufacture of pearl satin ware was issued to William Webb Boulton of Boulton and Mills on August 7, 1885. However, this patent concerns the just the etching process, a technically unimportant component in the manufacture of pearl satin ware. It is unlikely that this firm would have used the "PATENT" mark on their ware as a reference to this patent. At present, we can not confidently assign any example of "PATENT" marked ware to an English firm.

9. The opalescent spot optic used for the ball shape pitchers is often distorted into an ellipse, especially in the area of the neck. The designation of the spot optic pattern for the example in Plate 225, *Encyclopedia of Victorian Colored Pattern Glass 9* as "opalescent diamond" is incorrect.

10. A careful examination shows that the glass is expanded between 10 and 15% after the surface is crackled. One way to achieve the contraction in the size of the blown object, prior to crackling the surface, is to reheat it for short time at a temperature where the glass begins to flow. Another way to achieve the crackled effect is to re-blow the crackled object into a slightly larger shape mold. How the surface was cooled to crackle the glass is not mentioned in any of the trade notices, but most likely it was by a blast of cold air since there are no internal fractures in Phœnix Craquelle.

11. Lee, Ruth W., *Nineteenth-Century Art Glass* 3rd ed. (New York: M. Barrows, 1952) 7.

12. Elmore, J., *Opalescent Glass from A-Z* (Marietta: Antique Pub., 2000) back cover

13, Ruf, B., Ruf, P., *Fairy Lamps* (Atglen: Schiffer Pub., 1996) 49.

14. William Leighton left Hobbs Brockunier in 1888, the year of the reorganization into Hobbs Glass. The formulas used at Wheeling are recorded in Bredehoft, T., Bredehoft, N., *Hobbs Brockunier and Co. Glass* (Paducah: Collector Books, 1997) 39.

15. Heacock, W., Gamble, W., *Encyclopedia of Victorian Colored Pattern Glass 9* (Marietta: Antique Pub., 1987) 26.

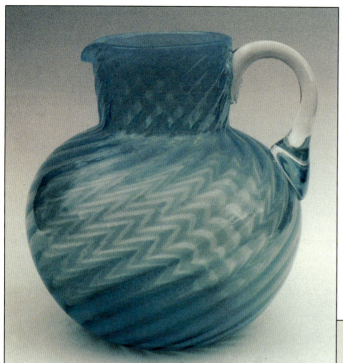

Plate 225. Pitcher, 5" h., bulbous shaped base with round top. Blue cased over opal sensitive crystal, with swirl optic pattern. The green fluorescence suggests this glass contains a very small amount of uranium. (F_1=green/white). $175-$250.

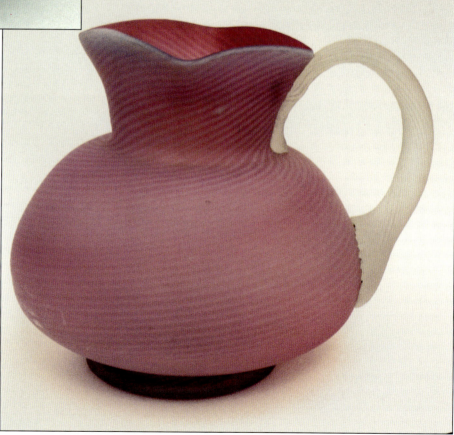

Plate 226. Pitcher, 7" h., squat shaped, with square top. Ruby cased over opal sensitive crystal, with opal swirl optic pattern. The manufacture of this color effect is described in U.S. Patent 370,089 issued to Joseph Webb. Here, however, the core is not cased in a shell. After molding, the core is heated to develop the opalescence, turned on the marver to form a spiral, then blown to final shape. (H=28, F_1=white). $500-$750.

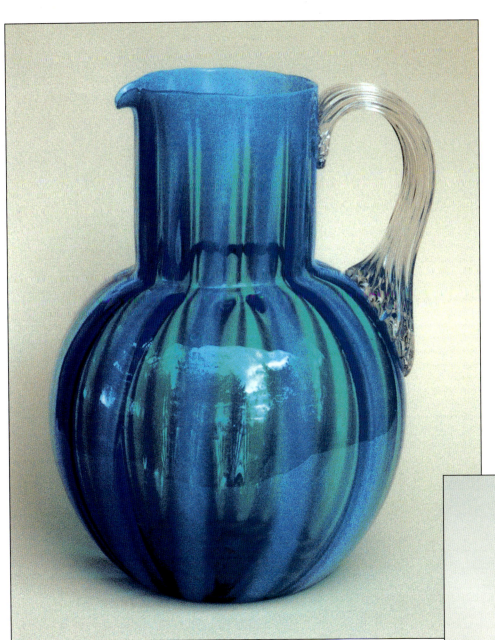

Plate 227. Pitcher, 8.12" h., ball shape mold with round neck. Blue with opalescent strip optic pattern. This same pitcher was also made in a ruby opalescent effect. Unlike canework examples, the stripes do not meet at a point in the base of this pitcher. (H=15, F_1=white). $250-$350.

Plate 228. Tumbler, 3.75" h., bronze die-away to opal sensitive crystal, with stripe optic pattern. $125-$175.

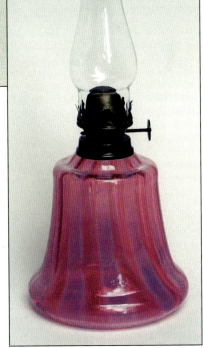

Plate 229. Miniature lamp, base is 4.75" h., no mark on burner, chimney replaced. Ruby cased over crystal, with embedded opal canes in a stripe optic effect. (F_1=white). $500-$750.

Phœnix Decorative and Novelty Products

Records show that Phœnix Glass made a wide variety of decorative and novelty products. At the time, novelties were heavily stocked by wholesale firms, such as Butler Brothers, and were comprised of individual items made in new colors, patterns, and shapes. Most often, novelties were made for just one (six month) selling season. Consequently, these items are not normally found in product lines, so documentation is provided by unique color effect combinations, mold patterns, and written notices in trade journals. Based on the entries in trade catalogs, the Mt. Washington Glass Company was the leader in this field between 1885 and 1890.

Salt and Sugar Shakers

Phœnix must have used many patterns for salt and pepper shakers, but we have been able to document just the ones shown in Plates 230-239. The most common is the barrel shape. These shakers were fitted with two styles of two piece metal caps with one section cemented to the glass. The top section of one style is hemispherical in shape, and screws into the base. New England Glass used this cap in 1883 for Amberina, Hobbs Brockunier used it in 1886 for Coral, and Mt. Washington used it in 1885 for Burmese. The top section of the second style cap is only slightly rounded. This cap appears on a shaker with Impasto Cameo decoration that is illustrated by Heacock,[1] so its use must date from 1888. Based on our observations of shakers illustrated in trade catalogs, caps that screw directly onto the glass body were not in domestic use until 1888.

Our identification of the barrel shape mold is made easy, for Lechler reports two instances of marked examples.[2] Mr. Heacock first thought the barrel shape "Coloratura" shakers were made by Hobbs Brockunier, but eventually this attribution was corrected.[3] Many of the shakers shown here have been previously attributed to other firms, notably Mt. Washington Glass. The distinction of shakers from this firm is easy, once it is recalled that Mt. Washington made virtually no clear, colored glass. We have been able to find a good representation of shakers made in common Phœnix colors and effects, but not in the well advertised colors of Mandarin or Bronze.

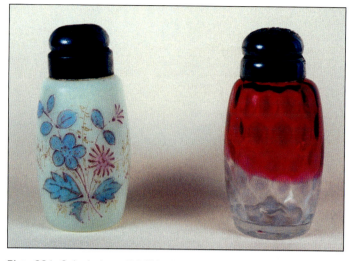

Plate 231. Salt shakers, 3.38" h., barrel shaped with cemented, 2-piece puff cap. Left: Tinted opal glass with light blue floral decoration. Right: Ruby die-away to opal sensitive crystal colors with opal spot optic pattern. (F_1=white). $250-$350.

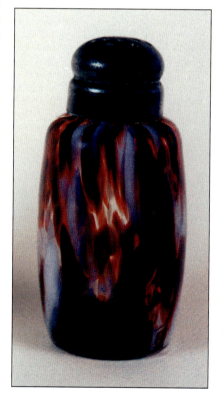

Plate 230. Salt shaker, 3.5" h., barrel shaped with spot optic pattern. Maroon and opal flakes in a pulled, mottled pattern. The cap is made in two pieces, with the bottom piece cemented to the neck. The identical shape shaker, in ruby die-away to light amber over opal colors, is shown in LCK, p. 244, top left. (The example shown there is obviously not made with a heat sensitive glass.) In this reference, it is noted that two pieces of this glass have been seen in museums with Phœnix paper labels. This shaker was also made with green and opal flakes in a pulled, mottled effect with a spot optic pattern, the same as shown in Plate 63. In addition, a satin finish, blue example of this shape, enameled with a 12-point buck is shown in LCK p. 177 (right.) This identifies one more design used for the Impasto Cameo line.

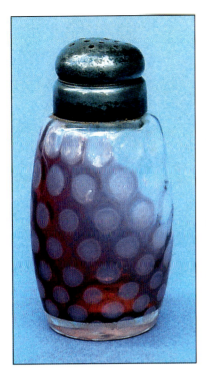

Plate 232. Shaker, ruby die-away (inverted) to opal sensitive crystal with opal spot optic pattern. The spot mold used for this shaker is the same that was used for the champagne tumbler shown in Plate 184. This is the second example to tie in the inverted ruby/crystal opalescent spot pattern to the Phœnix database.

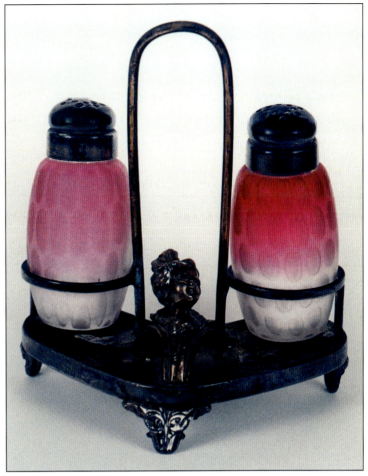

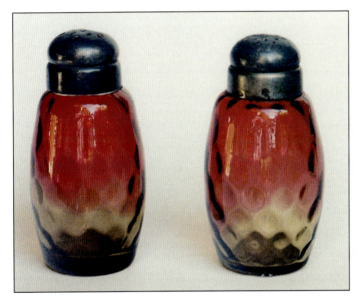

Plate 233. Salt and pepper shakers, 3.5" h., barrel shaped with cemented, 2-piece puff caps, ruby die-away to dark amber colors, spot optic pattern. The cap for the pepper has smaller holes than the cap for the salt. The same shape shaker, with ruby and opal flakes in a mottled effect with mica encased within amber glass (same effect as our Pt. 23) is shown in LCK, p. 97, top left. (F_1=0). \$350-\$500.

Plate 235. Salt shakers, 3.5" h., in metal holder (Meriden). Cemented, 2-piece puff caps with ruby die-away to crystal over opal in windows air-trap optic pattern. The same shape shaker, with floral "pod" decoration (same as our Pt. 166), over deep apricot die-away to pink over opal glass with windows air-trap optic pattern is shown in LCK p. 146, bottom right. Other air-trap examples (miss-identified in sources) include: Ruby-die away to crystal over opal glass, pod decoration, with windows air-trap optic pattern – LCK p. 147, top right; Yellow die-away to crystal over opal glass with diamond air-trap optic pattern – LCK p. 147, bottom right; Blue die-away to crystal over opal glass with diamond air-trap optic pattern – LCK p. 145, bottom right. \$1000-\$1500.

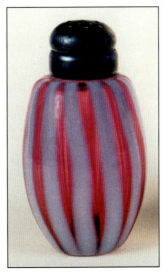

Plate 234. Salt shaker, 3.62" h., barrel shaped with cemented, 2-piece puff cap, ruby cased with opal sensitive glass, with opal stripe optic pattern. The clarity of the ruby glass suggests this is a later product made about 1890. \$175-\$250.

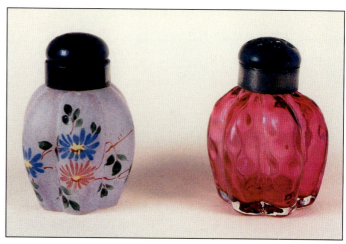

Plate 238. Salt shakers, 2.75" h., six lobed mold with cemented 2-piece puff caps, ruby cased crystal, and decorated opal in the spot optic pattern. Each $75-$125.

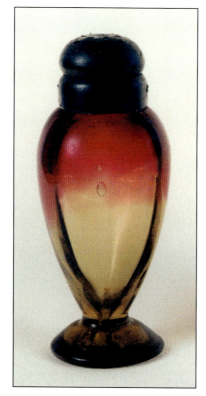

Plate 236. Salt shaker, pedestal type 4" h., two piece puff cap with ruby die-away to dark amber glass, with panel optic pattern. This same shaker with floral decoration is shown in LCK p. 253 top center. $175-$250.

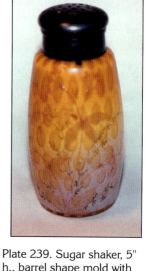

Plate 239. Sugar shaker, 5" h., barrel shape mold with two piece, flat top cap. Six salt shakers in various effects with this later cap style are shown in HCK-3, p. 51. $350-$500.

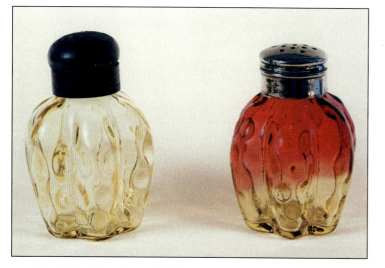

Plate 237. Salt shakers, 2.75" h., six lobed molds with cemented 2-piece caps, light amber and ruby die-away to amber colors in the spot optic pattern. The ruby amber shaker has a replaced top. This shape mold was also used for air-trap ware. A (miss-identified as Mt. Washington) blue die-away to crystal over opal with diamond optic pattern is shown in LCK p. 145, top right. Each $75-$125.

Match and Toothpick Holders

The identification of toothpick holders is difficult, owing to the difficulty in incorporating mold, color, and effect patterns into small pieces. We tried to distinguish holders from small vases, but found this was not a fruitful exercise. No doubt, some of the items shown in Plate 240-246 served more than one purpose. However, there is no question the firm made toothpick holders, for they are among the products listed in several early, Phœnix trade advertisements.

Plate 240. Toothpick holder, 2.25" h., ringed base mold. Ruby and opal flakes in a mottled effect, mica encased in amber glass. This shape toothpick was made in a wide variety of colors and effects. Other examples include the following: Inverted ruby die-away to opal sensitive glass with opal spot optic – NTHCS p. 23 #108; Blue with opal flakes in a pulled, mottled pattern with applied, pounded glass – NTNCS p. 32 #241; Green and opal flakes in a pulled, mottled pattern – NTHCS p. 32 #244, cobalt blue with floral decoration – NTHCS p. 31 #232, Ruby and opal flakes in a pulled, mottled pattern – HCK-1 p. 38 #257; Ruby die-away to crystal (inverted) with opal flake mottled pattern, with encased mica – HCK-M p. 55 #287; Decorated amber – HCK-M p. 49, #143. (F_1=white). $125-$175.

Plate 241. Toothpick holder, 2.25" h., ringed base mold. Ruby die-away to crystal over opal glass window air-trap optic pattern. This window air-trap toothpick was made in several colors, including apricot die-away to crystal over opal glass – NTHCS p. 24 # 118. (F_1=white). $500-$750.

Plate 243. Toothpick holder, 2" h., hexagonal column shape, ruby die-away to light amber (inverted) with diamond optic pattern. $125-$175.

Plate 242. Toothpick holder, 2.12" h., footed bulbous base with round top. Satin finish ruby die-away (inverted) to light amber, with diamond optic pattern. $125-$175.

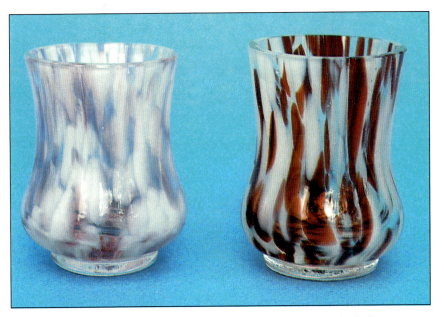

Plate 244. Toothpick holders, 2.25" h., slump base with applied wafer. Left: Ruby and opal flakes in a pulled, mottled pattern. Right: Maroon and opal flakes in a pulled, mottled pattern. (F_1=white). $75-$125.

Oils and Other Containers

From the descriptions in trade journals, we know that Phœnix made many different types of novelties. Containers for various products were undoubtedly made, but the only two that we have been able to identify are the humidor and covered cheese dish in Plate 248. Both of these products are made with the pulled, mottled effect that was popular during 1885. The objects we designate today as cruets were originally sold for dispensing oil or vinegar, and were often found in trade catalogs under the heading of novelty products. Phœnix made a significant number of oils, many in colors and effects used for other tableware items. The mold patterns we show in Plates 248-265 incorporate few elements of tableware. At the time, this made their sale easier (for they fit with many mold patterns), but it now makes their identification difficult. Sometimes the difference in shape is subtle, as is the case for the examples shown in Plate 249 and 251. The oil in Bronze color effect is slightly out of round and exhibits a slightly flaring, thickened foot. The mottled cruet is almost a perfect ball shape, and does not have a flaring rim though the foot is thickened. Attributing the manufacture of oils to Phœnix from the comparison of photographs is difficult. We have found that fewer mistakes are made by direct comparisons.

Plate 245. Footed toothpick holder, 2.25" h., with applied feet. Blue cased over opal glass in moire optic pattern. There appears to be some uranium in the blue glass. ($_{blue}F_1$=green, $_{opal}F_1$=0). $75-$125.

Plate 246. Pedestal footed toothpick holder, 2.88" h., ruby die-away to dark amber glass with spot optic pattern. Other examples include the following: Ruby die-away to light amber glass with diamond optic pattern – NTHCS p. 22 #82; Ruby cased with opal sensitive glass, spot optic pattern – HCK-TP p. 26 #1123; Blue cased with opal sensitive glass, spot optic pattern – HCK-M p. 51, #190; Etched crystal base with amber stain rim – BDFT-T p. 164 left. This last example was made to mimic the second version of New England's "Pomona" glass. $175-$250.

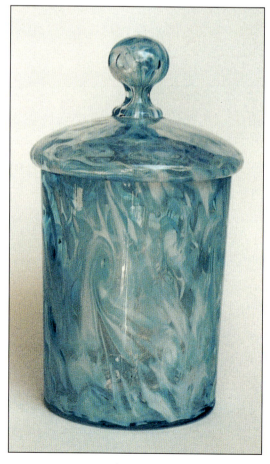

Plate 247. Humidor, 8.25" h., cylinder shape. Blue and opal flakes in a pulled, mottled with spot optic pattern. The lid is made in one piece. The finial is hollow and can be filled with water that will not drip out when inverted. This feature eliminates the need for a sponge. (F_1=white) $350-$500.

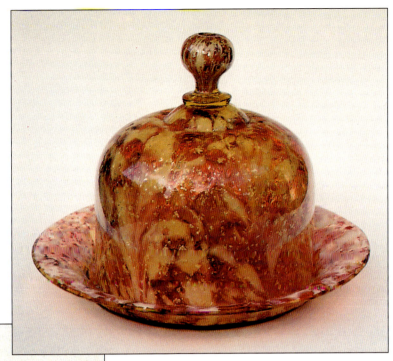

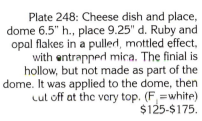

Plate 248: Cheese dish and place, dome 6.5" h., place 9.25" d. Ruby and opal flakes in a pulled, mottled effect, with entrapped mica. The finial is hollow, but not made as part of the dome. It was applied to the dome, then cut off at the very top. (F_1=white) $125-$175.

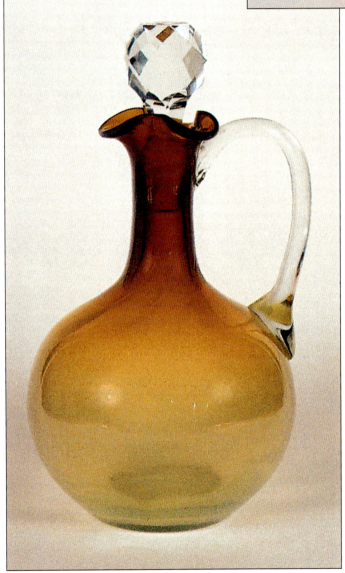

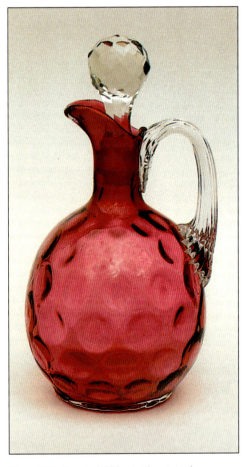

Plate 249. Cruet, 5.25" h. (without stopper), ball shape with tri-foil top. Panel optic pattern with "Bronze" color effect. (F_1=white). $250-$350.

Plate 250. Cruet, 6.5" h. (with original stopper), ovide body shape with single spout. Ruby cased with crystal, with spot optic pattern. This shape mold was used to make examples in the Phœnix drape pattern, with ruby die-away to amber cased over opal glass. (F_1=white). $125-$175.

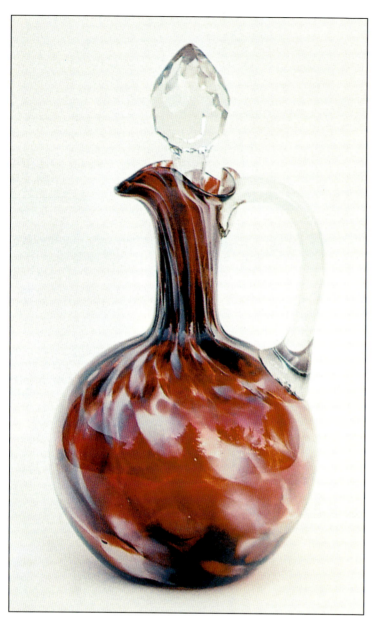

Plate 251. Cruet, 6.5" h. (without stopper) ball shaped mold. Spot optic pattern with maroon and opal flakes in a pulled, mottled effect. $175-$250.

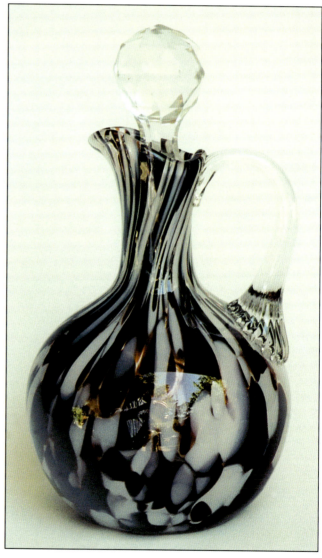

Plate 252. Cruet, 6" h., original stopper, ball shape with single spout. Maroon and opal flakes in a mottled effect, with pattern greatly distorted in the neck from manufacture. We thought these single spout cruets might not be Phœnix until we recorded one with ovide body in the Phœnix Drape pattern with ruby/light amber die-away color effect. (F_1=white). $125-$250.

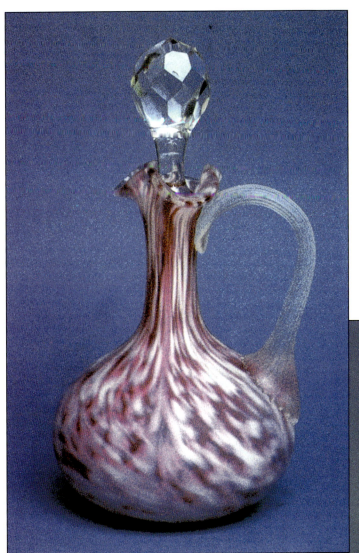

Plate 253. Cruet pitcher, 5.25" h., stopper not original, squat shape with tri-foil top. Satin finish, ruby and opal flakes in a pulled, mottled color effect. The stopper should be satin finish to be original. (H=22, F_1=weak white). $250-$350.

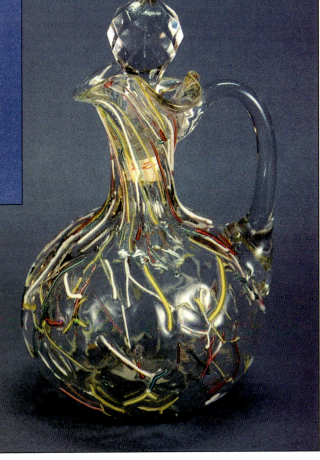

Plate 254. Cruet pitcher, 4.5" h., squat shape with tri-foil top. Crystal with white, yellow, and red applied threads, spot optic pattern. $250-$350.

Plate 255. Cruet, 5.62" h. with original stopper, squat shape with tri-foil top. Satin finish ruby die-away to crystal over opal glass with zig-zag air-trap optic pattern. The same cruet in blue die-away to crystal over opal is shown in MCO p. 17, bottom row #2. (F_1=white). $500-$750.

Plate 256. Cruet, 5.5" h. (without stopper) squat shaped base, rib handle with tri-foil top. Satin finish, yellow die-away over opal glass with diamond air-trap optic pattern. The various colors used for this cruet (yellows, salmon, peach, blue) are shown in MCO p. 17, top row, 1-4. With original satin finish stopper $500-$750.

Plate 257. Cruet, 5.5" h. with original stopper, round shape with single spout top. Satin finish, "Mandarin" color effect with windows air-trap optic pattern. $500-$750.

Plate 258. Cruet, 5.5" h. (without stopper) squared body shape, fine rib handle. 8 uneven lobes. Satin finish, yellow die-away over opal glass with zig-zag air-trap optic effect. This cruet shape was also made in blue die-away to crystal over opal glass, and is shown in MCO p. 16, bottom row #3. This shape was also used for mottled colors, an example is shown in MCO p. 24, bottom row #4. $350-$500.

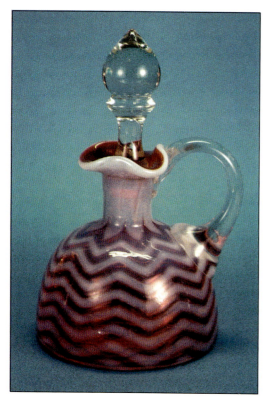

Plate 259. Cruet, 4" h. (without stopper), igloo body shape with tri-foil top. Ruby cased with opal sensitive glass, with opal zig-zag optic pattern. This shape cruet was made in several color combinations. A ruby die-away to light amber glass, with spot optic pattern, is shown in MCO p. 12, top #3. A ruby glass with diamond optic pattern is shown in GCD 4:3, p. 9. $750-$1000.

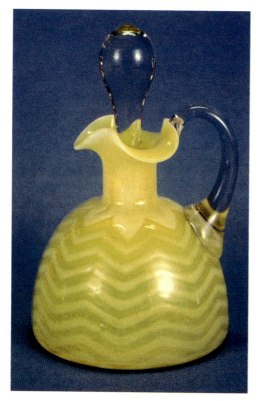

Plate 260. Cruet, 4" h. (without stopper), igloo body shape with tri-foil top. Yellow cased with opal sensitive glass, with opal zig-zag optic pattern. $500-$750.

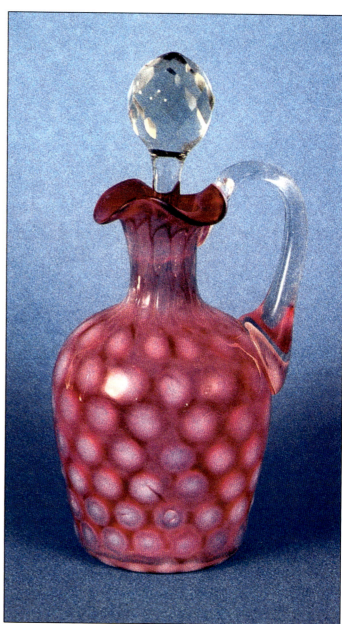

Plate 261. Cruet, 5.5" h., shoulder mold body shape with tri-foil top. Ruby cased with opal sensitive glass, with opal spot optic pattern. $750-$1000.

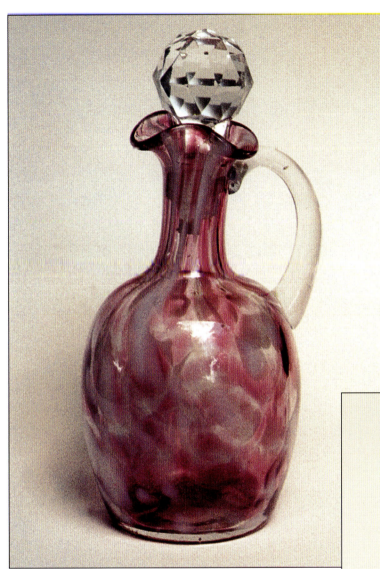

Plate 262. Cruet, 5.25" h. (without stopper), shoulder type body shape, tri-foil top. Ruby and opal flakes in a pulled, mottled effect with spot optic pattern. (F_1=white). $175-$250.

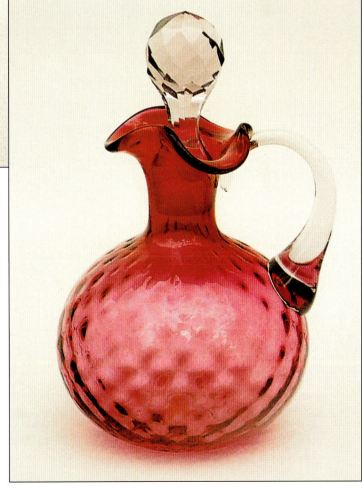

Plate 263. Cruet, 5.5" h., almost ball shape, with tri-foil top, original stopper. Ruby glass, with fine diamond optic pattern. The stopper fluoresces the same as the handle and body. (F_1=white). $125-$175.

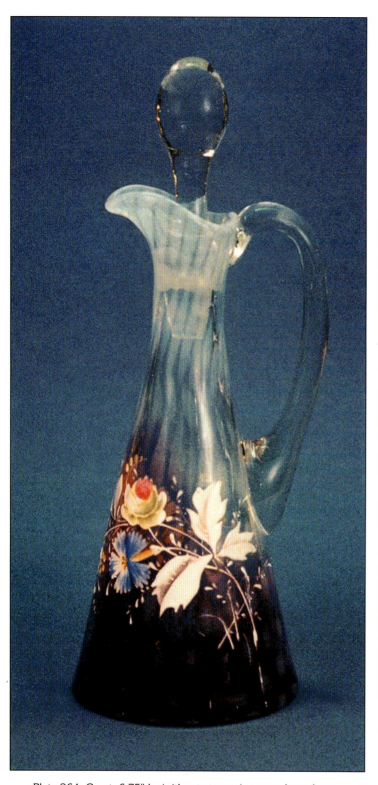

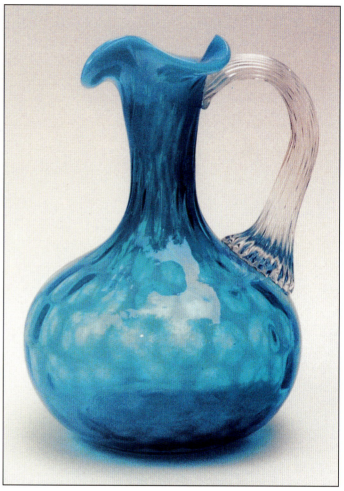

Plate 265. Cruet, 5" h. (without stopper) squat shape, rib handle with tri-foil top. Blue cased with opal sensitive glass, with opal spot optic pattern. (F_1=white). $250-$350.

Plate 264. Cruet, 6.75" h. (without stopper), tepee shaped with single spout top. Ruby die-away to opal sensitive glass with opal spot optic pattern. The decoration on this example was also used for ball shape pitchers with triangular necks. The same shape cruet was made in ruby die-away to light amber glass, with spot optic pattern, and is shown in MCO p. 12, bottom #1. A cruet in ruby die-away to canary is illustrated in OIG, p. 66, #181, where it is miss-identified as a product from Hobbs Brockunier. $1000-$1500.

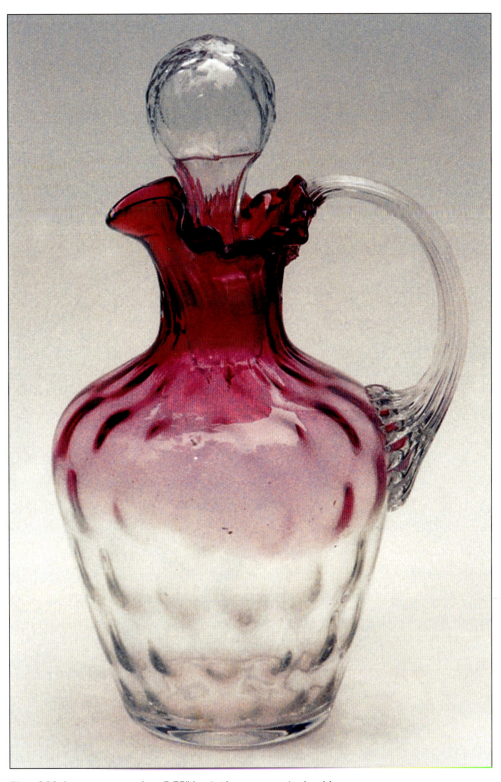

Plate 266. Large cruet pitcher, 5.75" h., (without stopper), shoulder shape body, rib handle with ruffled top, hollow blown stopper. Ruby die-away to crystal glass, in the spot optic pattern. $350-$500.

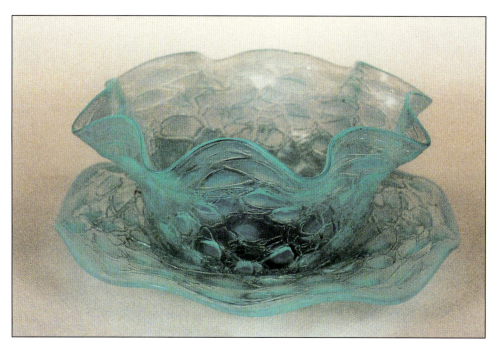

Plate 267. Finger bowl with place, bowl 5.5" d., place 6" d., with fluted rims. Blue cased with opal sensitive glass, with opal spot optic pattern and Craquelle effect. (F_1=white). $125-$175.

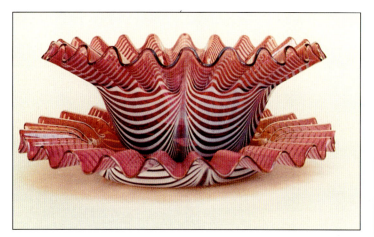

Plate 268. Finger bowl with place, bowl 2.25" h., 5.5" d., place 6" d., with even crimped rims. Dull red color with white, pulled Venetian Thread optic. This is a very unusual example of Venetian Thread, in that the glass was not etched with hydrofluoric acid. (F_1=weak white). $350-$500.

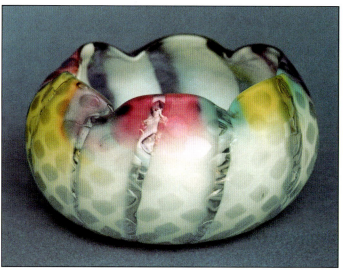

Plate 269. Finger bowl, 2.25" h., 4.5" d., with ruffled top, made of two parts. Outer part: ruby/blue/yellow die-away to crystal. Inner part: opal canes embedded in crystal. Satin finish only on opalescent canes. Made by the process described in U.S. Patent #363,190 issued to Joseph Webb on May 17, 1887. Marked "PATENT" in straight line, with non-etched letters. This effect was used to make a rose bowl, and an example is shown in GCD 5:1, p. 48. The "PATENT" mark is the same as noted. Another example (rose bowl) with applied crystal feet is shown in RVI opposite page 23. This is the best evidence that Phœnix made rose bowls, for they are not mentioned in the trade literature. (F_1=white). $1000-$1500.

Vases

The vases shown in Plates 270-288 have a connection with the Phœnix database, either by color or effect. There is no doubt that Phœnix made decorative pieces, as they are described in many trade reports. For example, the December 3, 1885 *Pottery and Glass Reporter* describes a new line of vases: "…the new peach glass just got out by the Phœnix Glass Co. is probably the most exquisite color, or rather combination of colors they have yet produced. A line of vases of this glass, enameled in gold, is the very acme of beauty and finish. They call them Mandarin." It is possible that the "peach" color combination did not sell well, and the brown shading to yellow was substituted for Mandarin at a later date. It is also possible that the reporter erred in referring to this glass as Mandarin. Reference to the manufacture of decorative vases is also given in the January 20, 1887 issue of the *Crockery and Glass Journal*. "Their lines of vases will stand comparison with the finest effort of foreign skill without losing by the contact and they have out several new styles surpassing those of last year."

To our knowledge, there is only one vase known to have provenance, for it is in the collections at the Smithsonian Museum. The vase is shaded blue, with satin finish, diamond air-trap pattern, that was acquired as a gift from Phœnix Glass.[4] The even color, and clipped off top of this vase is more typical of later, European import products. We note, however, that the top has been fire polished to seal the traps, something that is generally omitted from imports. Of significance is that this example does not exhibit a die-away color effect, as do most of the vases we have been able to identify as having been made by Phœnix.

Phœnix made a variety of small vases with crimped, or curly tops. There are two characteristics of these vases that aid in their identification. The first is that a narrow band of clear or amber glass is applied to the edge before the edge is crimped. Generally, three segments of the crimped glass were folded down to finish the top. The second, and more important characteristic, is the pattern imparted to the glass by the crimping device. Without exception,

the moveable pins push the glass towards the center of the vase, into the recesses of the matching stationary mold, just as for the water pitchers shown in Chapter 2. When the crimped top is folded down, the indentations face upward. We have found examples where 16, 20, 22, 24, and 26 pins were used to make the crimps, depending on the size of the crimp that was made.

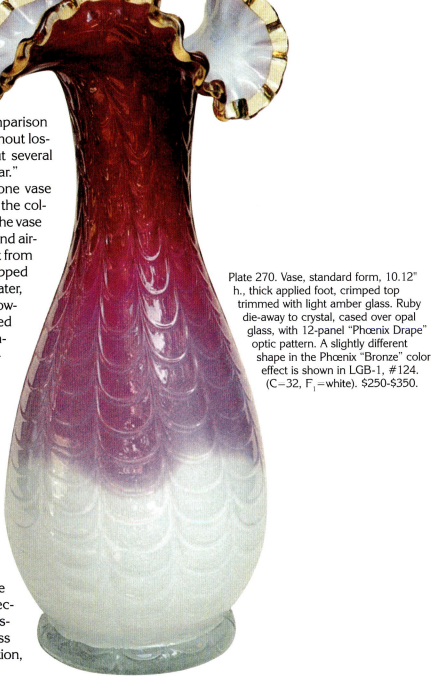

Plate 270. Vase, standard form, 10.12" h., thick applied foot, crimped top trimmed with light amber glass. Ruby die-away to crystal, cased over opal glass, with 12-panel "Phœnix Drape" optic pattern. A slightly different shape in the Phœnix "Bronze" color effect is shown in LGB-1, #124. (C−32, F_1=white). $250-$350.

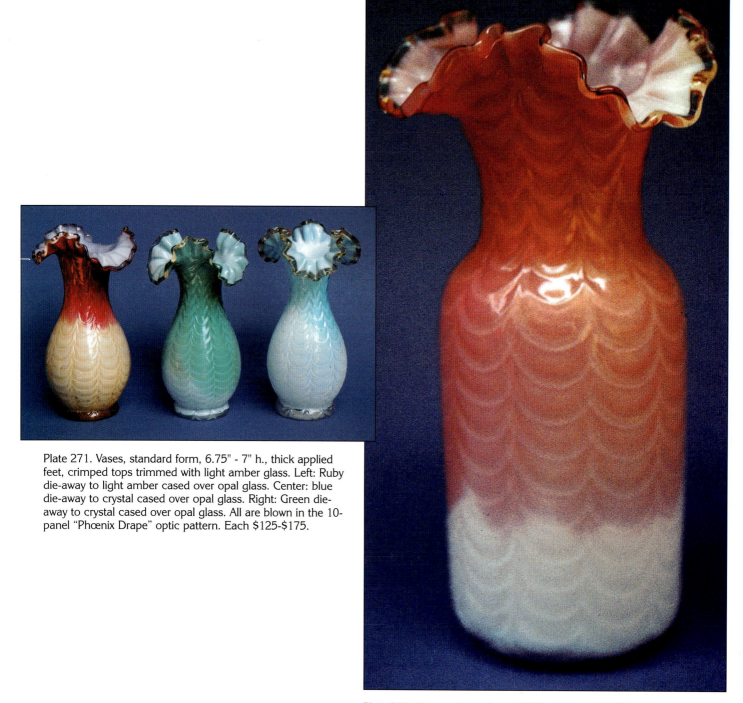

Plate 271. Vases, standard form, 6.75" - 7" h., thick applied feet, crimped tops trimmed with light amber glass. Left: Ruby die-away to light amber cased over opal glass. Center: blue die-away to crystal cased over opal glass. Right: Green die-away to crystal cased over opal glass. All are blown in the 10-panel "Phœnix Drape" optic pattern. Each $125-$175.

Plate 272. Vase, cylinder form, 8.5" h., thick applied foot, crimped top edged with light amber glass. Deep orange with die-away shading through pink to crystal, cased over opal glass with 10-panel "Phœnix Drape" optic pattern. This vase, made in blue die-away to crystal over opal, is shown in GCD 4:5, p. 16. $250-$350.

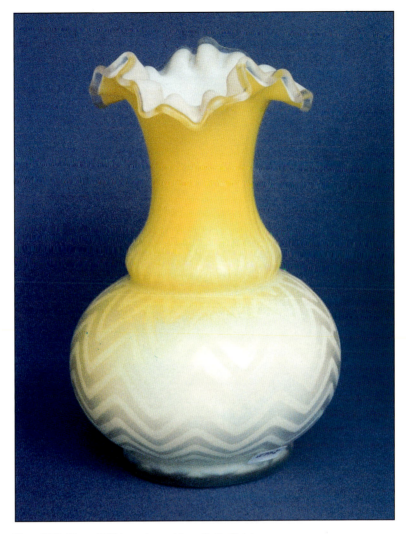

Plate 273. Vase, 6.5" h., crimped top. Satin finish, yellow die-away to crystal over opal glass with zig-zag air-trap optic pattern. ($_{yellow}F_1$=orange). $175-$250.

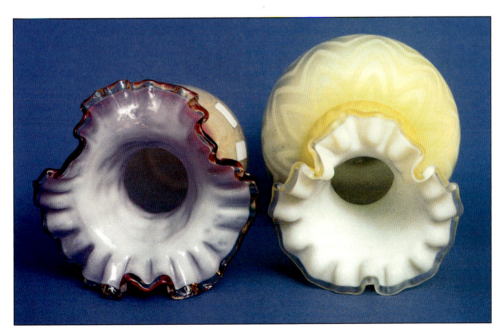

Plate 274. Vase, top view, standard shape, 6.75" h., thick applied foot, crimped top edged with light amber glass. Left: Ruby die-away to light amber cased over opal glass with 10-panel "Phœnix Drape" optic pattern. Right: Yellow die-away to crystal cased over opal glass with zig-zag air-trap optic pattern.

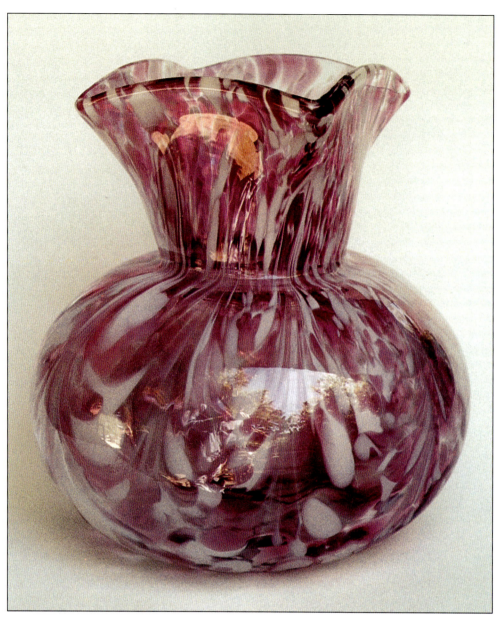

Plate 275. Vase, 6.75" h., 6.5" d., bulbous shape base, square top. Ruby and opal flakes in a pulled, mottled effect. (F_1=white). $250-$350.

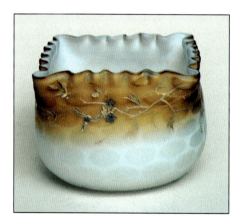

Plate 276. Small bowl, 3.25" h., 4" d., with crimped top. Satin finish, "Bronze" die-away to crystal cased over opal glass, with windows air-trap optic pattern. (F_1=white). $250-$350.

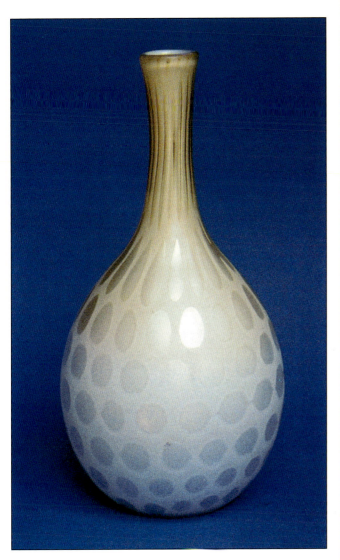

Plate 277. Stick vase, 9" h., bulb shape base. Satin finish, dark citron die-away to crystal cased over opal glass, with window air-trap optic pattern. This same shape in "bronze" effect is described in the October 7, 1886 *Pottery and Glassware Reporter*. It is doubtful that citron was the color used by Phœnix to make "Verde Pearl" products. Green die-away over opal air trap ware is one of the rarest colors. A better candidate for this effect is the example shown in GCD 6:5, p.16. (F_1=white). $175-$250.

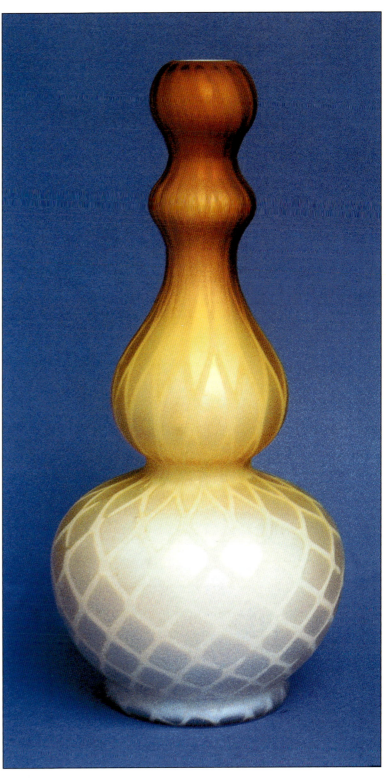

Plate 278. Vase, 10" h., triple gourd shape base. Satin finish, deep brown die-away through yellow to crystal over opal glass, with diamond air-trap optic pattern. This color effect corresponds to "Mandarin" described in the September 1886 *Crockery and Glass Journal*. (F_1=white). $500-$750.

Plate 279. Vase, 11" high, with tri-foil top. Satin finish, blue die-away to crystal over opal glass, with diamond air-trap optic pattern. A vase with the same shape but with top finished differently as shown in MCI p. 454 is in the collections of the Smithsonian Institution. (F_1=weak white). $500-$750.

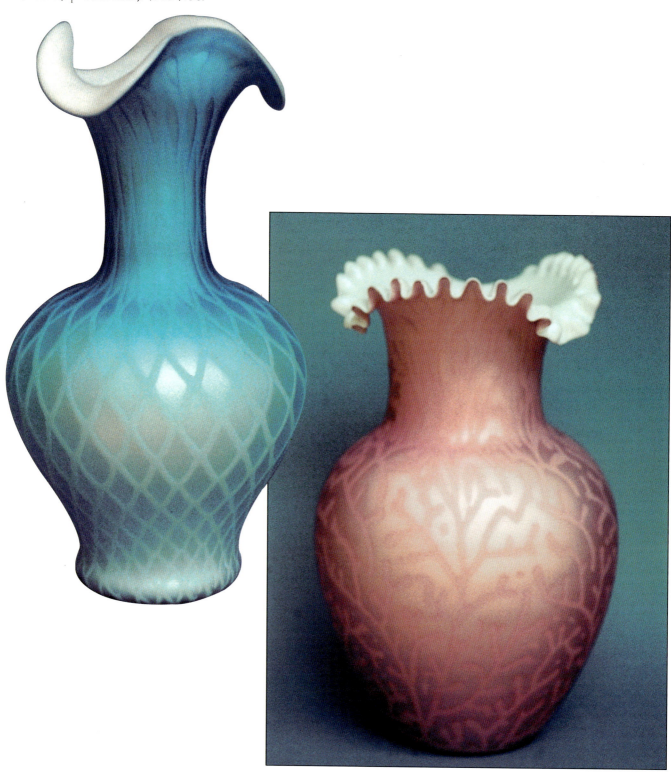

Plate 280. Vase, 10.25" h., shoulder type with crimped top. Satin finish heliotrope cased over opal glass with "seaweed" air-trap optic pattern. This piece is attributed to Phœnix based on the shape, color, crimp pattern, and the bright, chalk white fluorescence upon exposure to short wave ultraviolet light. (C=32, F_1=white). $1000-$1500.

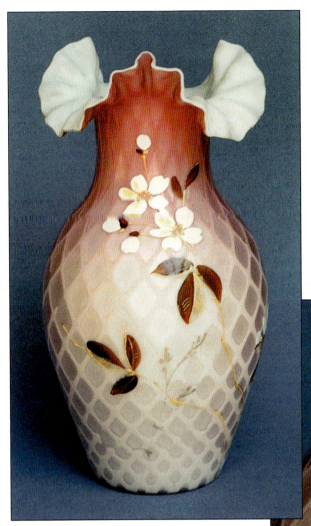

Plate 281. Left: Vase, shoulder type with crimped top. Satin finish ruby die-away to crystal over opal glass with diamond air-trap optic pattern. Right: Detail of the floral decoration, one that was also used on the water set in the mold pattern in Plate 154. (F_1=weak white). $350-$500.

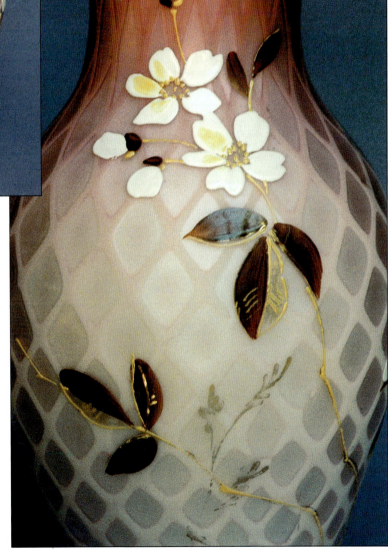

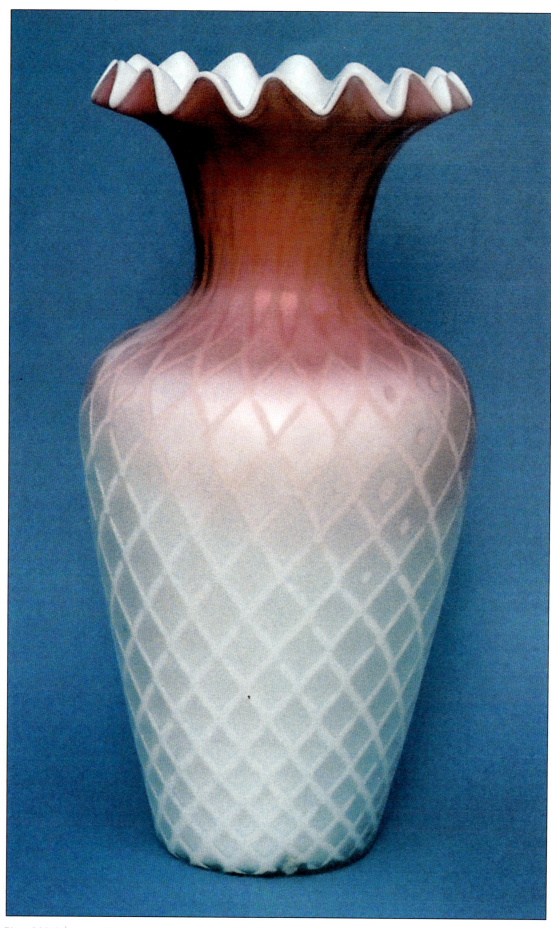

Plate 282. Vase, 10.5" h., crimped top, satin finish, blue die-away to crystal over opal glass with diamond air-trap optic pattern. (C=16, F_1=weak white). $250-$350.

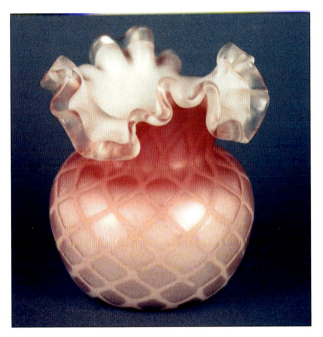

Plate 283. Vase, 2.88" h., bulbous base with crimped top. Satin finish, ruby die-away to crystal, cased over opal, with diamond air-trap optic pattern. This vase is also illustrated in OIG, #281, where it is misidentified as the product of Hobbs Brockunier. (C=20). $250-$350.

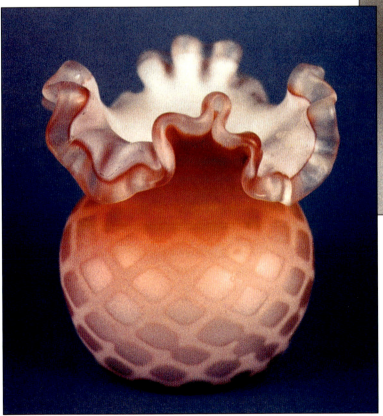

Plate 284. Vase, 2.88" h., bulbous base with crimped top. Satin finish, unusual red die-away to crystal, cased over opal with diamond air-trap optic pattern. (C=20). $250-$350.

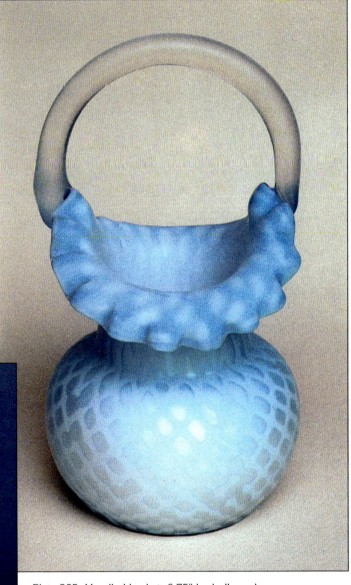

Plate 285. Handled basket, 6.75" h., bulbous base with crimped top. Satin finish, blue die-away to crystal over opal glass, with diamond air-trap optic pattern. (C=22, F_1=white). $350-$500.

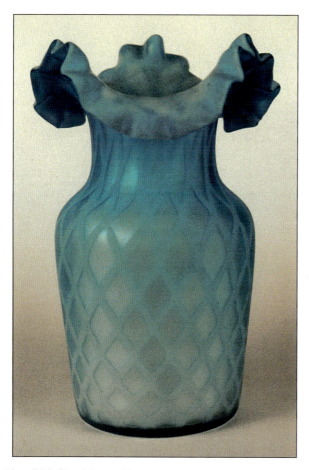

Plate 286. Shoulder mold vase, crimped top with three folds. Blue die-away to crystal over opal glass, with diamond air-trap optic pattern. (C=22, F$_1$=white). $250-$350.

Plate 288. Vases, 6" h., ribbed panel mold with crimped tops. Left: Yellow die-away to crystal over opal glass. Right: Ruby die-away to crystal over opal glass. (C=20, F$_1$=white) Each $125-$175.

Rose Bowls

While not specifically stated, it is clear from the descriptions in trade journals that Phœnix was making rose bowls. Owing to the rapid turnover in both mold patterns and colors, most of the Phœnix rose bowls are relatively hard to identify, but there are some in unique effects that stand out.

The first of these is Venetian Threaded (Nailsea) rose bowl as shown in Plate 289. They are known with red, deep blue, and light blue colors threaded with opal glass. The same colors (and more) were also used by Phœnix to make shades and bases for fairy lamps.

Spangled rose bowls, where mica is encased between layers of glass, are known in die-away colors of blue, ruby, and yellow. The examples shown here are made of very thin glass, and have finely ground but unpolished pontils. Both round and pouch shapes were made in the spangle effect, the latter almost identical to the shape used by Mt. Washington glass. The difference is in the way the side of the bowl rises from the base, and the smaller opening in the top. Although Phœnix rose bowls are made of very thin glass, they are comprised of multiple layers. Examples with three casings that we have measured are usually no more than 0.12 inch thick.

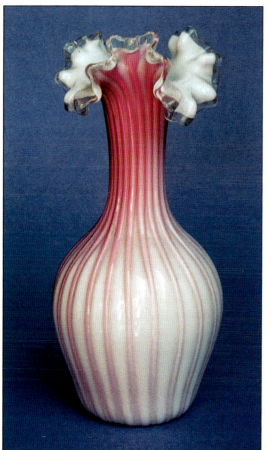

Plate 287. Vase, 6" h., shoulder type with crimped top. Ruby die-away to crystal over opal glass with ribbed panel optic mold. (C=22, F$_1$=white). $125-$175.

There are two facets that link rose bowls to the Phœnix database. The first is the unique size and distribution of mica, identical to the mica used for the pitcher in Plate 75. The second, but not shown, is that the large pouch shape was made in the identical effect as the water pitcher shown in Plate 23. Slightly larger mica particles were used for this effect.

Without doubt, most of the plain or satin finish rose bowls that are currently in the antiques marketplace were made in Europe. Butler Brothers imported them in huge quantities from 1893 up through 1903, in many tinted colors. This includes the round and pouch shapes similar to the ones used by Phœnix.

While not shown, several styles of rose bowls were made in an air-trap and canework combination in die-away rainbow colors. One is identical to the finger bowl shown in Plate 269, made by the process described in Webb's U.S. Patent #345,265. Here, the canework pattern is imbedded into the gather and the colored glasses imbedded into the cup. Most of the pieces in this combination are bowls, some with applied crystal feet and ornamentation. All are marked with "PATENT" in straight-line block letters that stand out against the etched background.

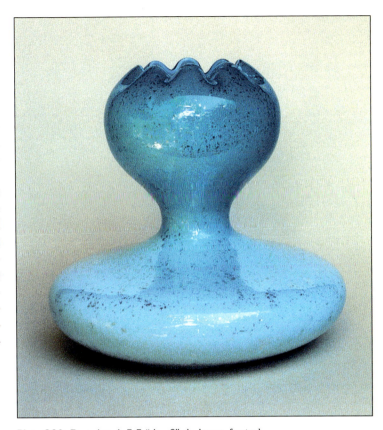

Plate 290. Rose bowl, 5.5 " h., 6" d., large, footed pedestal shape. Blue die-away to crystal over opal glass with encased mica. The color effect is identical to the pitcher shown in Plate 75. (F_1=white). $250-$350.

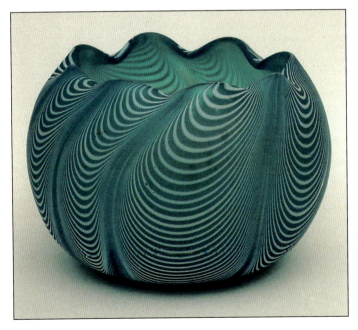

Plate 289. Low profile rose bowl, 2.75" h., 4" d., melon shaped. Blue with white, threads in a Venetian Thread optic. (F_1=white). $250-$350.

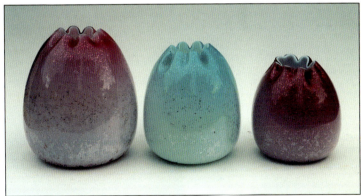

Plate 291. Rose bowls, pouch shape. Left: 5" h. ruby die-away to crystal. Center: 4.25" h., blue die-away to crystal. Right: 3.88" h., ruby die-away to crystal. All have mica encased between opal and crystal. The pouch shape is almost identical to that used by Mt. Washington Glass for their "lusterless," decorated rose bowls. (F_1=white) Each $ 35-$50.

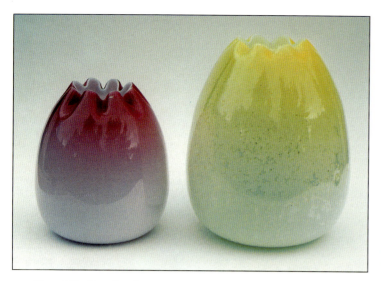

Plate 292. Rose bowls, pouch shape. Left: 5" h., ruby die-away to crystal cased over opal glass. Right: 8" h., yellow die-away to crystal with mica encased between the crystal and opal glasses. Each $ 50-$75.

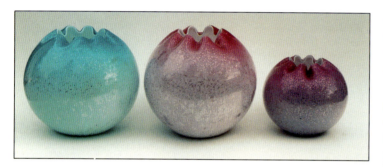

Plate 293. Rose bowls, round shape. Left: 4.5" h., blue die-away to crystal. Center: 4.5" h., ruby die-away to crystal. Right: 3.25" h., ruby die-away to crystal. All of these rose bowls have mica entrapped encased between the crystal and opal glasses.

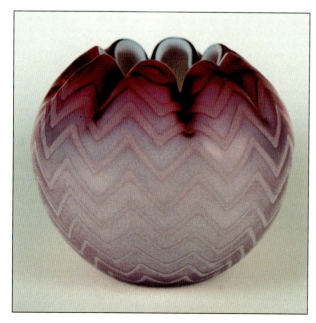

Plate 294. Rose bowl, 3" h., ruby die-away to crystal over opal glass with zig-zag air trap optic pattern. ($_{opal}$ F$_2$=weak green). $250-$350.

Cameo Glass

The *Crockery and Glass Journals* of June 14 and July 5, 1888, mentions a new line of novelties in "Impasto Cameo" effect in four colors. The main feature of this line was the excellent finish of the work. The products were, presumably, superior to their earlier ones where the design was etched out of the enameled portions of the glass. Obviously, these products were made to compete with the carved cameo produced in England by Thomas W. Webb and other firms.[5] One might expect that the molds and designs for this ware should mimic English patterns. Consequently, very few examples are likely to overlap with the Phœnix database. The object in Plate 295 is included because the artwork and color match an example in the "Coloratura" series of shakers.[6]

On occasion, we have observed objects with Impasto Cameo designs on a red, yellow, and blue satin background marked with "Florentine Art Cameo" in outline against the satin finish.[7] Albert C. Revi reports finding a reference to this ware in an undated Lazarus and Rosenfeld trade advertisement.[8] Although the ad mentioned that Florentine Art Cameo came from Bohemia, this may, or may not have been the case. We have observed that whether selling fine china or glass, small import firms did not see the need to provide wholly accurate information for the source of their wares. We know from trade journal reports that some New York importers purchased quantities of glass from Phœnix, then sold it back to Pittsburgh retailers as imported ware. In retrospect, a great deal of American glass must have originally sold as imported ware, since the American tariff essentially prohibited the import of high quality art glass. Our reason for the inclusion here is that this glass exhibits the characteristic white fluorescence upon exposure to short-wave ultraviolet light. Until examples are found that can connect Florentine Art Cameo to the Phœnix database, we really do not know if it is a domestic product or an import.

End Notes

1. Heacock, W., *Encyclopedia of Victorian Colored Pattern Glass 3* (Marietta: Antique Pub., 1976) 51.

2. Lechler, M., Lechler, R., *The World of Salt Shakers* (Paducah: Collector Books, 1992) 244.

3. Heacock, W., *Collecting Glass-Vol 3* (Marietta: Richardson Pntg., 1986) 61-65.

4. Innes, L., *Pittsburgh Glass 1797-1891* (Boston: Houghton, 1976) 454.

5. *The Crockery and Glass Journal* of June 14, 1888, states that these cameo pieces can hardly be distinguished from the examples of imported carved cameo.

6. Heacock, *3*. 51.

7. This mark was also made by applying acid resistant lettering to the glass prior to etching with hydrofluoric acid. When the resist is removed, the letters are outlined by the satin background.

8. Revi, A.C., *Nineteenth Century Glass*, 2nd ed. (Atglen: Schiffer Pub., 1967) 161.

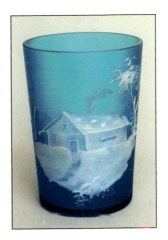

Plate 295. Tumbler, 3.88" h., crystal cased inside and out with blue, satin finish with Impasto Cameo decoration. This decoration also used on a salt shaker, shown in Plate 400 in HCK-CG. $175-$250.

Plate 296. Pitcher, 5.5" h., bulb shaped base with round top. Satin finish ruby with Impasto Cameo decoration. This ware was made to look like the cameo exported to this country by Thomas W. Webb (England). A Phœnix fairy lamp in Impasto Cameo with red background is illustrated in RUF-2, p. 177, Fig 624. It is difficult to tell if the color match is identical without actual comparison of examples. $125-$175.

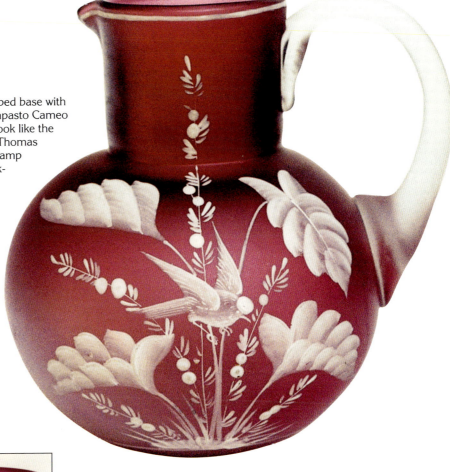

Plate 297. Tumbler, 3.75" h., satin finish, ruby with Impasto Cameo decoration. This example is marked "Florentine Art Cameo" where the letters are outlined by the etching on the base. $175-$250.

Undocumented Objects with Phœnix Characteristics

In this chapter, we illustrate a number of objects that incorporate one or more unique attributes of the glass made by Phœnix. However, they are either not connected or match just one example in the database. Whether or not these items were actually made by this firm will have to await the acquisition of more objects for study. It is important to show these examples here in order to facilitate the location of intermediates that are needed to establish links to documented examples, should they exist.

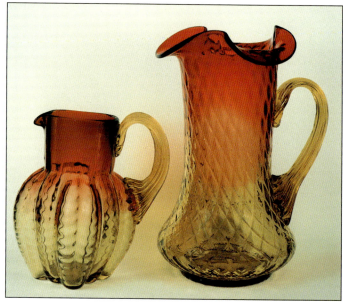

Plate 300. Example comparing color combinations. Left: Phœnix uneven lobe, overall square shape, 6.5" h. with 16 rib light amber handle, zig-zag optic pattern. Right: Footed tankard shape, 10" h. with 16 rib light amber handle. Both of these ruby, die-away to light amber pitchers are made with the same combination of glasses, but the optic patterns are different. Another color combination is needed to confirm a Phœnix origin for the tankard. (both F_1=white) Left $175-$250. Right $250-$350.

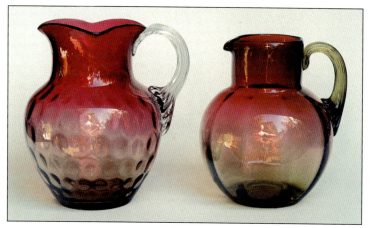

Plate 298. Example of pitcher comparison: Left: Shoulder shaped 7"h., spot optic pattern. Ruby cased with dark amber, and crystal ribbed handle; Right: Phœnix, 6.75" h. ball shaped, round neck, amber ribbed handle, with ruby encased in dark amber in a panel optic pattern. At first glance, these two ruby die-away to dark amber pitchers appear to be made of the same glass. However, the square top jug has amber cased over ruby, but the ruby in the round neck jug is encased within dark amber. This comparison does not provide confirmation that Phœnix made the ruby/crystal pitcher, though that might be the case. (Left: H=16, $_{ruby}F_1$=white. Right: H=20, $_{amber}F_1$=0) Each $75-$125.

Plate 299. Pitchers, "Duncan" shaped, spot optic pattern. Left: Pitcher, 6.5" h. with ribbed handle, flared foot, with ruby die-away encased in dark amber glass. Right: Duncan, 6.25" h. with ribbed handle, ruby die-way to canary. The ruby glass of the Phœnix jug that is exposed at the rim fluoresces a bright white. Note that the handle attachment for the example on the left continues onto the neck, while it stops at the lip on the example from Duncan. The ruby/dark amber is a color combination that Duncan is not known to have used. Other colors/combinations are needed to establish a Phœnix origin. (H=16, F=0). $175-$250.

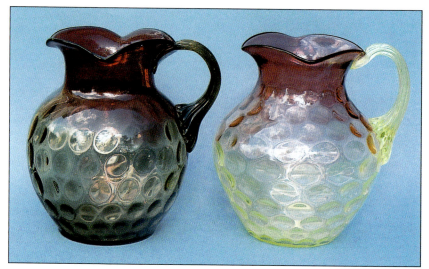

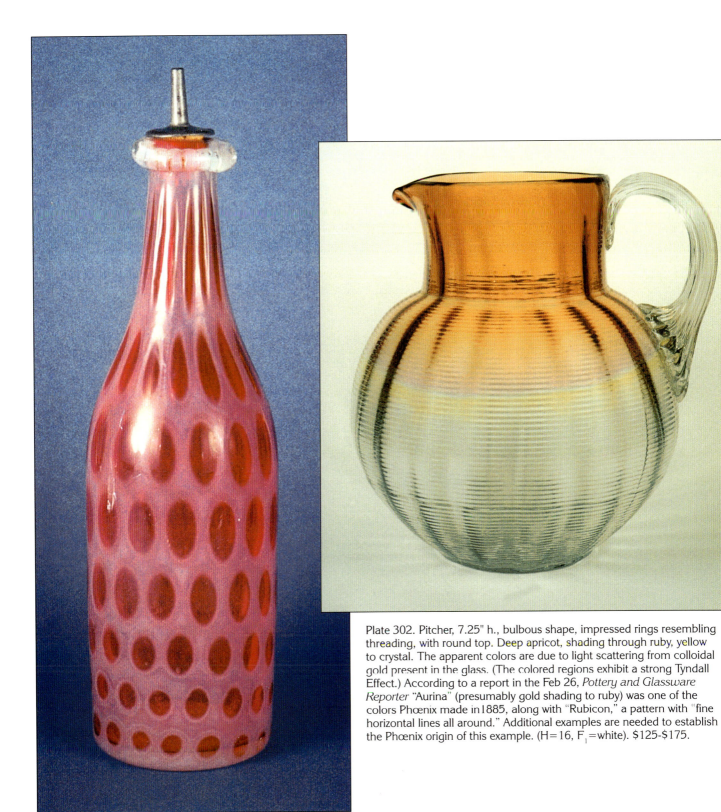

Plate 302. Pitcher, 7.25" h., bulbous shape, impressed rings resembling threading, with round top. Deep apricot, shading through ruby, yellow to crystal. The apparent colors are due to light scattering from colloidal gold present in the glass. (The colored regions exhibit a strong Tyndall Effect.) According to a report in the Feb 26, *Pottery and Glassware Reporter* "Aurina" (presumably gold shading to ruby) was one of the colors Phœnix made in 1885, along with "Rubicon," a pattern with "fine horizontal lines all around." Additional examples are needed to establish the Phœnix origin of this example. (H=16, F_1=white). $125-$175.

Plate 301. Barber bottle, 9" h. with top. Ruby cased with opal sensitive crystal, with windows optic pattern. The shape is atypical for barber bottles from Hobbs Glass. Another color combination is needed to confirm the Phœnix origin of this bottle. $175-$250.

The Competition

Changes in fashion during the late 1800s were scarcely any slower than they are today. If a pattern, color, or effect sold well, the entire glass community soon heard of it. In more than one instance, a success was either copied or simulated within the same season. Some firms, like New England Glass found this out a little too late in the case of Amberina and became mired with manufactured goods that would not sell. Few firms seemed to be free of interference from Phœnix, for Webb was capable of making virtually any glass that could be made by a domestic firm. The net effect is that there are many examples of glass from different firms that turn out to be quite similar. We thought it would be helpful to present some of the products that could be confused with those made by Phœnix Glass. Where possible, we give documentation for the origin and/or year of sale.

The "Pomona" glass made by the New England Glass Co. was, at first, produced by the needle etch process. The decoration of this ware was very expensive, owing to the labor involved in preparing the ware for etching. The firm then went to a plain etch surface, in an effort to reduce the cost. Webb used the same etching process then amber stained the rims, just as New England. The result is a product that is difficult to distinguish from Locke's less expensive version of Pomona. The footed toothpick shown by Bredehoft (BDFT-T, p. 164) is one example of a Pomona copy.[1] As a rule, examples of Pomona and Amberina can be easily distinguished from Phœnix copies, for their shapes are fully recorded in Locke's sketchbook.[2]

Some care must be exercised for the incorporation of pitchers with crimped tops and "duckbill" spouts into the Phœnix database. Harrach (in Bohemia at the time, now the Czech Republic) made very similar shaped pitchers. We are indebted to Brian Severn for showing us images of two objects in the Harrach Museum of retained products that illustrate this problem. The first was a pitcher in pin-stripe canework effect with the same relative dimensions and crimped top as those in Chapter 2.[3] The second was a vase with the same optic pattern as the pitcher in Plate 303. The difference between the pitchers made by Phœnix and Harrach is subtle, but significant. There is a sharp, right angle transition where the sidewall meets the base for the example from Harrach. Phœnix pitchers with this shape have rounded edges at the bottom, though the foot is considerably thickened. Another difference is that the ruffled rim is gilt. The rim of American products was rarely decorated with gold. The vase in Plate 304 has a crimped top similar to those shown in Chapter 5, but fewer crimped sections. Up to this point,

the major difference between European imports and ware made by Phœnix is in the colors and effects, rather than the molds.

A similar problem exists with pitchers having triangular neck shapes and handles that rise well above the rim of the jug. Harrach made several versions of this type of pitcher, all in color combinations quite different from those made by Phœnix. We have recorded a decorated, marked example with extended ruby handle on ivory body with ruby interior. In addition, we have recorded an unmarked example with extended handle, ruby die-away color, and heavy gold decoration. This and other examples suggest that the loop handle, triangular neck jug shape was made in England as well as in Europe. Clearly, a lot of copying was going on, but there are two ways to distinguish Phœnix products.[4] First, the loop of the handle rises vertically from the neck for Phœnix products, but at an angle for imported products. Second, Phœnix colors and effects as shown in this book are quite different from those used by other firms.

One of the interesting aspects of the Phœnix hexagonal crimp is that it is very similar to the one used by the LaBelle Glass Company at exactly the same time. The LaBelle water pitcher, Plate 305, is illustrated in the fall 1887 Pitkin and Brooks wholesale trade catalog as No. 0835 (crystal and blue opalescent spot) and No. 0910 (spot optic in crystal and blue colors.) At this time, Pitkin and Brooks used original manufacturer's names and/or numbers in their catalog listings. For all of the examples we have examined, both LaBelle and Phœnix pitchers were transferred to a punty in the process of fabrication. The glass left behind by this transfer was ground out, and the scar was polished. It is fortunate that the LaBelle products may be easily distinguished from those of Phœnix by two characteristics. First, the position of the handle of the LaBelle pitcher sits lower with respect to the top of the jug. Second, the spout shape within the crimp pattern is slightly different. The LaBelle hexagon crimp was later incorporated into Northwood's pattern #205 that was first made at Martins Ferry in 1888.[5] An example is shown in Plate 306. Northwood pitchers may be distinguished from similar shaped pitchers made at LaBelle and Phœnix by the lack of a pontil scar and the addition of a resting ledge to the bottom of the jug.

For most collectors, mottled patterns present an unattractive appearance. We are not aware of any serious effort to characterize the patterns that are prevalent today. Phœnix patterns stand out, as the firm used rather large flakes, and they were often pulled or worked into the surface in the course of manufacture. The flakes used

by Northwood Glass were quite different in color, and on average they were smaller in size. In addition, the flakes in Northwood examples of the type in Plate 307 were evenly distorted upon expansion of the gather into the shape mold. Northwood did not make extensive use of mottled patterns, for they seem confined to the Royal Ivy, Leaf Umbrella, and Ribbed Pillar molds. European examples of mottled products often used small flakes, most often in three or more colors. As an additional means of recognition, the pontil scars of mottled examples from Europe were rarely ground out, and almost never polished.

The ribbed panel optic mold was made by firms other than Phœnix. Hobbs Glass made new molds for a table set and half gallon jug and added them to Line 346 in 1891. These new molds had a pronounced rib between the panels, and were used to make objects in crystal and ruby colored glass. The decorated water pitcher in Plate 316 has been wheel cut, and the rough cutting filled in with fired gold. The major distinction of Hobbs ribbed panel is that the ribs are widely separated.

The opalescent swirl optic pattern was made by several American firms, but we can not recall any made by European manufacturers. Each domestic firm seems to have incorporated some characteristic in their ware that differentiates their product from all others. Products with swirl optic patterns made by Nickel Plate Glass Company are most likely to be confused with those from Phœnix. The U.S. Glass catalog illustration, reproduced by Heacock[6] shows the tableware made by Nickel Plate prior to the merger. The No. 90 half-gallon pitcher looks very much like the Phœnix pitcher shown in Plate 53, except that there is no pronounced foot. One observation we have made is that the handles applied by Nickel Plate were made of unusual tinted glasses, as is shown here in Plate 319. Objects made in the opalescent swirl optic by Hobbs Glass are readily identified by original catalog illustrations, many of which are reproduced by Bredehoft.[7]

The spangle effect produced by embedding mica between layers of glass was utilized by just two domestic firms, Hobbs Brockunier and Phœnix. On the other hand, glassware from Europe with spangle effects was imported in enormous quantities from 1892 up to WWI. How can one distinguish these products? We use two attributes. One is the size of the mica that is incorporated into the glass. Large flakes were in the mica that was used by Hobbs from 1883 to 84. An example from Hobbs is shown in Plate 314. This glass is easy to identify, for relatively thick layers of glass were used to incorporate the mica. Hobbs glass was cased with crystal and "Indian," an amber glass that does not fluoresce when exposed to short-wave ultraviolet light. Flakes used by European firms for ware exported to this country after 1894 were slightly smaller, and had a narrower size distribution. The example from Bohemia shown in Plate 314 contains mica with an average particle size of about 0.12", still about twice the size of the mica used at Phœnix. Examples with flakes that exceed 0.12" in size, layered with pink, blue, or yellow glass almost certainly came from Europe. The second attribute is the color of the glass in which the mica is embedded. Even though the mica in the pattern of the pitcher illustrated in Plate 317 is small, the color of the glass cased on the interior opal layer is atypical of those used at Phœnix.

End Notes

1. The toothpick shape in Plate 246 in "Pomona" effect is shown in Bredehoft, T. and Bredehoft, N. *Hobbs Brockunier & Co. Glass* (Paducah: Collector Books, 1997) 164.

2. Locke's sketchbook is reproduced in *Amberina* (Toledo: Antique & Historic Glass Foundation, 1970) 6-10.

3. The colors and patterns used by Harrach are, in general, atypical of those used at Phœnix. The example of the pitcher in the museum is an unusual light mauve with a dark mauve pin stripe.

4. The Czech glass industry during this period is well known to have copied American patterns. See Villanueva-Collado, A., "Bohemian Response" in the *Glass Collector's Digest* (13: 2 Marietta: Richardson Pntg., 1999) 3.

5. Northwood kept Line 205 in production for many years.

6. Heacock, W., Gamble, W., *Encyclopedia of Victorian Colored Pattern Glass - 9* (Marietta: Antique Pub., 1987) 25.

7. Bredehoft 106-107.

Plate 303. Pitcher, 8.5" h., "Phœnix" shape, crimped top, "duckbill" spout, and ribbed handle. Gold die-away to crystal, with encased ruby glass floral pattern. Crimped top is trimmed with gold, something that is atypical of Phœnix manufacture. The shape of the crimp is identical to that used by Phœnix. The diameter of this jug is 3 mm less than pitchers made by Phœnix, and the edge where the foot meets the sidewall is sharp, while those made by Phœnix are rounded. Note also that the glass lacks the Phœnix fluorescence characteristic. The museum at Harrach has two pieces with the same colors and encased ruby glass design in their collection of retained products. (H=20, C=20, F_1=0). $1000-$1500.

Plate 304. Vase, 6.5" with crimped top. Gold die-away to crystal with encased ruby floral pattern. The top of this example has two lobes, instead of three. Here also, the crimp pattern is identical to the one used by Phœnix. This is another example from Harrach. (C=18, F_1=0). $175-$250.

Plate 305. Left: Pitcher, 8.5" h., with hexagon shaped crimp made at LaBelle Glass Company. Blue cased with opal sensitive glass with opal spot optic pattern, factory #0835. Right: Detail of the top crimp showing the similar shape to the one used by Phœnix, but a comparison with Plate 32 shows that there is a notch above the point where the handle is placed. This pitcher was also made in amber, blue, crystal opalescent, and blue opalescent. The short-wave ultraviolet fluorescence of this example is exceptionally weak compared to the example from Phœnix. $75-$125.

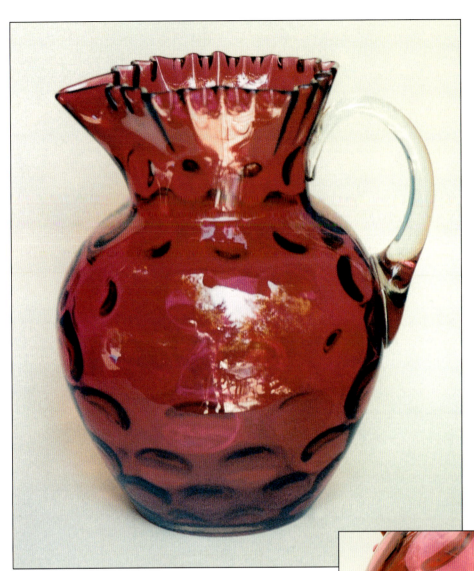

Plate 306. Left: Pitcher, 8.5" h., LaBelle shape with hexagon crimped top made at Northwood Glass (Martins Ferry), Ruby cased with crystal. Right. Detail of the base of the pitcher, shows the resting ledge and the absence of a pontil scar. This pitcher shape is illustrated as #205 in the ca.1889-1890 Irwin and Eaton wholesale catalog. Offered in amber, blue, blue opalescent, crystal opalescent, canary opalescent, and rose opalescent colors. Six sets with glass trays per barrel for $6.11. $75-$125.

Plate 307B. Illustration of the water set in the pink marbelescent finish from the Montgomery Ward & Co. fall 1890 catalog. The pitcher is made in the Northwood Glass "Pleat" pattern, but the tumblers are made in a different vertical rib pattern. *Courtesy University of Wyoming American Heritage Library.*

45376 Water or Lemonade Sets, satin finished, pink marbelescent, a new and beautiful color in glass. 1½-gal. jug, 6 tumblers and 1 13 in., hammered brass tray. Price.................. **$1 75**

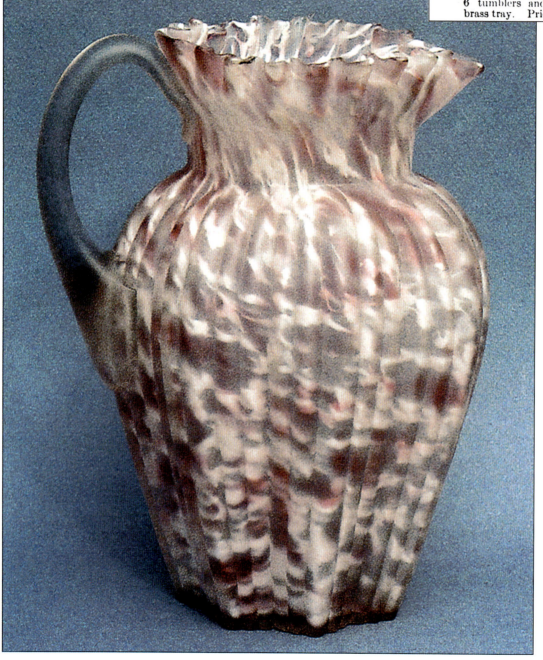

Plate 307A. Pitcher, 8" h., Northwood vertical rib mold pattern (Ribbed Pillar), with ruby and opal flakes in a mottled effect. Note the small size of the flakes, and their even essentially undistorted appearance. A water set that includes this pitcher is illustrated in the fall, 1890 Montgomery Ward and Co. catalog. $125-$175.

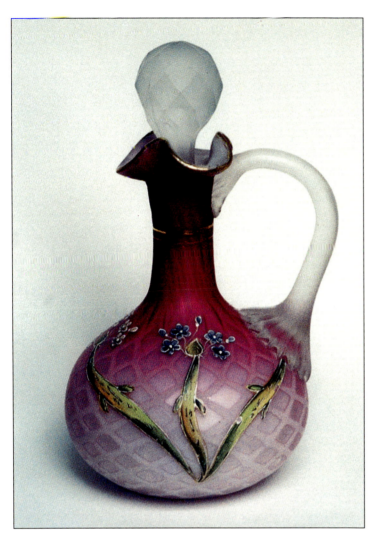

Plate 308. Cruet, 5.25" h., squat shape with rib handle and tri-foil top. Satin finish, floral decoration, ruby die-away to crystal over opal glass with diamond optic pattern. The top edge is gilt, and there are two gold bands on the neck. The shape of this example is almost identical to the cruets in Plates 253 and 256. The gilding, and the lack of fluorescence upon exposure to short-wave ultraviolet light, shows this is an imported example. $350-$500.

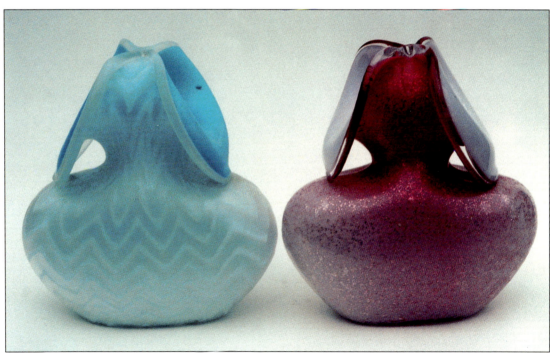

Plate 309. Lobed top vases, 5.5" h. Left: Satin finish, blue die-away to crystal over opal glass with zig-zag optic effect. Right: Ruby die-away to crystal over opal glass with encased mica. Note the similarity in the size distribution of the mica that was used by Phœnix (Plates 290-293). This shape was made at Stevens and Williams, England. Left $350-$500. Right $175-$250.

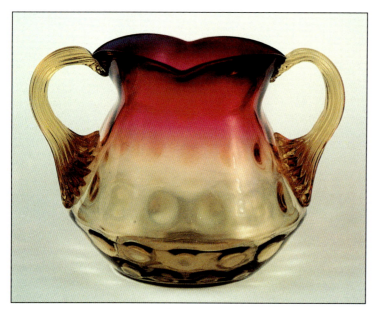

Plate 310. Sugar bowl, 4" h., squat shape with ribbed handles and square top. Ruby developed in heat sensitive glass containing colloidal gold. This example of Amberina exhibits the banded appearance that is typical of examples from New England Glass. The transition from ruby to clear is diffuse, but sharper than many die-away transitions where the color changes continuously from top to bottom. The shape is New England Glass # 105, as illustrated in the reprint of Locke's sketchbook. Both the New England pitcher and sugar bowl are misidentified in OIG, p. 65, #172 and #173. ($F_1 = 0$). $250-$350.

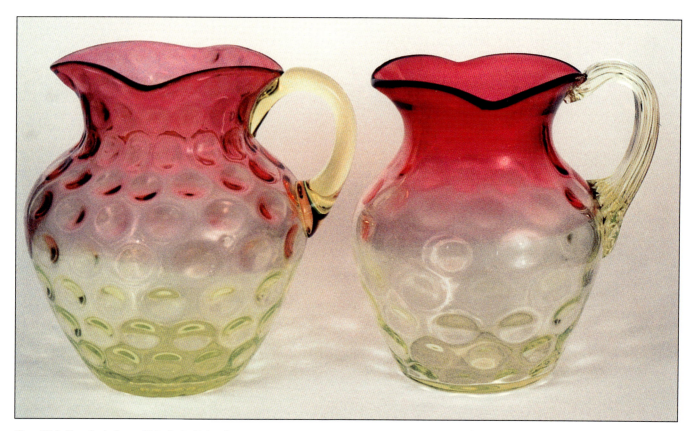

Plate 311. Small pitchers, 5" h. Left: Ruby die-away to canary in spot optic pattern made by Hobbs Brockunier & Co. The origin of these pieces is easily traced through factory catalogs. The Duncan #47 polka dot pitcher is illustrated in KRS, p.54. There are several characteristics that permit attribution. First, the spot optic continues to the top of the Hobbs pitcher, but stops at the neck for the Duncan. Second, the top of the handle is pinched to the rim of the Duncan example, but continues down the neck for examples from both Hobbs and Phœnix. Third, the rib handle was invariably used for Duncan and Phœnix pitchers, but not for those made by Hobbs. Last, Both Duncan and Hobbs used ruby die-away to canary, but Phœnix internally cased their ruby die-away to canary with a thin layer of opalescent glass. Duncan examples misidentified as Hobbs Brockunier are illustrated in OIG, p. 66, # 184-185. Right: Ruby die-away to canary in spot optic pattern made by G. Duncan and Sons. Left $125-$175. Right $175-$250.

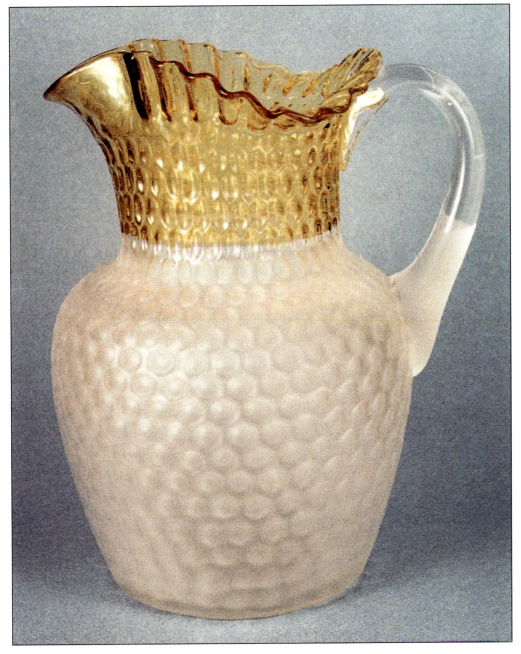

Plate 312A. Pitcher, 8.5" h., shoulder shape with crimped, amber stained top and etched crystal base. Made in the small spot optic pattern. By 1892, Hobbs Glass had been absorbed by the U.S. Glass combine and was known as Factory H. (F_1=>0, F_2=weak green). $175-$250.

Plate 312B. Illustration of the "opalescent" water set in the small windows optic pattern from the Butler Bros. "Santa Claus" 1892 catalog. Evidently, the "Frances" decoration was used in addition to the crystal, sapphire, old gold, and opalescent colors with ruby, crystal, and blue backgrounds that are mentioned in the catalog description.

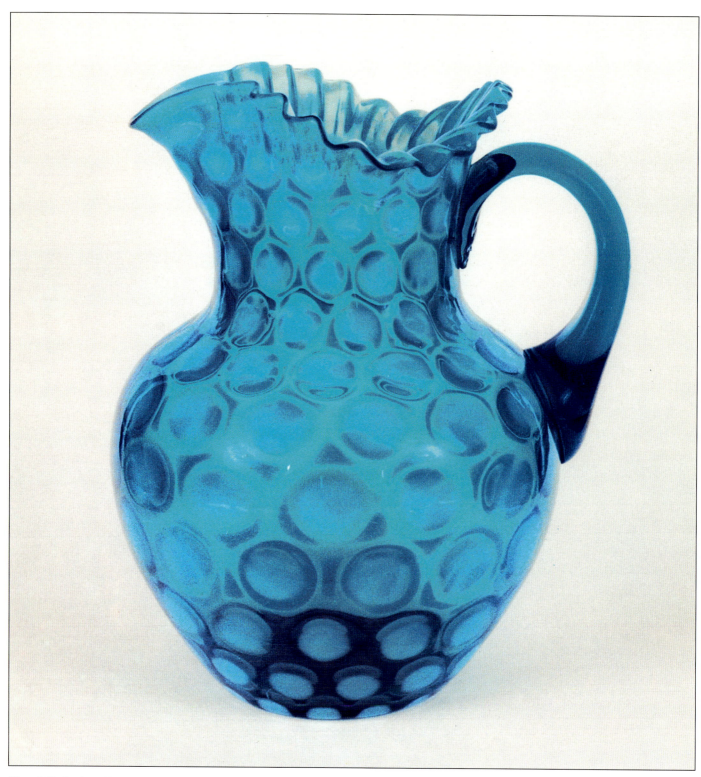

Plate 313. Pitcher, 9" h., shoulder shape with crimped top. Blue cased in opal sensitive glass with spot optic pattern. This product line was produced about the time of the merger of Hobbs into U.S. Glass, as it appears in a Falker and Stern 1893 catalog. The shape was also made in the "Coral" optic pattern now referred to as "Seaweed." The crimps in examples with these optic patterns are now made the same way as Phœnix. (F_1=›0). $250-$350.

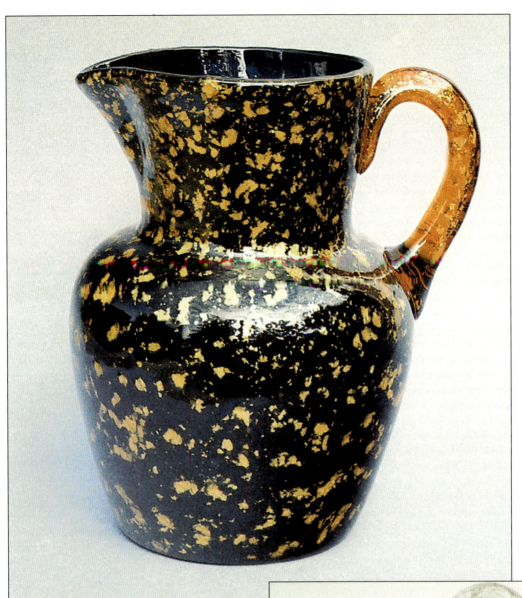

Plate 314. Examples of mica encased products from competitive firms. Left: Pitcher, 7" h., Hobbs Brockunier (1883), embedded mica on deep blue cased with amber. Note that the size distribution of the mica is very large. $(_{amber}F_1=0)$ Right: Basket, Bohemian origin with mica embedded between opal and amber glass. The size distribution of the mica used here is small, but the mean particle size are still larger than those used for novelties made by Phœnix. This basket is illustrated in the imported glass section of Butler Brothers 1892 Santa Claus catalog, where it was offered in blue, rose, or yellow with snowflake effect. $(_{opal}F_1=white)$.

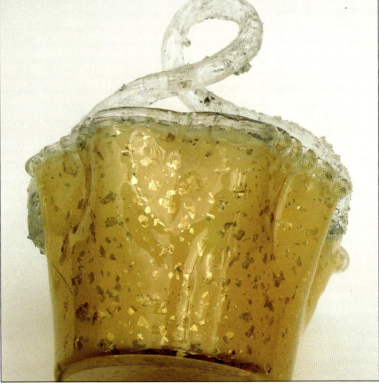

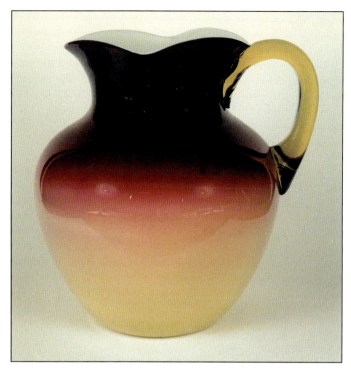

Plate 315. Pitcher, 7" h., shoulder shape with square top. Ruby developed in colloidal gold (heat sensitive) glass cased over opal. This ware was called "Coral" by Hobbs Brockinier, and was first sold in 1886. Overall, this ware has a banded appearance, even though the actual color transition is diffuse. Competing products made by Phœnix in the drape optic pattern show the same banding, though it is much more irregular, and there is a sharper boundary between colors. $1500-$2000.

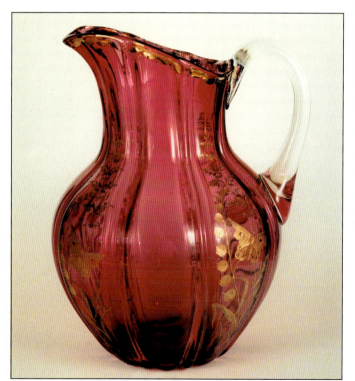

Plate 316. Pitcher, 9" h., shoulder shape in ribbed panel mold, ruby cased over crystal. The decoration of this example of #346 from Hobbs Glass is engraved, and the engraving is filled with gold. Though difficult to see, there is a butterfly engraved on each panel. The panels are larger, compared to the ribs, for this ware than for the objects made by Phœnix. Other examples of Hobbs #346 are shown in BDFT-T, p.127. $250-$350.

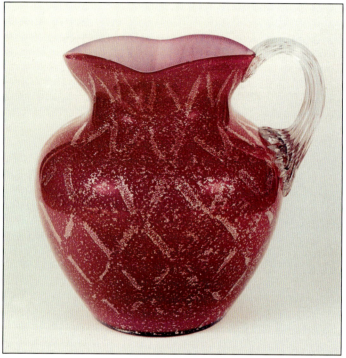

Plate 317. Pitcher, 6.5" h., ribbed handle with square top. Amethyst with entrapped mica in a criss-cross design, cased with crystal. The shape of this pitcher is very similar to Hobbs Brockunier #319 used for "Coral," and similar to the Phœnix shape shown in Plates 178 and 179. This pitcher was made in several colors, including an orange, and all appear to be different from the colors used by Phœnix. Other examples with this color/effect exhibit cut, gilt rims typical of European products. (H=16, F_1=white). $250-$350.

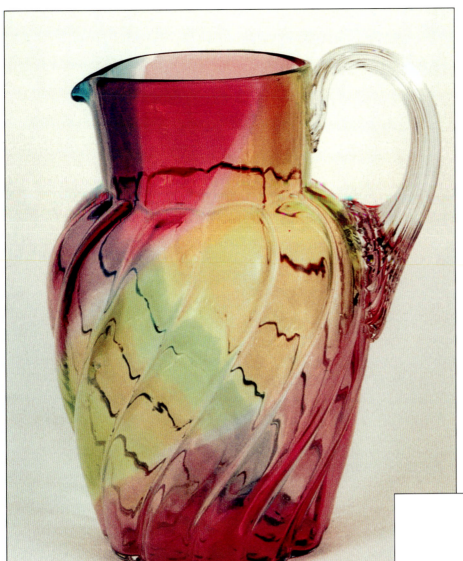

Plate 318A. Pitcher, 6.5" h., large spiral rib mold pattern, round neck and top. Ruby, blue, and yellow swirl (reversed) cane work colors in crystal. Note the intense colors in this example. This pitcher is described as coming from Bohemia in the accompanying catalog illustration. Many different colors/effects were used for this shape that are atypical of those made by Phœnix. $250-$350.

Purperina.

5380 Purperina Water Set; imported glass. The upper part of the pitcher is a dark ruby color, shaded to a beautiful amber towards the bottom. Sets consists of one ½-gallon pitcher, six tumblers to match, and 13-inch hammered brass tray. Per set..........$2 00

Plate 318B. Illustration of the "Purperina" water set from the winter 1891 spring 1892 Montgomery Ward & Co. catalog. *Courtesy of University of Wyoming American Heritage Library*.

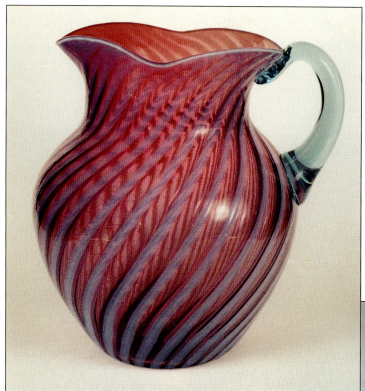

Plate 319. Pitcher, shoulder shaped with square top. Ruby cased in opal sensitive glass with opal spiral optic effect. Note that the color of the glass in the handle of this example is light blue. The pontil scar has not been ground out and polished. This example was made in 1891 by the Nickel-Plate Glass Co., and is illustrated as No. 89 half-gallon pitcher in their factory catalog. $750-$1000.

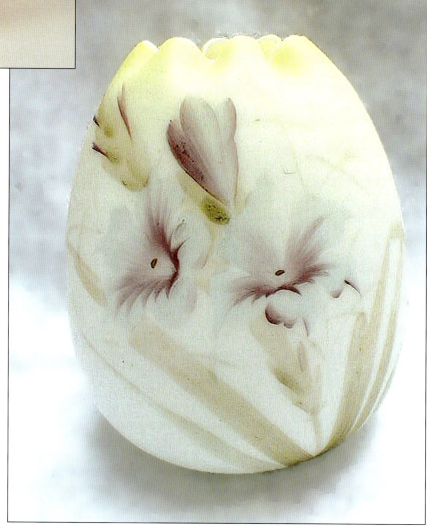

Plate 320. Rose bowl, 8" h., Phœnix pouch shape. Yellow die-away with floral decor attributed to Mt. Washington Glass on the basis of the decoration that is similar (but not identical) to that used on a "lusterless" pouch shape from this firm. The Mt. Washington example is shown in BIL, Fig. 124, p. 47. Other examples are needed to confirm that the object shown here came from Mt. Washington, in view of the lack of evidence for colored glass manufacture at this firm.

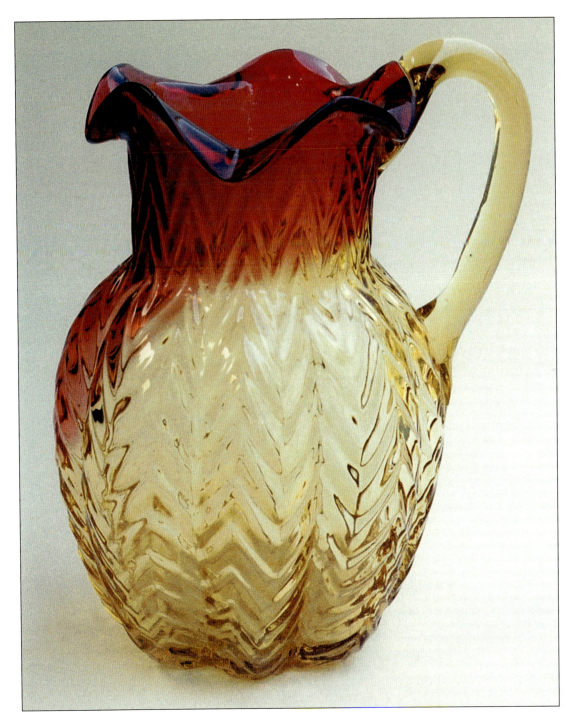

Plate 321A. Pitcher, 6.5" h., even lobe shape with wide round neck and "strap" handle. Ruby die-away to amber with zig zag optic pattern. This pitcher is listed as #31282 in the fall 1889 Montgomery and Ward catalog. Described as a Bohemian Glass "laced" water set, it was sold in ruby amber with a 13" tray and 6 tumblers for $1.30.

Plate 321B. Illustration of the Bohemian Glass "Laced" water set in the fall 1889 Montgomery Ward and Co. catalog. *Courtesy of the University of Wyoming American Heritage Library.*

31282 Bohemian Glass 'Laced' Water Set, 1 pitcher and 6 tumblers on a 13-inch embossed pearl metal tray, in ruby amber only.

Per set, complete $1 30
Per dozen sets 17 16

Glossary

Phœnix Glass produced so many different types of colors and effects that collectors may not be familiar with them all. Some of the terms used in the trade literature at the time have since been given new names, for lack of recognition of the originals. In addition, some of the effects are different from those of the same name used by contemporary glass making firms. So that there is no ambiguity, we list and describe the terms that are used in subsequent chapters, and especially in the captions. Some of the definitions may seem to be rather comprehensive, but it is this attention to detail that facilitates the identification of art glass products.

Air-trap. A two layer, cased glass containing air pockets entrapped in a predetermined, generally regular fashion.

Amberine. A die-away color combination of ruby and amber glasses cased over opal made by Phœnix at the end of 1884. Later, a reference to ruby die-away to amber glass.

Amberina. A colorless, heat sensitive glass containing a large amount of colloidal gold that was created by Joseph Locke while he was at the New England Glass Company. The apparent straw yellow color of this sol is due to the strong scattering of light in the near ultraviolet region of the spectrum. When a piece of finished glassware is heated to or above the annealing temperature, the colloidal gold particles grow through aggregation. The apparent orange, ruby, and violet colors stem from the increasing amounts of scattered blue and green light passing through sections of glass where the size distribution of gold has increased. Prolonged heating causes the apparent color to disappear and the glass to become slightly turbid.

Aurora. A name New England Glass Co. originally used for opal glass cased with heat sensitive, colloidal gold glass. Now often described as "Plated Amberina." The thermal coefficients of expansion of the two glasses in Aurora were mismatched, and most of the objects made at New England with this combination have or will likely self-destruct. The process for making Aurora was actually patented by F. Shirley at the Mt. Washington Glass Company, but there is no record that a product similar to Aurora was made there.

Azurine. A combination of blue and ruby glass made by Phœnix at the end of 1884. Today this combination is often called "blurina."

Bronze. A color combination of bronze shading to steel gray made by Phœnix in 1886.

Burmese. An opaque to translucent, heat sensitive glass containing a high content of colloidal gold, and low levels of uranium to provide a yellow base color. Sections of this glass when heated to or above the annealing temperature will turn pink.

Cameo. A cased glass that has part of the exterior layer mechanically cut or chemically etched away in a pattern.

Canary. A yellow, transparent glass, containing uranium that is added to the batch mix as one or more oxides. The uranium in glass made up to 1940 generally contained the fissile isotope U^{235}.

Canework. A color effect produced by the incorporation of colored rods into the initial gather of glass. When blown to shape, the rods expand into colored bands.

Carnelian. A color combination of orange and crystal cased over opal glass, resembling natural carnelian, made by Phœnix at the end of 1884.

Citron. A yellowed, green colored glass made by Phœnix after 1883. Some, but not all types, contain uranium.

Coral. A trade name for the opal cased with heat sensitive, colloidal gold glass made by Hobbs Brockunier from 1886-1887. Now often described as "Wheeling Peachblow." Coral is not nearly as internally stressed as Aurora.

Coraline. A mold pattern that should resemble a natural coral. Phœnix used this name for a narrow, vertical rib pattern that was used extensively for domes and shades for lighting products.

Craquelle. The name used by several firms for glass with a cracked effect. Craquelle made by Phœnix has a brecciated surface pattern.

Dewdrop. A name used by Hobbs Brockunier for their glass that at present is generally called "Hobnail."

Die-away. The gradual transition between two colors of glass.

End-of-day. See "Mottled."

Fingerbowl. A low profile bowl with a rim that rises upright or away from the center of a bowl made for use at the table. Often made in two sizes, a large measuring 4"-5" diameter, and a small measuring about 2" diameter.

Gadget. English term for the snap, or tool that holds a piece of glass to affect a transfer from the blowpipe.

Glass. A liquid that will supercool without crystallization, often becoming rigid. The physical properties of glass more closely resemble those for a liquid rather than a solid. The apparent "color" of glass is the complement to the dominant wavelength of the radiation absorbed by the glass when illuminated with "white" light. For example, a glass that absorbs blue light in the 300-450 nm region of the visible spectrum will appear to be yellow.

Honeycomb. A term used to denote the optic pattern that results from the close packed arrangement of circles. Different from windows in that the framework is just a small portion of the overall pattern, and the openings are shaped more like hexagons than circles.

Inverted Thumb Print. A term frequently used for the spot optic pattern.

Impasto Cameo. A term used by Phœnix for hand painted, white enamel designs on colored (satin) backgrounds.

Knob. A name used by Phœnix for a mold pattern that today is generally called "Hobnail."

Lear. A horizontal oven, where one end is maintained at the annealing temperature of the glass being made, and the other end at room temperature. Objects are mechanically conveyed through the oven to remove the residual stress from the manufacturing process.

Mother of Pearl. See "Pearl Satin."

Mottled. A term used by the trade to describe the effect produced when colored flakes are fused to the surface of a gather before expansion into the shape mold. At present, this effect is often called "spatter," "splatter," or "end-of-day."

Overshot. A term used to describe the effect produced by evenly coating a newly shaped object with pounded glass, and reheating to firmly affix the adhering particles.

Peachblow. This term was originally used to describe any glass that faintly resembled the color of the famous "Morgan" vase. The effect was achieved in different ways by glass making firms. New England Glass and Mt. Washington Glass made it by preparing a high content gold colloid in a translucent to opaque glass, and re-heating part to develop an apparent red color. Hobbs Brockunier made peachblow by casing opal glass with heat sensitive, colloidal gold glass, and re-heating part to develop the red color. Thomas W. Webb (England), Stevens & Williams (England), and Phœnix made peachblow by casing opal glass with a die-away combination of ruby and amber or peach colored glasses. In general, the die-away process gives a much smoother transition of colors and a better clarity, but there are no violet, purple, or "chocolate" highlights.

Pearl Satin. A name originally used by glass manufacturers for air-trap ware where the surface is chemically etched to produce a pearly, satin effect. Webb Boulton obtained a patent in England (1885) that describes a solution etching process to make pearl ware.

Peloton. The effect created by the application of short, colored strings of glass to an object that has just been mold blown. The effect was first used on European glass about 1880, and was popular for just a few years.

Phœnix Drape. The name used in this work to denote an optic pattern that resembles a curtain, where the sags join in vertical segments. This pattern was made in many colors, including die-away cased ruby/amber over opal that is often described today as "Wheeling Drape."

Place. A plate made to fit under a finger bowl or berry bowl.

Plated Amberina. See "Aurora."

Pontil. A scar of residual glass left on a finished object after it is detached from the punty iron.

Punty iron. A tool used to hold the partially shaped glass upon transfer from the blowpipe.

Rose Amber. A name Mt. Washington Glass used for the heat sensitive, colloidal gold glass that was essentially identical to Locke's Amberina. Mt. Washington was enjoined from producing Rose Amber until late 1886 when the patent dispute with New England Glass was resolved.

Rose Bowl. Any small, usually round bowl that curves inward at the top.

Rose du Barry. A name used for a color (unknown) that was made by Phœnix in 1886 and H. Northwood in 1888. The Burmese made by Phœnix, while similar in color to the Rose du Barry thought to be made by Stevens and Williams, is not Phœnix's Rose du Barry, for none was made in the required diamond optic pattern.

Rubicon. A color or effect pattern made by Phœnix in the first part of 1885 with "rings all around." There is a possibility this refers instead to a "*moire*" air-trap pattern.

Rubina. A common name for a glass with ruby die-away color. Also spelled rubena.

Ruby. The apparent color of a colloidal gold glass that develops when it is heated to an annealing temperature. Once developed by repeated trips through an annealing lear, the apparent color is stable.

Ruby/amber. The die-away combination of ruby and amber glass made to simulate Amberina.

Snap. The tool used to hold the partially shaped glass prior to its removal from the blowpipe.

Sol. A suspension of a solid in a liquid.

Spangle. A visual effect produced by coating a gather with mica flakes, then casing with crystal (silver spangle) or amber (gold spangle) glass and blowing to shape.

Spatter. See "Mottled."

Threaded. A term used for the appearance of a glass surface on which a glass thread is wound in an even spaced, spiral fashion in the course of manufacture. Used extensively by Phœnix to make novelties in the "Venetian" or "*Verre Moire*" effect, where the threads were later pulled together to make a pattern resembling a curtain.

Topazine. A color combination of ruby die-away to crystal cased over opal glass that was made by Phœnix at the end of 1884.

Venetian. A name used by the trade to denote several types of color effects. The Venetian made by Phœnix was an opal glass threaded on a colored ground, then pulled into a curtain pattern. About 1888-1890, Venetian was the name used by the trade for any swirled, opalescent optic pattern.

Verde Pearl. A term used for the satin finish, air-trap product line made by Phœnix during 1887-1888.

Verre Moire. The effect produced by the application of opal threads on a colored ground, then pulling the surface of the glass toward the blowpipe to create a drape or curtain pattern.

Wheeling Drape. See "Phœnix Drape."

Wheeling Peachblow. See "Coral."

Windows. A framework pattern produced by the arrangement of circles with a substantial framework between them. This pattern is distinguished from the Honeycomb pattern, in that the openings are circles instead of hexagons.

Zig-Zag. A trade name for a pattern of parallel lines that alternately tilt up and down from the horizontal in short segments. A common optic effect that Phœnix used for air-trap ware, and is commonly called "Herringbone."

Appendix 1
Trade Journal Excerpts

In this section, we have recorded various products and events at Phœnix Glass, by paraphrasing and quoting directly from articles written in contemporary trade journals. We are indebted to Thomas Bredehoft for retrieving this information from issues of the *Pottery and Glass Reporter* (PGR), and the *Crockery and Glass Journal* (CGJ) at the Corning Museum of Glass in New York.

1880

April 15 PGR: Charter was secured for the Phœnix Glass Company, with Andrew Howard as the "capitalist" and other practical men. Construction commenced at the Phillipsburg, Beaver County PA site.

July 29, PGR: "Fischer and Thomas, the foundrymen, shipped a patent teaser (furnace) to the Phœnix Glass Company at Phillipsburg, PA last week."

Aug. 12 CGJ: The Phœnix Glass company started operation with one 11 pot furnace.

Dec. 2 CGJ: "The Phœnix glass works of Phillipsburg, Beaver County, have shut down for four weeks. On hundred and sixty men and boys are out of employment."

1881

Mar. 31 CGJ: Phœnix advertised the manufacture of annealed lamp chimneys and reflectors.

Sept. 1 PGR: Phœnix assumed the chimney business of Dithridge Chimney Company.

1882

May 4 PGR: Phœnix advertisement – all styles and sizes of opal and flint globes and shades.

Oct. 5 PGR: "Phœnix Glass Co. are adding a new 12-pot Teaser furnace to their works at Phillipsburg."

Dec. 7 PGR: "The Phœnix Glass Company have completed their new furnace, and will commence making glass with it on next Monday. They also have a new building nearly ready for cutting and decorating purposes."

1883

July 19, PGR: "The Phœnix Glass company find trade somewhat improved and things look better generally. They will be ready to start up on August 1. They have now ready berry and ice cream sets of the hobnail and rosette diamond pattern, toilet sets, spoon holders, jelly dishes, and stem ware from goblet to cordial."

Oct. 11 PGR: "Phœnix Glass Company have out a splendid array of finger bowls, with or without places, in plain and crackled glass of every shade and color, blue, green, amber, canary, lemon, citron, & etc. Phœnix has secured the services of Joseph Webb, of Stourbridge, England, and he is now superintending the manufacture of these goods."

Nov. 29 CGJ: "The Phœnix Glass Company will make no tableware in future, having disposed of their molds, but will confine themselves to chimneys-principally engraved-decorated shades, globes, and other specialties in colored, crackled, and fancy glass which were specified in these columns a short time ago."

1884

Jan. 17 CGJ: "The Phœnix Glass Co. laid off ten chimney shops last week, but they are running steadily with the factory, including the decorating department, working up to its full capacity. They are still busy on colored glass and are making a big success of it."

Feb. 21 CGJ: Fire on January 29 destroyed Phillipsburg factory.

Feb. 21 CGJ: "They (Phœnix Glass) will operate the Doyle works near the site of their burned factory. These works are new, commodious and in excellent order, having been run only for a short time since they were built. The former proprietors expended nearly all their capital in erecting the factory, and the combined depression of the chimney business, which the place was built for, compelled them to draw out."

Feb. 28 CGJ: "The Phœnix Glass Co. have resumed work at the Doyle factory, Philipsburg, and will be ready to meet all orders in a very short time."

April 17 CGJ: "The Phœnix Glass Co. have definitely decided to rebuild on their old site at Phillipsburg, Beaver County, and they have already commenced to clear away the rubbish from the ground. The fire that destroyed their works last winter did not do much damage to the furnaces, which, with a little alteration and repairing will be as good as ever. One of the reasons that induced them to rebuild here is the opening up of new coal deposits which extend clear down to their factory and from which they can obtain fuel at a minimum cost."

May 15 CGJ: "The Phœnix Glass co. have a very active demand for fancy glassware and engraved goods. Their present factory (Doyle) is too small for their requirements, and restricts their operations considerably." "They could sell more colored glass than they are able to turn

out with their present accommodation, and they cannot increase their output of this particular kind of ware without reducing the other lines which the nature of their trade also compels them to keep in stock."

July 10 CGJ: "New works finished in a couple of weeks, Among the latest novelties are several lines of lamps, all complete in colored glass, foot, fount, shade, and chimney. They have them in coraline body, also in blue and polka-dot. They have a new water set in several sizes and many colors..."

Sept. 4 CGJ: "The Phœnix Glass Company, having arranged matters satisfactorily with their hands, started to work with one furnace and are running that on full. The second furnace is ready and would be working only that they expect to have natural gas connections made in a week or two, and did not care to light up with coal and then have to change things again for gas in so short a time... They will be able to supply full lines of their fancy and colored glassware, and production of which was much interrupted and hindered by the destruction of their works last winter. No kaleidoscope ever showed more rich and varied colors than adorn the large table at their show rooms on Water street, this city, and it is safe to say that there is no exhibit of American glass in the country which surpasses this."

Oct. 12 PGR: "The Phœnix Glass Co. are preparing to put natural gas in one of their furnaces and if it is successful to introduce it into both. They are running the two at present and intend to fix things so that the fire will not go out while making the necessary alterations. They are doing a good trade at present in all the lines of goods they manufacture. They had a fine exhibit of fancy and colored glassware at the Beaver County Fair, which was held last week, and it attracted considerable attention. They made the display at the special request of the managers of the fair, who desired to show the degree of perfection local glass manufacture had attained."

Nov. 20 PGR: The Phœnix Glass Co., while not as busy as they were, have still as many orders as they can fill. They are running full time with both furnaces. They have already secured space at the New Orleans Exposition, where they intend to make a fine exhibit of their wares. They have a good location surrounded by aisles on three sides. They have a long table for the appropriate display of their goods and around this will be a gas pipe with burners about a foot apart, upon which will be placed a number of their new glass globes, each a different color from the other. In the passageways about their table they will have the gas pipe raised in steps like stairs, to allow people to pass underneath, and the whole design, as now planned, and being carried into execution is very fine. They expect to have the best show of American fancy glassware at the exposition."

Dec. 25 CGJ: "...this (Phœnix) is the most important concern in the district where it is situated, the pay-roll amounting to nearly $5,000 a week. Mr. Geo. W. Fry has gone to New Orleans to attend to the firm's exhibits at the Exposition there. Their display is superb, and is said to contain colors and combinations of colors not before seen in glassware."

Dec. 25 PGR: "The extensive glass works of the Phœnix Glass Co. are situated at Phillipsburg, on the Pittsburgh & Lake Erie railroad, about 27 miles from Pittsburgh, in which latter place they have their sample rooms and general offices. These works are newly built, having been entirely reconstructed after the great fire which completely destroyed them early last spring. The following are the dimensions of the various buildings: Factory building, 175 by 75 feet; annex, 185 by 65 and 3 stories high; another building, 185 by 25, 2 stories; decorating room 115 by 25 feet, with an addition, 100 by 20 for ovens/ warehouse, 140 by 50 feet; and a cooper shop, 75 by 25 feet with an L, 30 by 30 feet. There is also a small decorating shop apart from the other buildings for certain kinds of fine ware. The factory contains two furnaces, one 11 and the other 12 pot, both heated by natural gas, which fuel is used all over the works, except in the decorating ovens. There are 8 lears with convenient devices for conveying the pans, and 7 glory holes, heated by a perfect arrangement which entirely excludes flames from contact with the glass, while it leaves the interior at a perfectly white heat. The factory is large, commodious and well ventilated, and as cool in summer as it is possible for such a place to be. They have all modern improvements and machinery here, and everything provided for the proper working of the concern. They have their own mold shop and box and barrel factory; in fact everything needed is made on the premises except pots. They have an excellent double pot-arch conveniently located, and 2 large steam elevators for communication between the various floors, also a blacksmith shop and other similar conveniences. They have a long railroad siding in front of the premises, and a platform running the entire length of the buildings. Besides this accommodation, they can also ship by the Ohio river, which is close by on the other side of the works. Their railroad siding is built upon open trestles, through which they dump coal when they used that fuel, and through which they now discharge soda ash, sand and other material by means of chutes into the basement of the mixing rooms. Formerly this firm worked chiefly on chimneys, afterward they commenced on shades, and still later on colored glassware, which is at present their most notable product. They make chimneys yet, however, and the finest lines of decorated shades in the country, but in colored glassware they have achieved a triumph never before consummated in the land. The variety of shapes, shades, and colors in this ware they have on exhibition at their factory is perfectly bewildering, and altogether impossible to describe. They have table sets, pitchers of all sizes and descriptions, ice cream sets, finger bowls, water sets, berry sets, and a host of other miscellaneous wares. The diversity of colors in itself is

not so remarkable as the fine shading of one color into another and the different shades in one and the same article, which shows a different color as one changes its position in relation to the light. Some of the articles have a body of one color and are plated or cased inside with a different color and the effect is very fine. Also on pieces cased outside the colored part is cut away, by machinery in any desired pattern and leaves the crystal to be seen beneath, forming a crystal design on colored ground. Among the colors are carnelian, topazine, amberine, azurine, all shades of opalescent, such as flint, spotted, blue crystal, canary, pink, etc., rose blue green, all shades of red, ruby, amber, blue and gold, and numerous others. They also make kerosene and glass globes and duplex chimneys in all colors and finely engraved, as well as salt and pepper sets, vases, and ornamental glass of every kind. The colors are all brilliant, sparkling and full of life and spirit, if such an expression be permissible, and combinations of shades are here produced that have never before been attempted in this country or Europe. In the cutting shop, which is very large and well equipped, they do a great deal of work on engraved globes, chimneys etc., and also on colored ware as noted above. They show fine engravings of birds, flowers, animals and landscapes, as well as monograms and portraits, and the effect of these fully equals that of steel engravings. The decorating department is apart from the main building herewith which is connected by a bridge. Here they have an immense number of shades of all sizes and descriptions in every process of decoration. We have no space to enumerate even a few of the various designs, but a representation of the exposition building at New Orleans is a very notable and timely piece of ornamentation."

1885

Jan 22 CGJ: "…running factory full time, table, water, sugar/cream, berry sets are artistic in design and resplendent in color. Jugs, tumblers, and finger bowls, gorgeous with every color of the rainbow and many combinations not in the rainbow at all. Their good have begun to attract attention even in England, and they have established a regular agency in London in consequence."

Feb. 5 PGR: [report on the New Orleans Exposition] "The Phœnix glass Co. of Pittsburgh, Pa, at V V 7-8. In their space, surrounded by a gilded railing is a column riding in each corner to support an elevated tier, upon which are thickly studded jets, and over each is a beautiful globe, each one of a different design and a different color, all arranged so as to blend harmoniously. Entering on either side one passes under a pyramid arch in the tier. Over the jets in these arches are large open hall globes, upon each one shines forth a letter of the word Phœnix. Going in you are greeted by a representative of the company in charge of the exhibit, who will show you all the beautifully designed amberine, and other ware, which the four large pyramid sample tables are laden with. One table is laden with globes for gas or kerosene of every possible shape and color, crackled, amberine, and topazine, with different colors fused in. Upon another is a full line of shades of opal and all colors, of crackled and art glass. On each corner of this table stands a flower vase of large size and antique shape, made of mottled amberine ware. Upon the other table are the different shapes of table ware, cream, sugars, bowls, finger dips, etc., all of the most novel design and elegantly blended color - the amber, blue, white rose, opal and mottled, all in perfect harmony. Mottled wine colored and amberine water sets attract attention to the next table. Next to the railing in front, rests all the different designs of electric light globes made by this company, which are the most complete made. Four Brush lights shine down from above each corner giving the ware a brilliancy and luster, which makes a beautiful scene. At the end of this exhibit, upon pyramid shelving are more than 800 samples…"

Feb. 25 PGR: "The Phœnix Glass Co. are showing some elegant new fancies in colored glass. Among them we note a gorgeous "Aurina" punch bowl with little glass hooks on the exterior to hang the handled glasses on. Also a "Rubicon" iced-tea cup of exquisite color and with fine horizontal lines all around. They have also a pitcher with hooks to hang glasses on, and a Roman punch bowl of beautiful finish."

March 26 PGR: "The Phœnix Glass Co. are running one furnace full time. Trade in staples, such as chimneys, shades, opal goods, etc., is slow but the demand for colored glassware is good. They have out a new product called "Cameo" glass. The articles are cased with ruby on the inside and figures on the exterior in relief."

May 14 CGJ: "Novelties, flower basket shaped like a tall conical hat, with position reversed they call Rubicon ware. Berry sets in citron and rose coraline, also in topaz and rose colors are very rich. The have an ivory colored nappy with fluted edge which is also a new production and a handsome one."

May 28 CGJ: "Company received two medals of first class at the exposition in New Orleans for opal glass and best assortment and quality of colored glass."

June 5, Am. Glass Worker: "This firm has spent probably more money experimenting in colored glass than any other firm in this part of the country."

July 16 PGR, Business Memoranda: "They have assortments of their "Common Sense" jugs in 5 opalescent colors, 4 ordinary colors, 1 ruby and 1 crystalline." …"They are putting up lemonade tumblers, tooth pick holders, table salts, individual salts, Roman punch and ice cream glasses in boxes containing one dozen assorted colors, no two colors being alike."

July 23 CGJ. "They have some fancies in ice-cream sets, lemonades, punch sets, berry dishes, etc., suitable for the warm weather, and put up in neat boxes of a dozen each."

Nov. 12 CGJ. "The wonderful variety of shapes made here – only blown ware is turned out – and the diversity of colors and combinations produce effects of great richness. Many of the articles have several different colors running imperceptibly one into the other like those of the rainbow, and it may be said that a tawdry or overdone piece cannot be found among them."

Nov. 19 PGR. "The Phœnix Glass Co. have now on exhibition at their showrooms, 87 Water Street, a magnificent Venetian Art punch bowl, which is a marvel of beauty and workmanship, and the combination of colors is superb. Their new Etruscan and threaded ware, just out, and patented by themselves is especially attractive, and is fully up to what might be expected from this house."

Dec. 3 PGR. "The new peach glass just got out by the Phœnix Glass Co. is probably the most exquisite color, or rather combination of colors they have yet produced. A line of vases of this glass, enameled in gold, is the very acme of beauty and finish. They call them the Mandarin. Their Venetian thread is also worth of note. They have got out a great many new colors and designs for the spring trade and others will be ready in a few days...." "They have lately been much annoyed by small peculations of ware, from their factory, which in the aggregate amounted to a good deal, as only the most valuable articles were taken. Not only this but models of their most expensive molds were taken for the benefit of another establishment. They are reluctant to have recourse to harsh measures, but will have to do something to prevent a recurrence of these annoyances and losses. This firm are now making a line of 7 and 10-inch ring dome shades, the first of the kind made in these sizes in amber, blue, flint opalescent, light blue opalescent, marine opalescent and ruby."

1886

Jan. 7 CGJ. "Their (Phœnix) new lines in "Peach," "Ivory," and "Venetian" glass, enriched with enameling and other forms of decorations, will compare favorably with any made, and their exhibit of gas globes leaves nothing to be wished for in that line."

Feb. 11 PGR. "They have secured the services of Mr. Tietz of Philadelphia, one of the foremost etchers in the country, and he will have charge of their etching department hereafter."

Feb. 25 PGR, Business Memoranda: "The Phœnix Glass Co. have ready a salad bowl in ivory glass, with crystal ornamentation in relief and crystal twisted feet, which for beauty of design and delicacy of tint cannot be surpassed. Also a line of Rose du Barry ware in diamond pattern, comprising spoon, sugar, cream, celery, jugs, etc., and of an exquisite shade of color."

Aug. 6 CGJ: "The great point with this firm is that no matter when one visits them or how often he is sure to find novelties ready. As they make only blown ware there

is no limit to the variety of shapes and the same seems to be the case with colors." "...The company are at present engaged in the production of Fairy lamps, (Clark's patents) on a large scale, and they have recently increased the output of shades, in which they have many new and rich decorations."

Sept. 16 CGJ: "The Phœnix Glass Co. are doing a very excellent trade in all the varied lines of ware they produce. They are selling fancy goods and art ware as fast as they can make them, and have orders ahead in all lines. Shades, many novelties in which they have introduced this season, are going off well. They have a lot of new shapes out in Mandarin glass and many new decorations."

Oct. 7 PGR: "The Phœnix Glass Co. find orders still increasing and are running as hard as they can. Their latest novelty is steel or bronze ware. They have a unique vase of this ware now ready, with globular body and long plain neck. The body is of a bronze shade, and the neck dark steel gray. It is very pretty and entirely out of the common."

Oct. 28 CGJ: "Their sample rooms present an ever-changing panorama of the most unique shapes and beautiful colors, scarce a week passing by without a complete transformation. Their latest novelty, bronze glass, must not be confounded with the glass made here a few years ago by another house under that name. The latter was merely crystal glass superimposed on a thin film of bronze, and for some reason or other it proved a failure. The Phœnix Co's product has the color incorporated in it, and the name merely illustrates this. While they have many more brilliant tints, this is remarkable for its novelty and the easy gradation of the color from bronze at one end of the article to steel gray at the other." Oct. 28 CGJ.

Nov. 11 CGJ: "The coral, ivory and "Mandarin" glass now being manufactured by The Phœnix Glass Co. are well deserving of attention at this season, as finer specimens of the art are seldom to be seen. Indeed, it is hard to reconcile the appearance of some of these wares with that of glass at all, unless one happens to be posted. For delicacy of shading and color the "Mandarin" is unequaled. The graduation from pale yellow to dark brown is imperceptible at any particular spot, and yet the contrast is immense between the top of a vase of this glass and the bottom. A favorite mode of decoration, and a very effective one, is where the inside and outside parts of an article are of different shades of glass, and a pattern is cut through the outside casing, disclosing the inside color. They have many fine examples of this style of ornamentation."

Dec. 23 CGJ: "...the fairy lamps made by them under Clarke's patent (England) have also proved a big card, and their noted ivory and Mandarin wares have drawn hosts of customers since their introduction. At the factory they have been overwhelmed with work, and have employed every man they had room for."

1887

March 17 CGJ: "Also a new water set-tall tankard pitcher and tumblers to match. They are making large quantities of fairy lamps in all colors, and they are going off briskly, as they are goods particularly well suited for the late spring and summer seasons."

March 21 CGJ: "The Phœnix Glass Co. have now ready in pearl, coraline, Venetian thread and other fine colors a full assortment of "Fairy" lamps, which good are coming to the front with rapid strides and promise to make an unprecedented success."

April 7, CGJ: "Not only are they (Phœnix) filling all orders for their elegant productions and bringing out new and effective specimens of the glass makers art, but they have recently arranged with Mr. Samuel Clarke, the English patentee of the celebrated fairy lamps, for the sole right to manufacture these dainty articles in the United States, and they have already produced a large and attractive variety of them, which they are showing at their Broadway store with a beautiful collection of all the elegant novelties brought out for this season."

April 14 CGJ: "The Phœnix Glass Co. have some magnificent novelties in water sets ready now - tall tankard pitchers in Venetian thread, with tumblers to match, elegantly shaped and really among the finest things in the market. They are also showing a variety of Ivory glass goods, enameled in beautiful designs, and cased with rose, ruby and other colors, presenting a remarkably rich appearance."

May 26 CGJ: "The Phœnix Glass Co. are about to enlarge their glass-cutting facilities, and will considerably increase their working force in that department."

Aug. 4 CGJ: "They are making cut glass on a large scale now and have made a success of this class of business, having facilities of the best kind for doing the work and plenty of experienced help."

Sept. 1 CGJ: "Fairy lamps are made in all colors - cut glass, satin finish, plain and decorated - and candelabra of these dainty lamps in numerous styles and of the most delicately tinted glass are on exhibition. Crystal, or bridal pearl, gold clouded fancy ware is the latest, and is attracting a great deal of attention. This house also manufactures cut tableware, and has one of the largest assortment of these goods in the country, and for purity of color, richness of design, and quality stands unexcelled."

Sept. 15 CGJ: "Though not saying much about it they are making better ware than ever, and an inspection of their new products is a treat indeed. They are not making so many of the cheaper grades of colors as they used to, but are mainly employing themselves upon better class work."

Nov. 24 CGJ: "They have a large line of fairy lamps in Venetian thread and other styles, and these are doing tip top."

1888

March 1 CGJ: "They make none (colored glassware) but the finest colors, and those without the tawdry and garish effects that were so common up to about a year ago and helped to bring colored glass into disrepute all over the country."

March 15 CGJ: "They have a fine variety of tableware and specialties in cut glass, comprising rare colors and effects, and they illustrate the possibilities of domestic manufacture of a superior kind in the highest degree."

June 14 CGJ: "The latest novelty shown by the Phœnix Glass Co. at their big showrooms at 729 Broadway is the new cameo glass. It is an impasto cameo, applied in strikingly pretty designs to a variety of useful table articles, gas globes, shades, etc."

July 5 CGJ: "Their new product, cameo glass, has been a decided hit, amid promises to be a great attraction for the fall trade. They have it in four colors, and the decorations are of rare excellence. They have ready shades, water sets, and other articles in the ware, and will extend the line. This is the first time this kind of glass has been made in this country, England having hitherto had a monopoly of its manufacture."

Appendix 2
Patents, Advertisements, and Illustrations of Phœnix Glass

Printed advertisements and illustrations from various print sources are very important to keeping the identification of the art glass on track. Excerpts from some have been incorporated into the various chapters, but here we seek to show the entire advertisements. Many of the Phœnix advertisements ran for several weeks in the *Crockery and Glass Journal,* but we have provided just the earliest dated example.

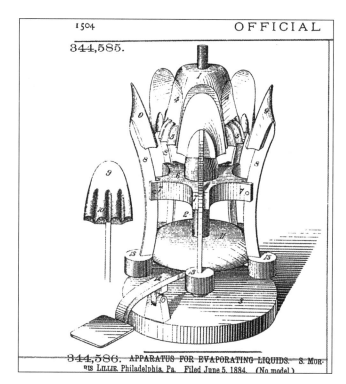

Plate 322. Illustration of the crimping device in U.S. Patent 344,585 issued to William Leighton, Jr. of Wheeling, WV on June 29, 1886. This drawing clearly shows that the "humps" face away from the center of the crimped object.

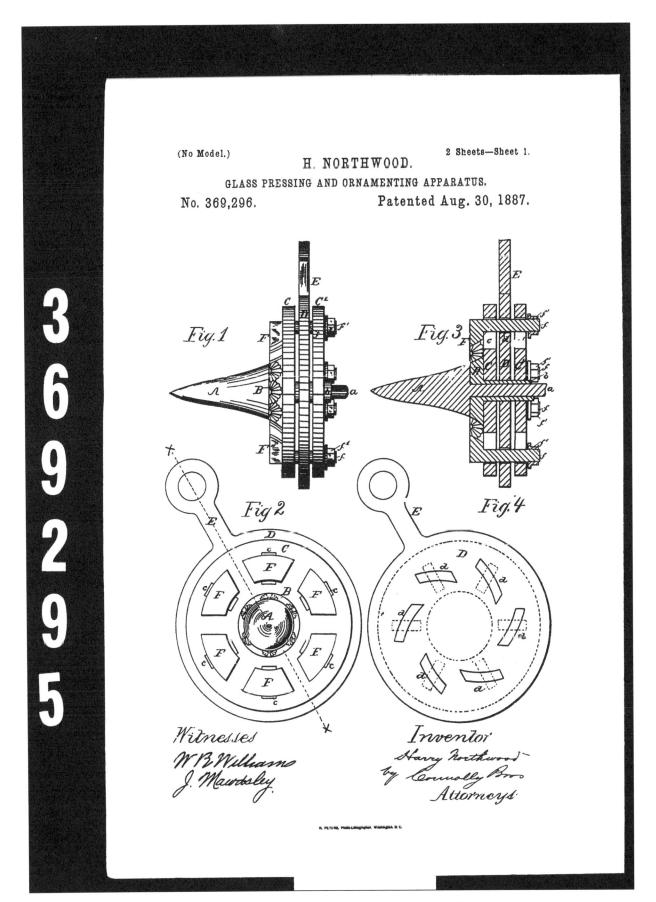

Plate 323. Illustration of the crimping head in the device described in U.S. Patent 369,296 issued to Harry Northwood of August 30, 1887. Figure 3 shows the head in position to receive the glass, and Figure 1 shows the moveable pins in the pressed position. Figure 4 is a detail of the piece that moves the pins back and forth as it is rotated.

J. WEBB.

FANCY GLASSWARE.

No. 363,190. Patented May 17, 1887.

Fig 1

Fig. 3.

Fig 2.

WITNESSES:

A C Rawlings
Daniel Scott,

Joseph Webb
INVENTOR

BY *Connolly Bro*

ATTORNEYS

Plate 324. Illustration of a vase assembled by the insertion of a crackled gather into a prepared cup, as described in U.S. Patent 363,190 issued May 17, 1887 to J. Webb and assigned to Phœnix Glass Company of Pittsburgh, PA. Normally, patent illustrations of finished objects do not resemble actual items being made, but this drawing clearly shows the characteristic foot that was applied to many of the objects made at Phœnix.

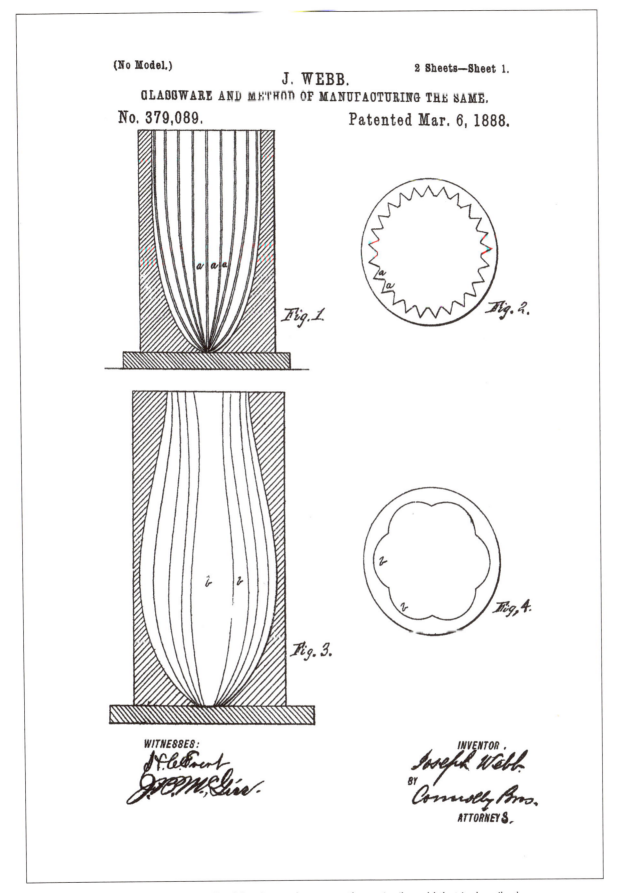

Plate 325. Cross sections (Figures 1, 2) of the die used to create the optic rib mold that is described in U.S. Patent 379,089 issued March 6, 1888 to Joseph Webb of Phillipsburg, Beaver County, PA. Note that the ribs extend to a point at the center. Cross sections of a typical shape mold are shown in Figures 3 and 4. At present, no air-trap examples are known with the "melon" mold exterior.

Plate 326. Illustration of the Dec. 20, 1883 advertisement in the *Crockery and Glass Journal*. The addition of opalescent glassware is due to the technical expertise of Joseph Webb. No domestic glass firm was making blown opalescent ware at this early date. *Courtesy of the Corning Museum of Glass.*

Plate 327. Illustration of the Feb. 12, 1885 advertisement in the *Pottery and Glassware Reporter*. This trade ad implies that artistic tableware was made in the "Art Coraline" color. This might be the name used for a colored or tinted opal glass. At the end of 1886, Phœnix uses Coraline for a mold pattern. *Courtesy of Corning Museum of Glass.*

Plate 328. Illustration of the trade ad in the Oct. 15, 1885 *Crockery and Glass Journal* that references the "Celebrated Webb Glass." This notice includes Venetian as an effect that was being made. Venetian refers to the pattern that results when a spiral thread of opal glass is applied to a gather of colored glass, then pulled into a design. *Courtesy of Corning Museum of Glass.*

Plate 329. Full page advertisement in the Nov. 12, 1885 *Crockery and Glass Journal*. The list of agents in this ad show that Phœnix was selling glass in England as well as the entire United States. *Courtesy of Corning Museum of Glass.*

Plate 330. Full page advertisement in the May20, 1886 *Crockery and Glass Journal*. Note the list of products made. We have yet to see examples of punch bowls or ice cream sets. Also note there is no mention of a catalog, and the buyer can inspect the stock at the new showroom. *Courtesy of Corning Museum of Glass.*

Plate 331. First page of a two page advertisement in the July 15, 1886 *Crockery and Glass Journal*. Note the extensive line of glassware offered at this time. Note in the center portion that Phœnix was making "novelties of great merit" in many colors and effects. It is clear that the examples shown in this book reflect just a small fraction of the glassware made, as well as the colors and effects that were used. *Courtesy of the Corning Museum of Glass.*

Plate 332. Second page of the July 15 advertisement. Note the optic patterns used for library and table lamps include spot and diamond. *Courtesy of the Corning Museum of Glass.*

Vol. XXV. No. 14 NEW YORK, APRIL 7, 1887. $4.00 per Annum

Fairy Lamps!

We have arranged with SAMUEL CLARKE, of London, England, for the SOLE RIGHT of manufacturing **FAIRY LAMPS** in the United States under his patents and trade mark.

Our assortment is very large, comprising NEW and ORIGINAL designs in

PEARL, IVORY, PLATED, SNOW-STORM, ETCHED, CUT, IVORY AND GOLD,

and other **RICH** DECORATED EFFECTS.

In addition to our other lines of Tableware, Vases, Globes, Shades in **ART GLASS** we have recently added

 Cut Glass,

and assure our customers that these goods will be equal to the very best productions of either home or foreign manufacturers.

PHŒNIX GLASS CO.,

729 Broadway, New York.

43 SIXTH AVENUE, PITTSBURGH, PA.

Plate 333. Front page illustration of the Phœnix April 7, 1887 advertisement in the *Crockery and Glass Journal*. This ad appeared shortly after the arrangement with S. Clark to make lamps according to his patented designs. Note the cut glass products that were offered. The advertising space allotted to cut glass increased until the manufacture was discontinued in 1894 when the import tariff was reduced. *Courtesy of the Corning Museum of Glass.*

Plate 334. Illustration of the Phœnix advertisement in the Nov. 1887 *The Decorator and Furnisher*. This is one of the last ads to mention the manufacture of Webb Art Glass. *Courtesy of the Corning Museum of Glass.*

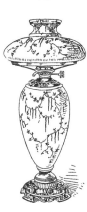
Plate 335. Illustration of the Phœnix advertisement in the Nov. 1890 issue of *Harper's Magazine Advertiser* showing examples of table lamps. We are not aware that any of the "illuminated" catalogs have survived. *Courtesy of the Corning Museum of Glass.*

The Finest American Cut Glass

-:- ——Is that Manufactured by the—— -:-

Phœnix Glass Co.,

(Of Pittsburgh, Penn.)

Read the following from the " Awards and Reports of Judges" of the Pennsylvania Museum and School of Industrial Art :

" In the exhibit of Heavy Cut Glassware the exhibitors were the Phœnix Glass Company and * * *. There were also miscellaneous pieces exhibited by * * *. While the exhibit of the Phœnix Glass Company was the only one in competition, THE JUDGES MADE A CAREFUL EXAMINATION OF ALL pieces exhibited, and came to the conclusion that in PURITY OF METAL, BRILLIANCY OF COLOR, AND GENERAL EXCELLENCE, the PHŒNIX GLASS COMPANY EXHIBIT IS SUPERIOR TO ALL THE OTHERS."

Phœnix Glass Company,
729 Broadway, New York.
43 Sixth Ave., Pittsburgh. Penn.

Plate 336. Illustration of the Phœnix advertisement in the Nov. 1890 issue of *The Jewelers Circular and Horological Review*. Note the unusual puff shape shade of the table lamp, and the shades for the hanging electric lamp assembly. *Courtesy of Corning Museum of Glass.*